GUILLERMO DEL TORO'S
THE DEVIL'S BACKBONE

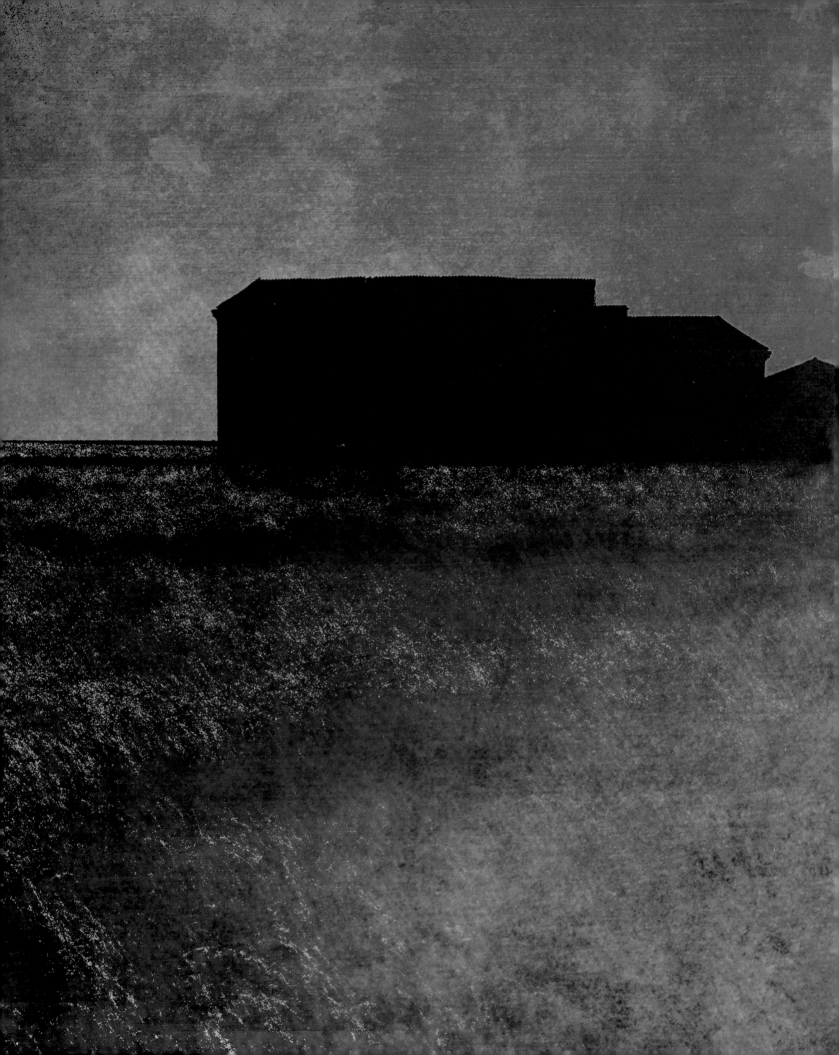

GUILLERMO DEL TORO'S
THE DEVIL'S BACKBONE

MATT ZOLLER SEITZ & SIMON ABRAMS
FOREWORD BY GUILLERMO DEL TORO

INSIGHT EDITIONS
San Rafael, California

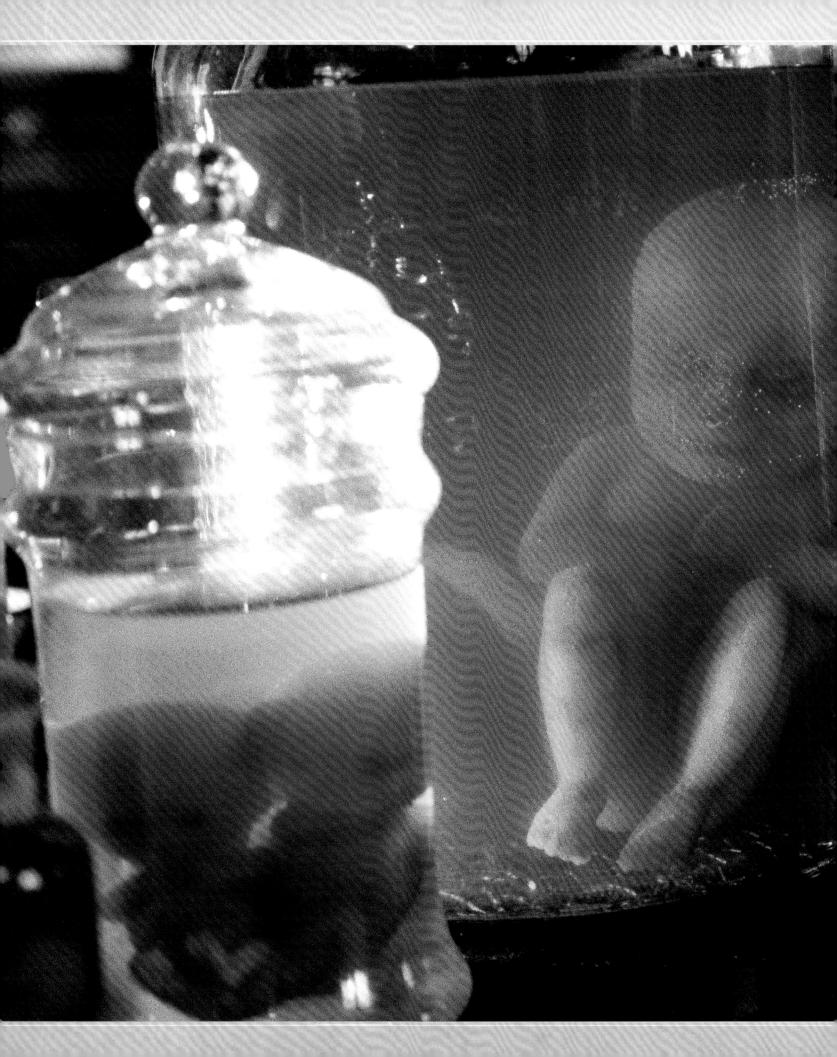

Contents

Foreword

Regret is a ghost—a road not taken, a reckless moment, a missed opportunity. In this manner, we are all haunted.

In the early 1990s, after doing *Cronos*, I found myself in a bit of a limbo.

It was a limbo I am now quite familiar with. I don't belong in any safe film category: too weird for full-on summer fare, too in love with pop culture for the art house world, and too esoteric for hardcore fandom. The fact is, every premise I am attracted to has an inherent risk of failure. I often find myself wondering why I cannot choose an easier path.

But I guess I cannot. It's in my nature. I am one with my vices and I believe that, well regarded, our vices render our virtues.

The Devil's Backbone was, originally, a horror tale set against the Mexican revolution. The film authorities in charge viewed it with great displeasure, as they did *Cronos*, and the shelfful of national and international awards the latter title had garnered was not helpful at all. We were denied any official funding or support.

A few years after *Cronos*' debut at Cannes, as I was at the tail end of the festival tour, I felt no closer to getting a film made. Ever. Again. The promise of a career in film was fading fast, and regret, with all its ghosts, was settling in.

Then Pedro Almodóvar saved me.

How did he do it? Where did it happen? You'll have to read on . . .

That story and many more are chronicled in the book you have in your hands. It consigns, in great detail, the making of what *really* felt like my first film after the frustrations or inexperience of *Cronos* and *Mimic*.

Making *The Devil's Backbone*, I finally felt in command of my visual style, my narrative rhythm, and was able to work in a profound manner with my cast and crew to craft a beautiful genre-masher: a Gothic tale set against the backdrop of the greatest ghost engine of all—war.

The second greatest ghost engine is, in my opinion, memory. With this in mind I started trying to make a movie that would join these two strands and make one thing clear: The ghost is not the scariest thing in the tale. It is human cruelty.

The visual and narrative rules I set out to meet were a bit crazy—I wanted to combine the look of a Western with the flair of a horror film and the austerity of a war chronicle. I wanted to make the personalities of the children in the tale as real as possible. I wanted to avoid the notions of innocence and embrace purity and solidarity.

I was able to put together one of the finest casts I've ever assembled, and we all set out to meet a visual ambition that far exceeded our budget (three–four million Euros). This ambition/budget imbalance has been a constant in my quarter-of-a-century career.

This tale of orphans coming together against the deficient, perverse, and brutal world of adults remains one of my top three films. I have tried to be as candid as possible in the interview that constitutes the backbone of this book. I tried to keep the truth unadorned and unvarnished by nostalgia.

The Devil's Backbone, however, was also one of the most pleasant shoots I've ever had. Protected by the Almodóvar brothers and their production company, El Deseo S.A., I was free to create and was given total control.

I needed this. I needed it so much. After going through a nightmarish shoot on *Mimic*, I felt that Hollywood filmmaking was not to be.

I was entering this new process full of fear and worry.

And then, it all changed.

I remember discussing the notion of "final cut" with Pedro early in the process and seeing him grow genuinely confused. "I need to have final cut, of course," I said. "What is a final cut?" he asked me. "Well," I tried to explain, "the final cut means that the final edit decision globally and in any scene rests with me." His eyes widened and he looked around confused, "But, of course, the decision is yours!" he said. "You're the director!"

And that started me off on a joyful, enraptured creative experience.

The movie healed all my wounds—made me whole again. I am as grateful as I've ever been to Pedro. In fact, I've since produced and "godfathered" many first films in order to pay it forward, trying to thank the universe for giving me this film.

And then, lest I forget, *The Devil's Backbone* bore a companion piece you may like to get familiar with—it's called *Pan's Labyrinth*. They are "mirrored movies," which reveal symmetries and reflections if you ever watch them together . . . and I love them both with equal passion.

So, a film about ghosts cleared all ghosts from my past. A film about loss gave me life again. A story of orphans gave me a filmmaking family.

Disguised as a Gothic tale, *The Devil's Backbone* hides a beating heart and a story about loss and the phantoms of regret. It is a worthy "boy's adventure" and a small fable full of melancholy.

This film is full of love and worthy of love.

I do hope you'll agree.

–GUILLERMO DEL TORO
Toronto, Summer 2017

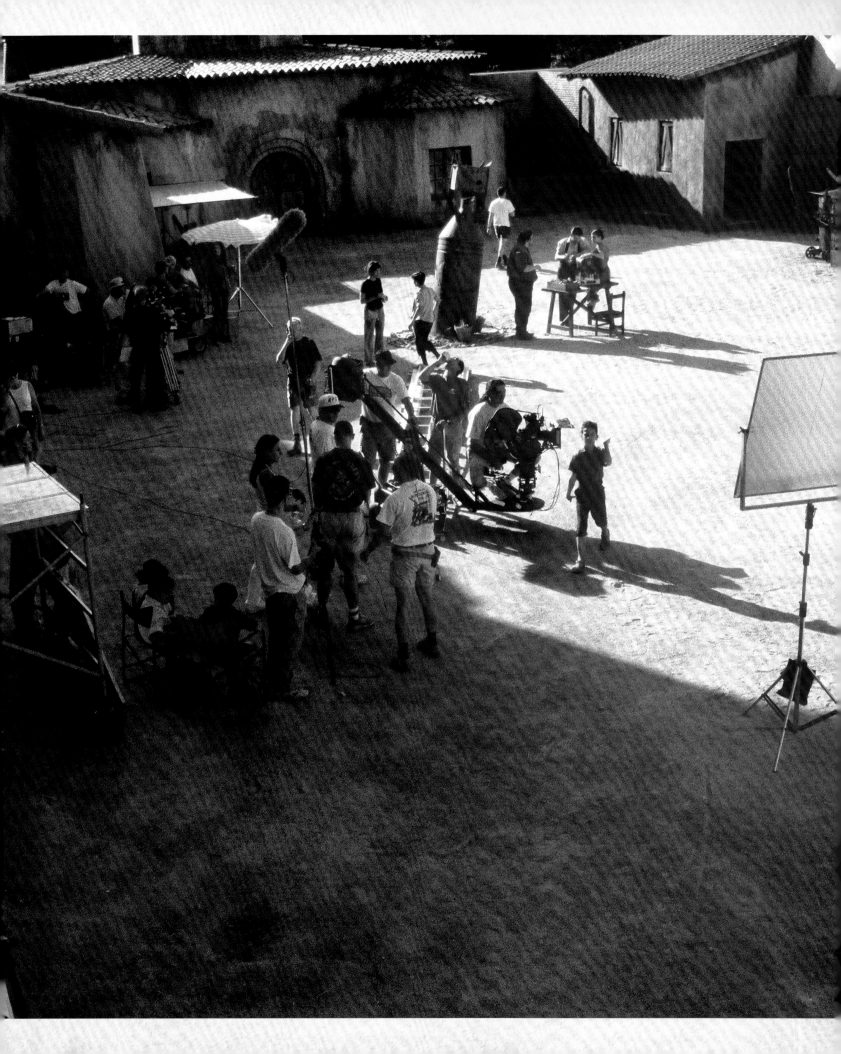

Preface

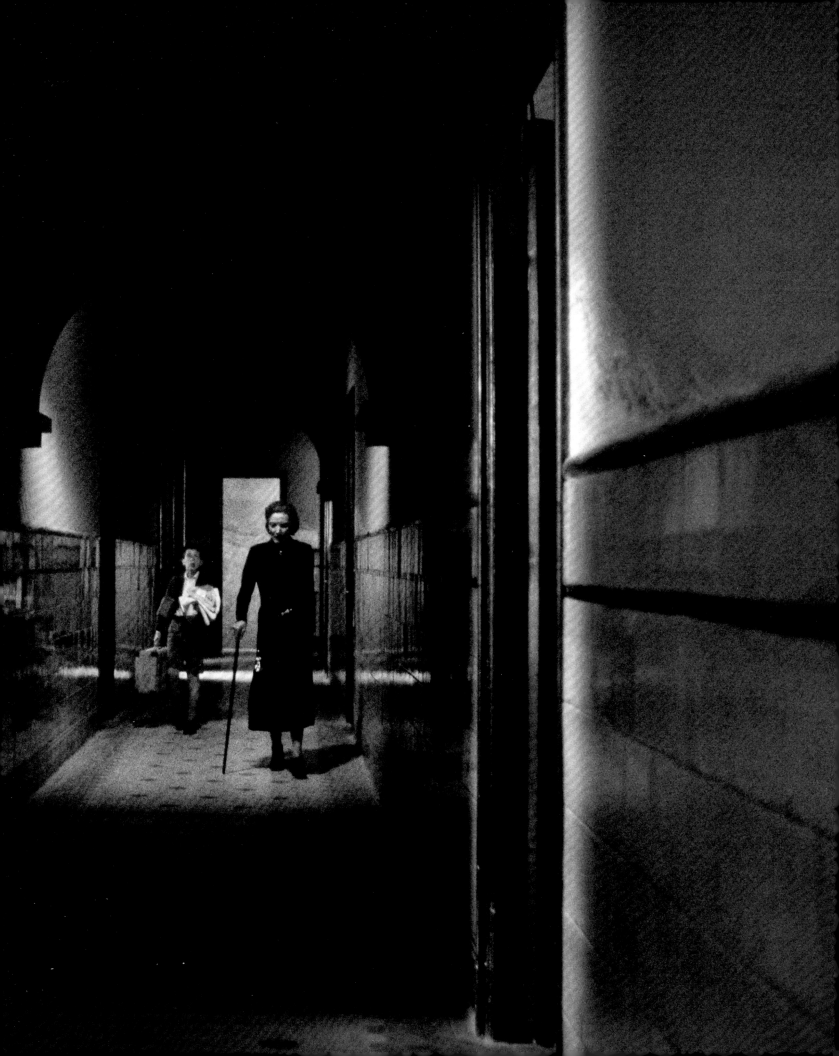

THE PLAY

Directed by **Guillermo del Toro**
Written by **Guillermo del Toro**, **Antonio Trashorras**, and **David Muñoz**

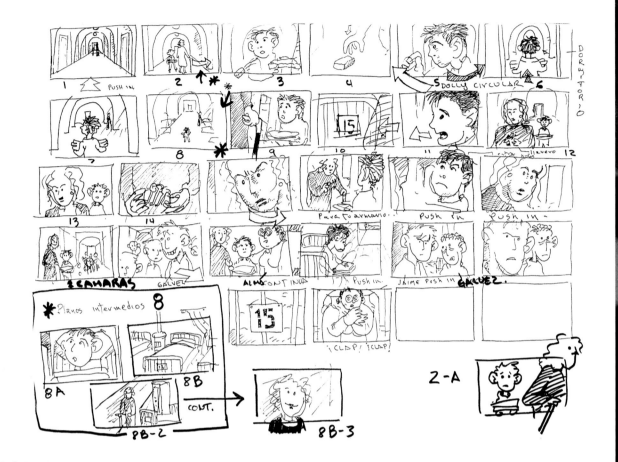

IN THE TABERNAS DESERT at the height of the Spanish Civil War sits an orphanage called Santa Lucia. It houses seven boys: six living, one dead. The dead boy's name is Santi. He haunts the grounds at night. The other children call him the One Who Sighs.

Santa Lucia's headmistress, Carmen, lost her husband and her leg to the war. Carmen's companion is the orphanage's doctor, Casares. He adores Carmen but can't make love to her because he's impotent. Casares keeps deformed fetuses in jars full of amber fluid and mixes this liquid with rum to create a rejuvenating elixir that he sells in town to earn money for the orphanage. Carmen's late husband died battling the Fascists. Carmen and Casares honor him by hoarding gold for the Republicans, who are fighting the Nationalists in the desert.

Casares drinks the amber elixir to cure his impotence, but it does no good. No matter: Carmen gets what she needs from her secret lover, the caretaker Jacinto, an angry young man who was raised by her at the orphanage. Jacinto has a loving fiancée, the kindhearted Conchita, and talks about escaping with her, but he also fantasizes about destroying the place where he grew up.

In the middle of the courtyard sits an enormous, unexploded bomb. It fell into the courtyard on the night Santi died. The event was either a coincidence or a sign.

Into this hothouse comes Carlos, a bright and sensitive twelve-year-old orphan who enjoys drawing comic art. He is assigned the bunk that once belonged to Santi. His bunkmates include a posturing, young would-be tough named Jaime, who secretly draws comics, too, and is a better artist than Carlos.

TOP Storyboards of Carlos arriving at the orphanage, being assigned a bed, and sensing Santi's presence.

RIGHT In the filmed version of the storyboarded scene, Carlos (Fernando Tielve) takes in his surroundings.

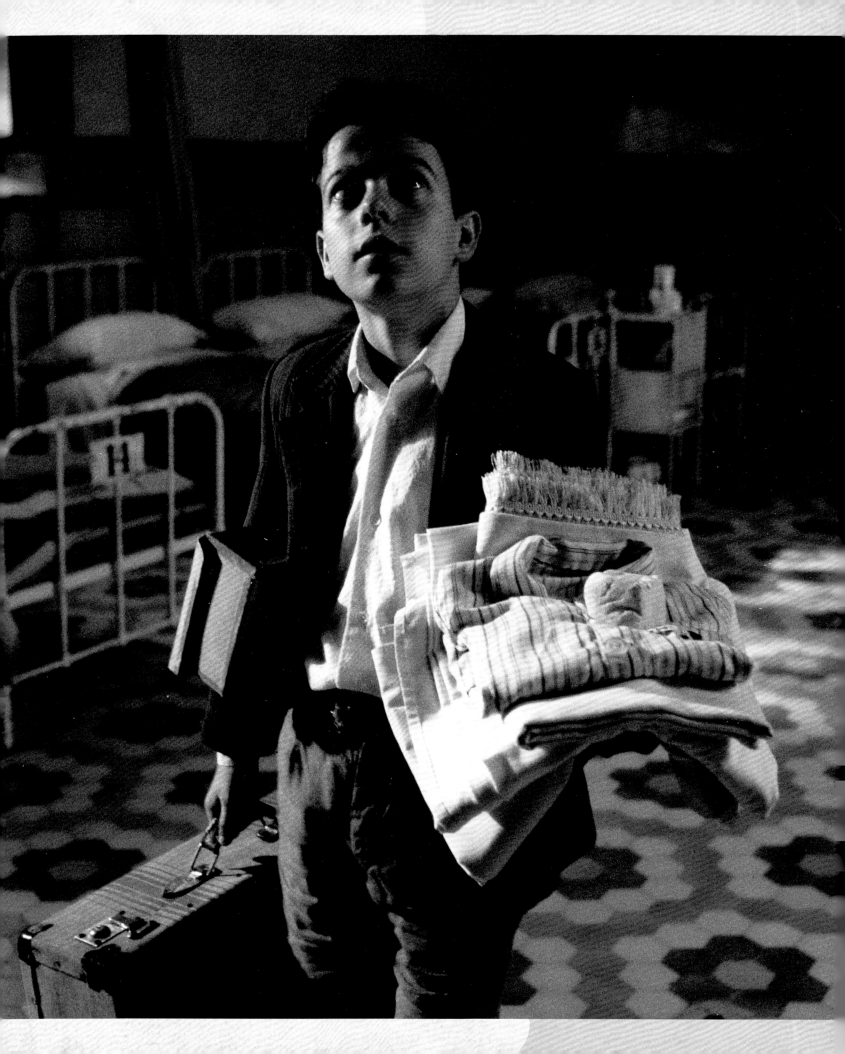

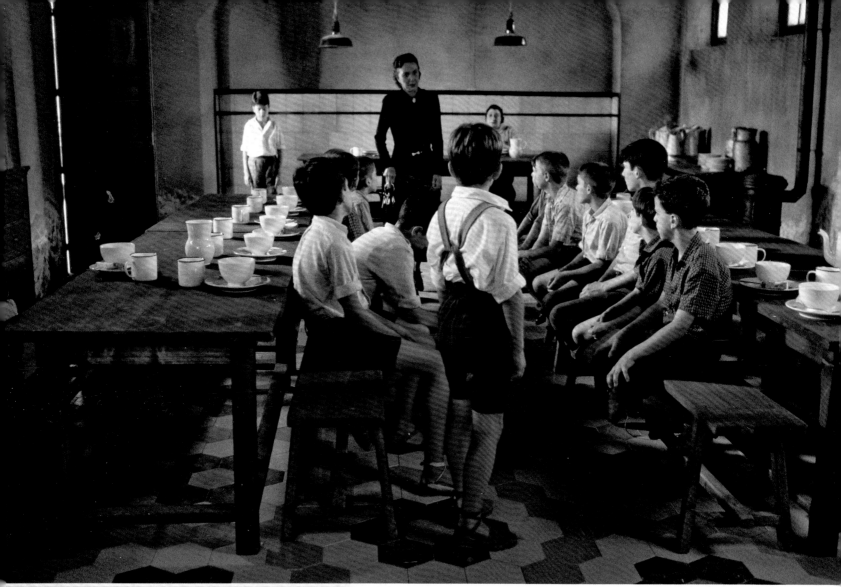

Carlos gains the other boys' trust in a pair of incidents that prove his integrity. First, he gets caught sneaking into the kitchen late at night with the other boys—part of a dare by Jaime, their leader, to get Carlos to confront the One Who Sighs—but refuses to give up the names of his accomplices. Later, in an after-dark outing to the orphanage's cistern, Jaime asserts his dominance over the group by pulling a knife on Carlos. The boys fight; Jaime, who can't swim, falls into the cistern, and Carlos dives in to save him. Jacinto arrives, breaks up the confrontation, spots Jaime's knife lying on the floor, and demands that Carlos tell him who it belongs to. Carlos once again refuses to tattle, and Jacinto flicks the knife against his cheek, leaving the boy with a cut that becomes a small scar.

Dr. Casares treats Carlos's wound in the infirmary and tells him about the jars of deformed fetuses he keeps there. The orphans reveal to Carlos that Santi disappeared on the same night that the bomb fell and that he likely ran away and was murdered by highwaymen. Later that night, Carlos hears the One Who Sighs whispering, "Many of you will die," and decides to investigate the matter on his own. He encounters the ghost, a lost-looking, semi-translucent apparition whose blood streams into the air from a gash in his head. Carlos runs away in terror, locks himself in a linen closet, and stays there until morning. He later discovers a drawing of Santi in Jaime's sketchbook and realizes that his bunkmate knows more about the ghost than he's letting on.

Carlos learns the awful truth right after Dr. Casares decides that the war has gotten too close to the orphanage and they must evacuate immediately. Jacinto takes the crisis as an excuse to fulfill his fantasy of burning the place to the ground by soaking the kitchen in kerosene. Carmen points a gun at Jacinto to make him stop, then shoots him in the arm when he mocks her. Jacinto succeeds in lighting the kerosene; the adults try to evacuate the building

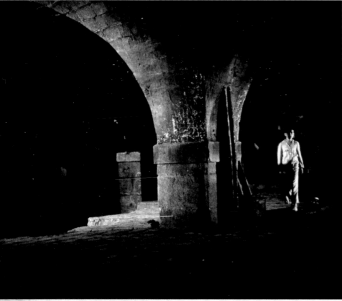

TOP Headmistress Carmen (Marisa Paredes) addresses her charges.

ABOVE Carlos enters the cistern for the first time.

OPPOSITE The ghost of Santi (Junio Valverde) appears.

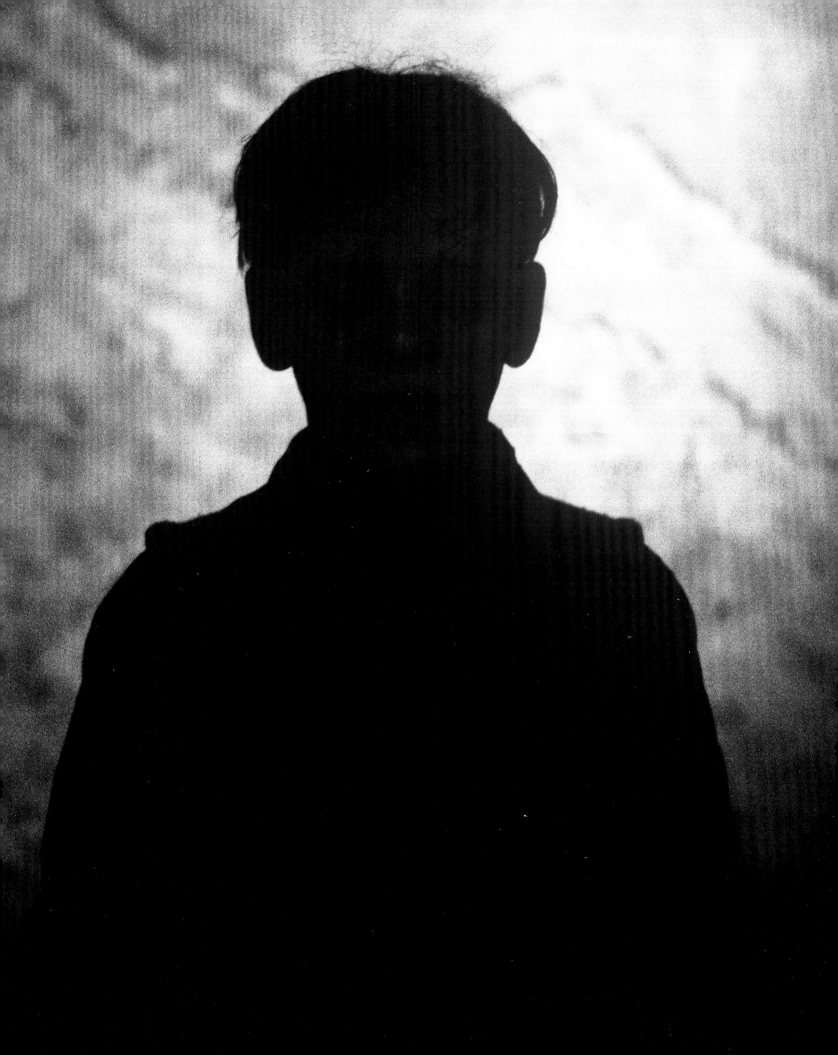

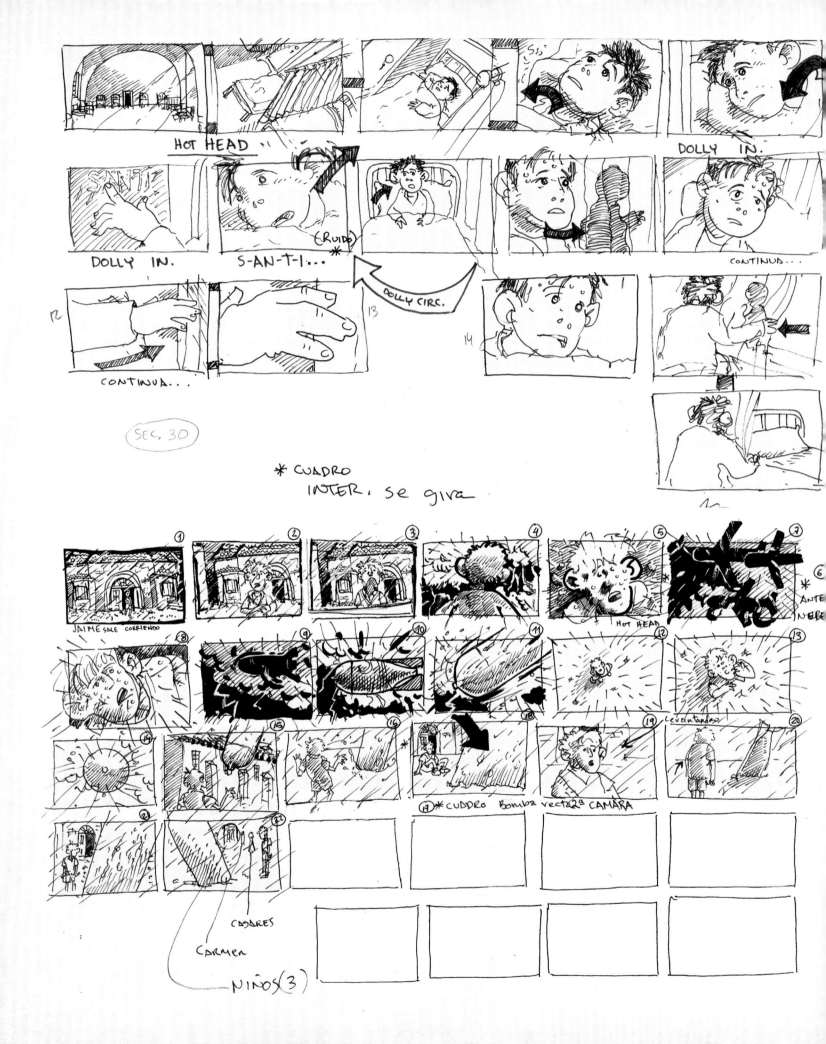

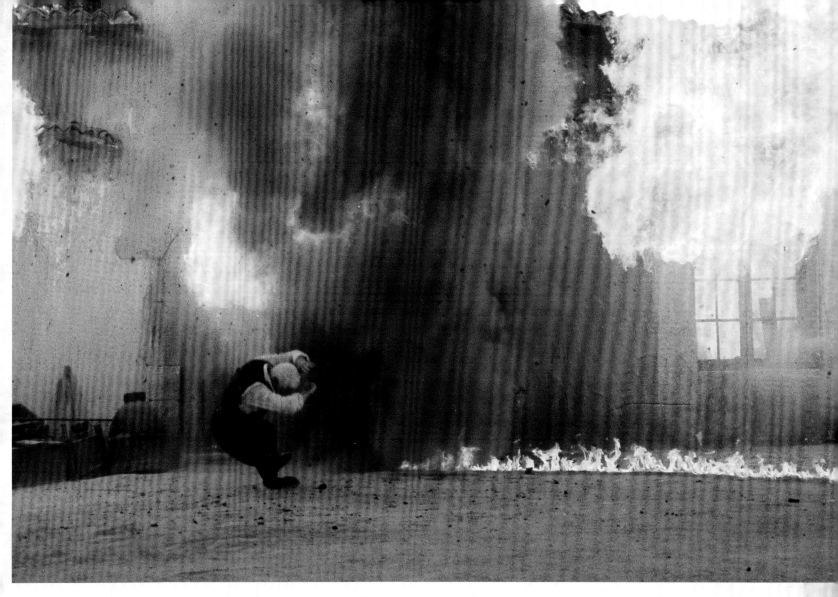

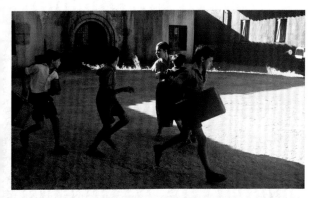

before the unexploded cans of kerosene in the kitchen detonate, but the explosion kills several of the boys (fulfilling the ghost's whispered prophecy) and also mortally wounds Carmen. Carmen dies as Casares, who was also badly injured in the explosion, leans over her reciting a poem. Jacinto was also badly hurt by the explosion but escapes into the surrounding desert.

Carlos learns the secret of Santi's death: Santi and Jaime stumbled upon Jacinto in the act of trying to rob the safe where Dr. Casares and Carmen store gold for the Republican rebels; Jacinto lost his temper and accidentally bashed Santi's head against the wall hard enough to kill him. He then tied up his corpse with ropes and threw him into the cistern to cover up his crime, threatening Jaime with death if he ever spoke of it.

Conchita leaves the orphanage to find help following the fire. While walking along a desert road, she runs into Jacinto and two friends, who are driving back to the orphanage to finish stealing the gold. Appalled, Conchita levels a gun at her fiancé to make him stop, but he takes it away from her and stabs her, snuffing out any redeeming qualities he might have still had in the process. Returning to the orphanage, Jacinto is enraged to find the safe emptied of gold but then discovers a cache of it in the dead Carmen's hollow leg. Jacinto tries to share his new fortune with his two friends, but they tell him he's crazy and abandon him.

Carlos gathers together a posse of orphans to confront Jacinto. They face off at the edge of the cistern. They take turns stabbing Jacinto with homemade spears like the mammoth-hunting cave dwellers they saw in a school lesson and then shove his bleeding body into the pool. Jacinto tries to swim back to the surface but is weighed down by the gold he stole. Santi's ghost emerges from the murk and administers the coup de grace, holding his murderer underwater until he drowns. Waiting to confront Jacinto and take his revenge, Casares dies alone from his wounds. He joins Santi as a ghost haunting the orphanage as the children wander into the desert.

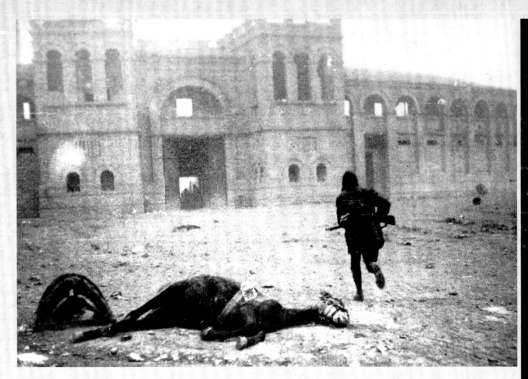

THE STAGE

THE SPANISH CIVIL WAR (1936–39), known within Spain simply as the Civil War, was a devastating intrastate conflict that claimed, by some estimates, a quarter of a million lives. The warring sides were the Nationalists and the Republicans. The Nationalists, led by General Francisco Franco, were a mix of Falangists, Carlists, and aristocratic conservatives with authoritarian tendencies. They dreamed of restoring the Spanish empire but settled for exterminating their enemies, the Republicans, a coalition of left-leaning democrats who were loyal to the Second Spanish Republic.

The war started when a group of generals in the Second Spanish Republic's armed forces rebelled against the government and eventually took power in a coup. Madrid, Barcelona, Valencia, Bilbao, and Málaga remained under the control of the Republicans, who attacked the Nationalists from strongholds in the west and south. Nationalist military units held Pamplona, Burgos, Zaragoza, Córdoba, and other major cities, as well as Spanish-controlled Morocco. The Nationalists allied themselves with Nazi Germany during the run-up to World War II, accepted munitions from them, let them try out tactics and weapons in-country, and turned more crudely Fascistic in character as the war raged. The country split into a shifting patchwork of territories, with ground continually being seized and relinquished. Friend killed friend, brother killed brother. Towns were destroyed, swaths of earth scorched.

In 1938 and 1939, the Nationalists decisively turned the tide, taking large sections of Catalonia and finally taking control of the entire country. Many Republican loyalists fled Spain and settled in other countries, including France and Mexico. It was later estimated that at least 130,000 and as many as 200,000 Republicans were killed by Nationalists, often through executions, and that somewhere around 55,000 Nationalists died at the hands of Republicans. Franco remained in power for another thirty-six years.

The Civil War inspired some of the greatest popular and fine art of the twentieth century, much of it of an anti-authoritarian or specifically anti-Fascist nature. These works include Pablo Picasso's mural-sized painting *Guernica*, which depicted the aerial bombardment of the eponymous Basque Country village in northern Spain by Nazi and Nationalist planes; Ernest Hemingway's novel *For Whom the Bell Tolls*, one of many pieces of fiction inspired by the author's stint as a volunteer ambulance driver on the Republican side; and George Orwell's *Homage to Catalonia*, a memoir of the Fascist takeover of Spain from 1936 to '37, which Orwell observed while serving as a volunteer soldier in the army of the Republic.

ABOVE A photograph captures the Spanish Civil War's Siege of Teruel, December 1937–February 1938.

RIGHT Captured Republican soldiers are searched in *The Devil's Backbone*.

PAGE 18 Santi looks out at the courtyard, an image that evokes a signature shot from Mario Bava's *Kill, Baby, Kill* (1966), about a castle haunted by the ghost of a murdered girl.

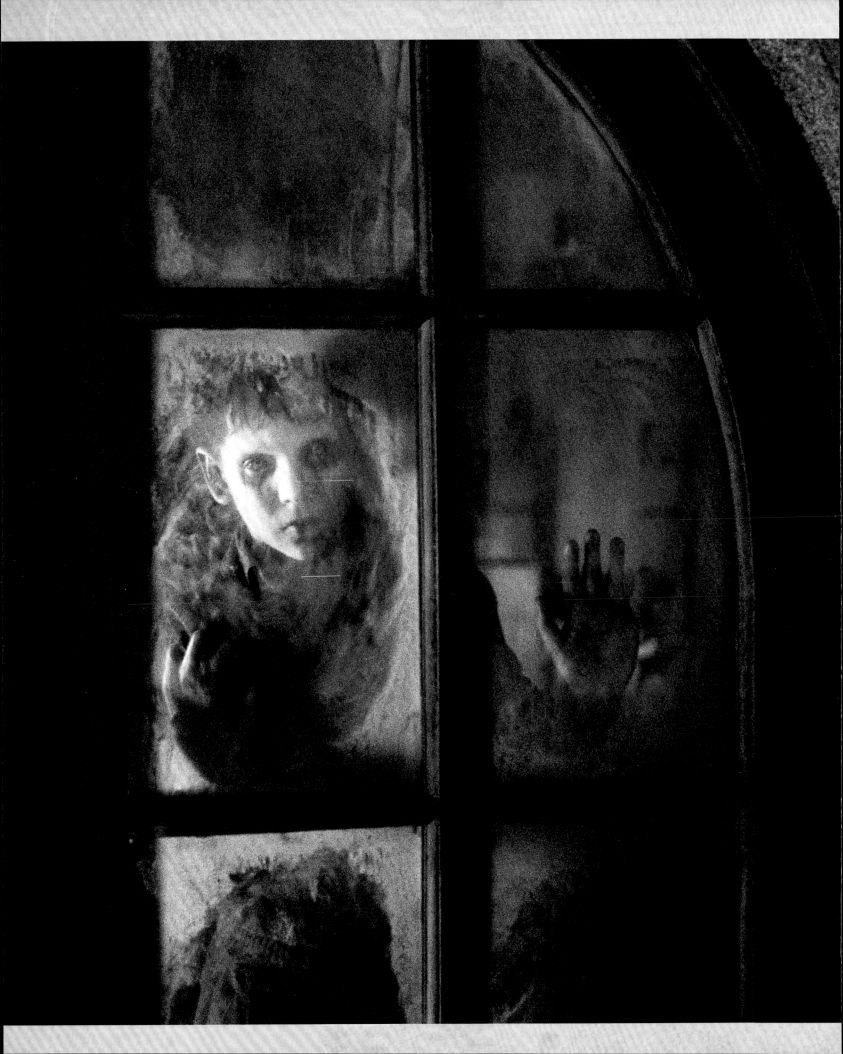

DRAMATIS PERSONAE

CARLOS
(Fernando Tielve)

Carlos is the son of a dead Republican war hero. He is abandoned at the Santa Lucia orphanage by his tutor and soon finds himself haunted by the ghost of Santi, a former resident of the orphanage. Carlos initially has an antagonistic relationship with fellow orphan Jaime, but eventually they become friends.

SANTI
(Junio Valverde)

Santi is a ghost who haunts the orphanage—a former Santa Lucia resident who was murdered under mysterious circumstances. He is not a vengeful spirit, though he terrifies Carlos. The other children hear him at night, but he reveals himself only to Carlos.

CARMEN
(Marisa Paredes)

Carmen is the headmistress of the Santa Lucia orphanage. She lost her leg—perhaps in the same incident that claimed her husband's life, though the details are never discussed. She and Casares have the settled, affectionate demeanor of a longstanding couple even though it's clear that he has more ardor for her than she does for him.

CONCHITA
(Irene Visedo)

Conchita is Jacinto's fiancée and a fellow employee at the Santa Lucia orphanage. She shows him love that he can't reciprocate because of his anger and brokenness. Conchita tries to get Jacinto to leave the orphanage with her and settle down, but he resists.

JAIME
(Íñigo Garcés)

Jaime is an orphan at Santa Lucia and initially seems to be a typical bully. But he eventually lowers his defenses and reveals his ambition to be a comic book artist. Jaime knows something about Santi's death but is reluctant to elaborate to Carlos.

DR. CASARES
(Federico Luppi)

Casares is an empathetic but powerless intellectual who runs the orphanage. He is in love with the orphanage's headmistress, Carmen, a fellow Republican loyalist, but cannot express his love physically because of his impotence. To help fund the orphanage, Casares sells an elixir made of rum fermented in jars of unborn fetuses. He has a fatherly bond with Carlos.

JACINTO
(Eduardo Noriega)

Jacinto is a handyman and caretaker at Santa Lucia. He is gruff and expresses himself mainly through action. He has sex with Carmen but won't touch his fiancée, Conchita. Jacinto knows about the safe that hides the loyalists' gold and has plans to steal it and leave the orphanage with Conchita.

OWL (Javier González Sánchez) and GÁLVEZ (Adrián Lamana)

Owl and Gálvez are orphans and Jaime's closest friends. They bond with Carlos immediately and share their toys and comics with him.

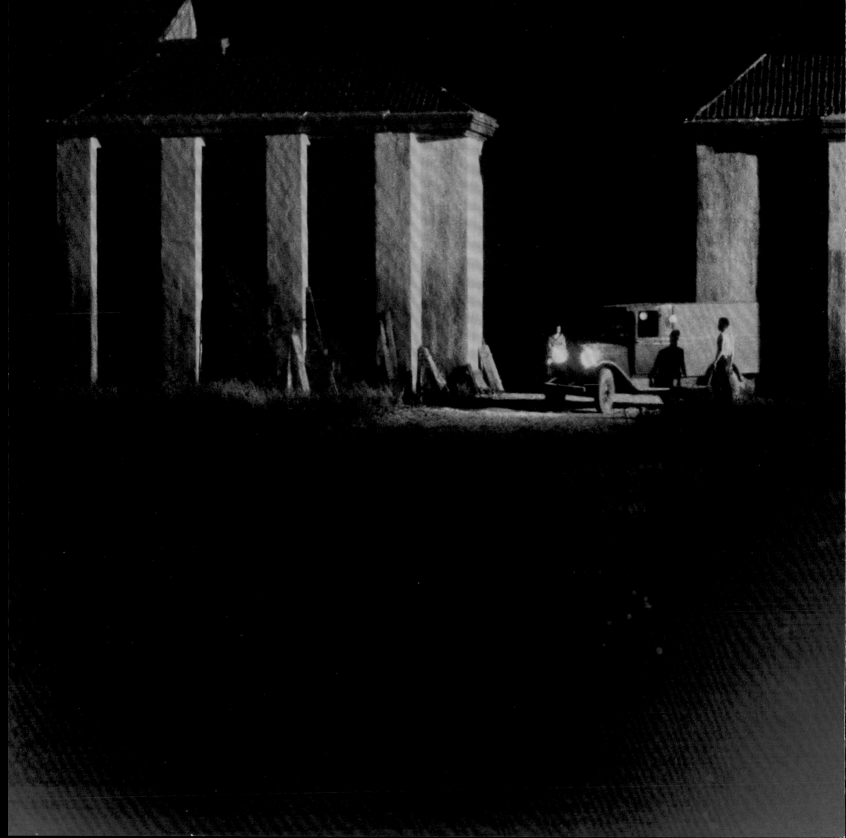

part one

Introduction

By Matt Zoller Seitz and Simon Abrams

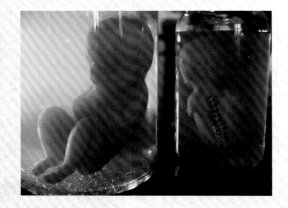

THE DEVIL'S BACKBONE IS DIRECTOR GUILLERMO DEL TORO'S FIRST MASTERPIECE. It also marks the moment when del Toro (*Crimson Peak, Hellboy*) truly became del Toro, a filmmaker who knows popular genres inside and out but is never content just to work within their conventions. He comes at his subjects from unique angles and delves deeper than you might expect. The result often divides audiences into camps—those who are frustrated that the film didn't do what that sort of film usually does, and those who appreciate that del Toro has made another obsessive gem that only he would think to direct.

The rough outlines of his films are always easy to describe: *Pacific Rim* is a science fiction thriller about giant monsters fighting giant robots. *Blade II* is about a good vampire fighting bad vampires. *Pan's Labyrinth* is about a girl who enters a fantasy world to escape the daily misery of life in a dictatorship. But the longer you study del Toro's movies, the more likely they are to slip the shackles of their loglines. *Pacific Rim* reveals itself as a film about duty, teamwork, and the political and emotional necessity of becoming a part of something bigger than yourself. *Blade II* is a dynastic tragedy about the bonds and rivalries of fathers and their sons. *Pan's Labyrinth* shows what it means to breach the membrane separating reality and fantasy, and then asks if the membrane is itself an illusion.

Shot over fifty-one days during the summer of 2000 in Madrid, the Spanish province of Guadalajara, and primarily in Talamanca (where the interiors and exteriors of the film's orphanage set were built on location), *The Devil's Backbone* is where del Toro perfected his persona as a storyteller and showman. Every film he's made since builds on lessons he learned while making it. True to form, *The Devil's Backbone* is easier to

22

summarize than it is to describe. You could call it a ghost story set in an orphanage during the Spanish Civil War and not be wrong. You could fixate on the symbolism and allusions that connect the movie to a tradition of anti-authoritarian, specifically anti-Fascist, art. And you could call it a revenge tale or a murder mystery and be right, too. The film's young hero, Carlos, a newly arrived orphan, becomes the target and then confidant of a wandering spirit named Santi, aka The One Who Sighs. Carlos the sleuth and Santi the poltergeist-in-limbo become one of the most unusual "buddy" teams in movie history. There are times when it's hard to tell if Santi is Carlos's instrument or the other way around.

Although the screenplay is steeped in historical details and has a real-world sense of place, *The Devil's Backbone* is also an Expressionist and sometimes surreal work filled with images and situations that can be interpreted as symbolism or allusions, as in del Toro's subsequent Spanish Civil War fable, *Pan's Labyrinth*.

While it touches on several genres, *The Devil's Backbone* is ultimately a melodrama. Co-written by del Toro, Antonio Trashorras, and David Muñoz, the tale is filled with archetypal yet rich characters. The wide-eyed Carlos is a classic guide, truth-seeker, and audience surrogate—a tough but decent boy. Santi, as his name implies, suffered for others' sins and now keeps the guilty world up at night. The cruel orphan Jaime only pretends to be ruthless; he melts when Carlos compliments his drawings and becomes his closest mortal ally. There's a committed but haunted-looking headmistress, Carmen, with an older, impotent companion, Casares, and a secret lover, the domineering and resentful Jacinto. The film keeps rearranging its characters into configurations that express ideological and political conflicts. Both Santi and the bomb are specters representing the legacy of the Civil War; Casares, the film's narrator, at first seems like their human avatar, but at the end we realize he's dead, too. When the boys join forces to expose and punish Jacinto for killing Santi, they surround him like the ancient hunters they glimpsed during a history class and spill his blood with handmade spears.

The movie joins reality to fable in an intuitive, poetic way. Opening credits juxtapose images of a deformed fetus floating in amber, plus disconnected flashes of horror: explosives dropping from a bomber's belly; a boy bound with ropes, drowning in brackish water. These strobe-flash compositions connect to the rest of the film and the way in which Santi infects Carlos's mind with images that drive him to unravel the mystery at the heart of the story. The film's title refers to spina bifida, which was once thought of as a curse rather than a condition. The fetus glimpsed in the opening credits has a deformed spine that peeks through the flesh of its back. But the connections between all these elements become clear only after you've let the totality of the movie ferment in your mind.

And it is always possible to experience the movie simply as a collection of images, moments, statements, and actions. The bomb is an immense emblem of the film's undetonated power, likened in dialogue to a fertility goddess—director of photography Guillermo Navarro films it like a shrine to a god—but it is also a thing people have to walk around when they cross the orphanage's courtyard.

The movie's ability to connect rhetorical, architectural, and personal elements is dazzling. Consider how *The Devil's Backbone* links the development of Spain's national character to the development of its individual humans, letting each stand for aspects of their war-torn country as well as their private struggles. You can see this dynamic at play in the triangle of Jacinto, Carmen, and Casares. Jacinto, a budding authoritarian, expresses himself by screwing and fighting his problems away; he gets high on his own alienation and resentment. Casares and Carmen, a pair of liberal conciliators who secretly help Republican soldiers, are intellectually superior to Jacinto but older and physically weaker: The headmistress is missing a leg, while her boyfriend can't get it up and drinks rum from the spina bifida tanks to heal himself. It's a classic left wing–right wing configuration. Moderate leftists like Carmen and Casares, who are fighting to preserve the status quo while keeping their day jobs, will never be as seductive as a volatile young stud who isn't afraid to literally burn it all down. Jacinto's fiancée, Conchita, is probably the film's most pure-hearted character besides Carlos and Santi; she represents a more compassionate, merciful future.

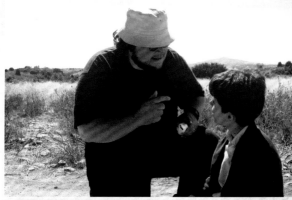

OPPOSITE TOP Storyboards of the first proper scene in the movie, Carlos's abandonment at the orphanage.

OPPOSITE BOTTOM Spina bifada–deformed fetuses float in jars of rum.

TOP RIGHT *The Devil's Backbone* director Guillermo del Toro advises Fernando Tielve during the filming of Carlos's arrival at the orphanage.

CENTER RIGHT Del Toro directs the scene where Republican soldiers are executed by Nationalist troops.

BOTTOM RIGHT A wounded Jacinto faces his fate.

23

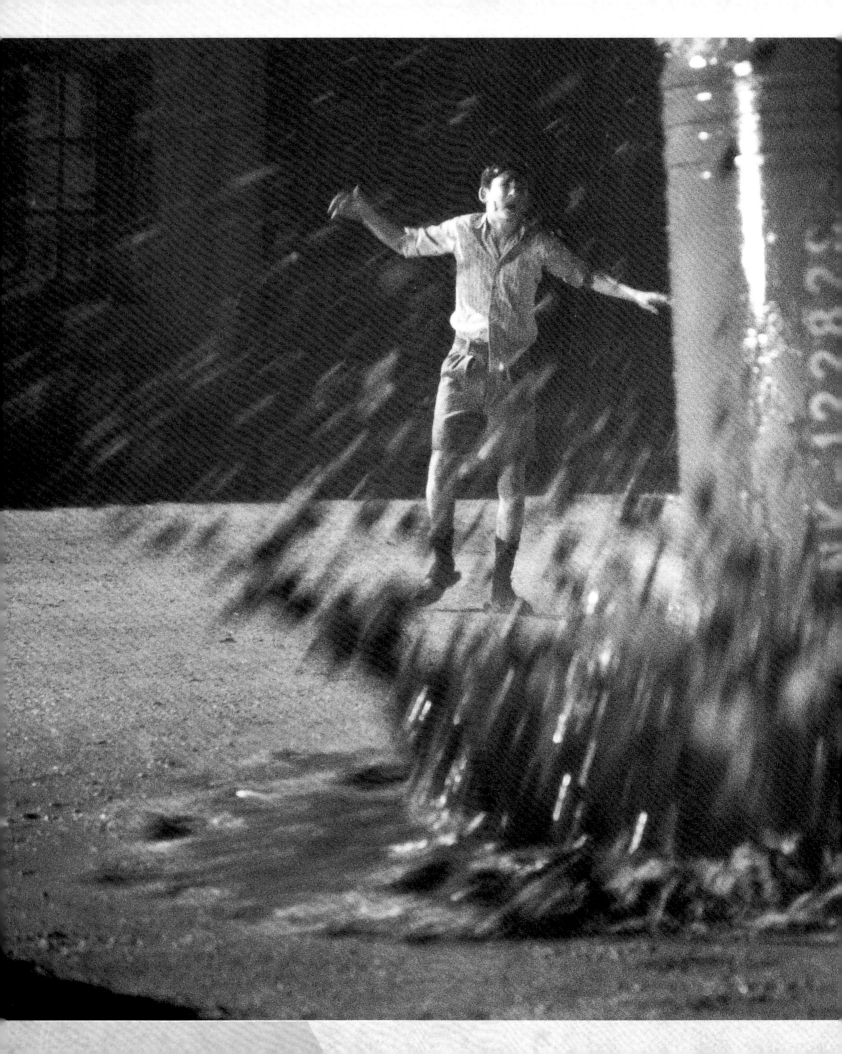

Jacinto is a portrait of the nihilist as teen pinup, sweating through his Stanley Kowalski T-shirt. He can picture only brute force, fire, sex, and death. That's probably why he won't sleep with Conchita. He treats her as an idealized symbol of wholesomeness, of everything he can never be. Having sex with her might infect her with his perceived worthlessness. By lashing out against Carmen and Casares (his de facto parent figures), the orphanage (the institution that raised him), and the motherland itself (through proto-Fascist behavior), it's as if Jacinto is trying to reenact the primal trauma that forged him and destroy the parents he feels abandoned him.

If there is a single moment that captures *The Devil's Backbone*'s emotional complexity, it's the scene that plays out just before Jacinto meets his fate. In del Toro's worlds, every monster is a victim of tragic misunderstanding. Jacinto is among the most indelible examples in the director's filmography. His crimes come to light by the film's end, but his death is not strictly a matter of moralistic retribution. The snarl on his face as he meets his doom is the face of a cornered animal that knows the hunters have won.

There's a sad edge to every moment of *The Devil's Backbone*. It is amplified by Javier Navarrete's melancholy score, the cast's unaffected performances, and Navarro's ability to draw the eye to the place where light meets shadow. But the sadness never tips over and becomes maudlin. Del Toro may weep for these kids, but he won't allow the film to weep on the viewers' behalf. At the end of the story, Jaime and Carlos wander off into the wasteland and head for parts unknown. The fact that they resorted to violence to dispatch Jacinto is not presented as a good or bad choice but rather as pragmatic and maybe inevitable. It wounds their souls, hardens them. Jacinto is the film's unbilled second protagonist because he, more so than Jaime or Casares, mirrors Carlos's plight: They are both "[princes] without a kingdom," as the caption on an old family vacation photo of Jacinto describes him. Troubled and abandoned, they have no strong moral compass to follow and must make their own way. The grown-ups are gone. The kids are alone. Ghosts are everywhere.

LEFT Jaime (Íñigo Garcés) is nearly killed by the bomb that embeds itself in the courtyard of the orphanage.

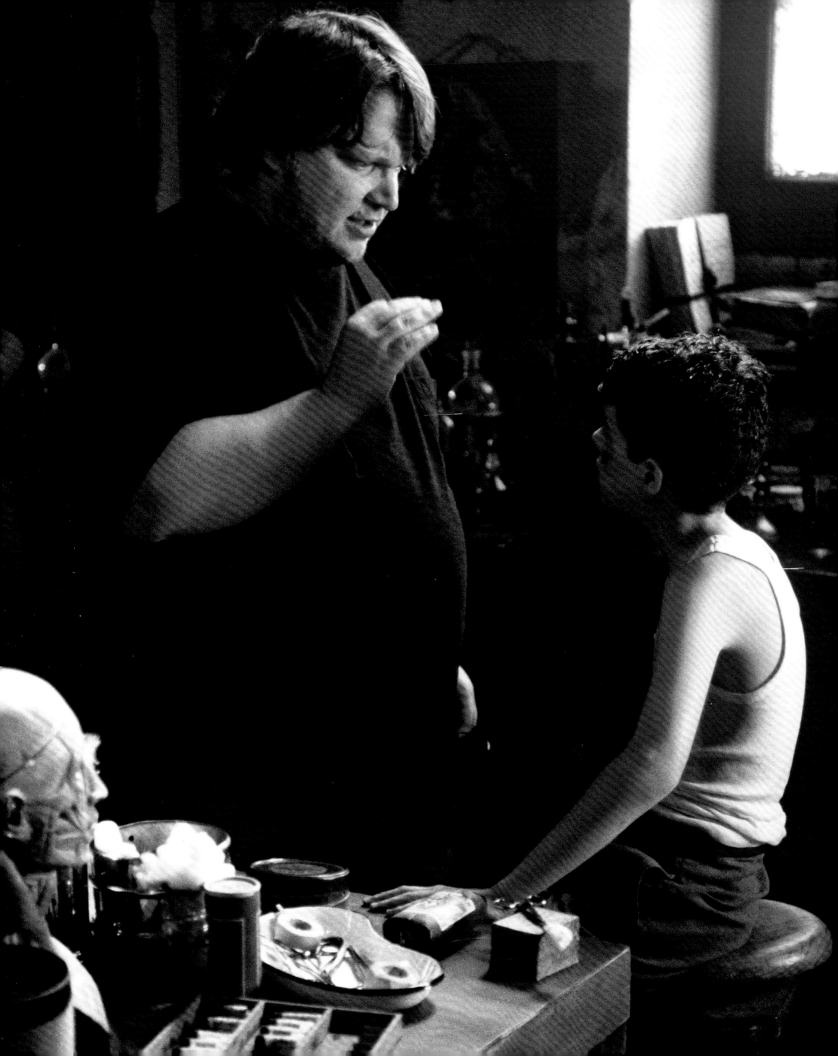

Dreams of War

Matt Zoller Seitz: Why are you so obsessed with the Spanish Civil War?

Guillermo del Toro: When I was a kid, the only place I had heard of Generalissimo Franco was *Saturday Night Live*.

M: Right, "Generalissimo Franco is still dead!" I remember, Chevy Chase on "Weekend Update."

G: That's all I knew. That, and *For Whom the Bell Tolls*. I knew that Hemingway wrote about [the Spanish Civil War]. It seemed like a war that happened so close to World War II that it was not exactly something that you discussed in history classes. In Mexico, they did talk about the Spanish migration, when refugees from the Republic escaped Franco by coming to Mexico. But they didn't teach you about the Spanish Civil War in history class in Mexico.

[Spanish filmmaker Luis] Buñuel ended up in Mexico, not because he was escaping the Spanish Civil War but because he couldn't go back to Spain after Franco had taken over. He had already left Spain and was in America, and he then made his way down to Mexico, which was a country that he didn't think he was going to like at all, to the point where he once famously said, "If I ever disappear, search for me anywhere but Mexico." [*Laughs.*] And he ended up becoming a Mexican. The most important part of his career as a filmmaker was in Mexico. Little by little, I started realizing that, like Buñuel, a lot of the people I admired—actors, set designers—were people who had escaped the Civil War and came to Mexico.

One of them was a character actor named Ángel Garasa, who appeared in every movie in the golden era of Mexican cinema. When I was in my teens, I befriended Emilio García Riera, the most important historian of Mexican cinema. He was the son of a Spanish refugee and had arrived in Mexico with his mother when he was a kid. He moved to my city, we became friends, he commissioned a book from me on [British filmmaker Alfred] Hitchcock, and became like a father figure for me. He talked to me about the Spanish Civil War and told me how he really thought that most people think they know about it, but they really don't know about it.

Then there was a movie I had fallen in love with as a young cinephile, *The Spirit of the Beehive*.

M: By Victor Erice. I know that's a major one for you.

G: Major. That cast a long shadow.

M: I would say at least two of your films feel like unofficial sequels to *The Spirit of the Beehive*.

G: Absolutely.

M: Take a moment and describe *The Spirit of the Beehive* for the readers.

G: *The Spirit of the Beehive* is a movie that obliquely talks about the Spanish Civil War and its consequences. It does not look at the conflict directly, but [tackles it by setting the story] in a small household in a small town in Spain. The war is seen, or experienced, through the eyes of a young girl played by Ana Torrent, who sees her first horror movie in an improvised cinema in the town. It's [James Whale's] *Frankenstein*, and she's so absolutely in awe and overwhelmed by the Creature that it becomes mythical in her mind. And her little sister, when they're going to sleep, tells her that the creature is real, and she finds a wounded resistance fighter and befriends him, and identifies him with the Creature.

That's the setup. It's not really a movie about the Civil War, but the Civil War permeates every act in the movie. It's sort of a fracture line in the way I saw film because it really spoke about the inescapable link between fantasy and reality for me. It really expressed some ineffable things that, to this day, I don't think I can fully articulate. It's just . . . I understood how profoundly fantasy is linked with reality and politics. And innocence.

M: Yes, but the boundary between reality and fantasy is very permeable within your films, so things that you think are normally a dream or a fantasy turn out to be real, but not scientifically, verifiably real. They're real to the characters, they're real to the world. *Pan's Labyrinth* is probably the most extreme example of that. You come to the end and realize the real world and the dream world are the same world.

G: What's really interesting is that a conceit like a ghost, or a fairy, or a faun—these are things that are seen as childish and not verifiable. But you have characters in that context who have agreed to be Republican and Fascists, which are also conceits that are not verifiable! And they say, "This is Spain. This is good. This is bad. This is geography. This is politics," all of which are not scientifically verifiable. They are conceits that adults agree on, that they are willing to kill each other for, but these are complete abstractions in the same ways fairies, fauns, and ghosts would be abstractions to anyone but the people experiencing them.

27

M: It's interesting you put it that way because years ago, I interviewed David Milch on *Deadwood*, and his affinity for *McCabe & Mrs. Miller*. I'm paraphrasing here, but he says that all of human civilization, whether it's the foundation of a country or a small town, is an agreement upon an illusion: A bunch of people get together and agree on this illusion that they want to make real.

G: It is, it is.

M: So, in a way, if you have somebody who's a Republican and somebody who's a Fascist, what they're saying is, "This is my worldview and I would like to make it real now."

G: Well, that's one of the things that Emilio told me that impressed me the most. He said, "What is tragic about the Civil War is"—and I verified it from many accounts as I did my research—"there would be families where the father would be a Fascist, one of the sons would be Republican, the other would be a Fascist, and they would eventually kill each other. The father would murder the son, or the son would murder the father, or the brother." It was a fratricidal war in the most literal sense of the term.

M: That happened in the US Civil War, particularly in areas like Kansas and Missouri, which are right next to each other, and were on different sides of the conflict. There were families killing each other.

G: And you had neighbors who would love each other for twenty years, and then murder each other.

What I tried to do in the movies is say that those things are ultimately abstractions. We play at those things—we game-play and role-play—but they are not reality. The reality is, if you take a photograph of the land, there is no division between Mexico and the States. It's a chunk of land floating on top of a bunch of water—not floating, but you know what I mean. Rising above a bunch of water. It's a chunk of Earth. That's it. We all live on the same chunk. And if you zoom back, we all live on the same fucking floating ball of dust in space with limited water!

But these borders are things we choose to believe in, and now more than ever, everything has become relative to the point where that pact that David Milch was talking about is disintegrating. We are not agreeing on the fundamental things that allow us not to kill each other.

RIGHT In the cistern, Eduardo Noriega's Jacinto is haunted by memories of a terrible crime.

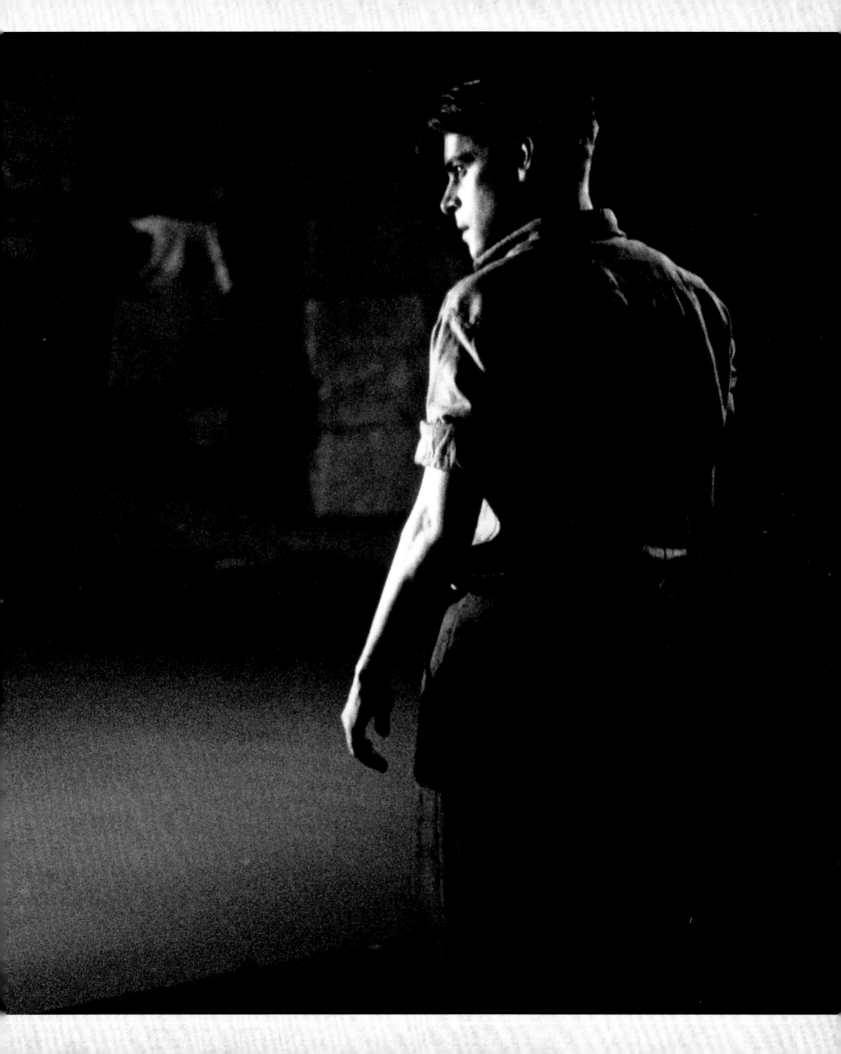

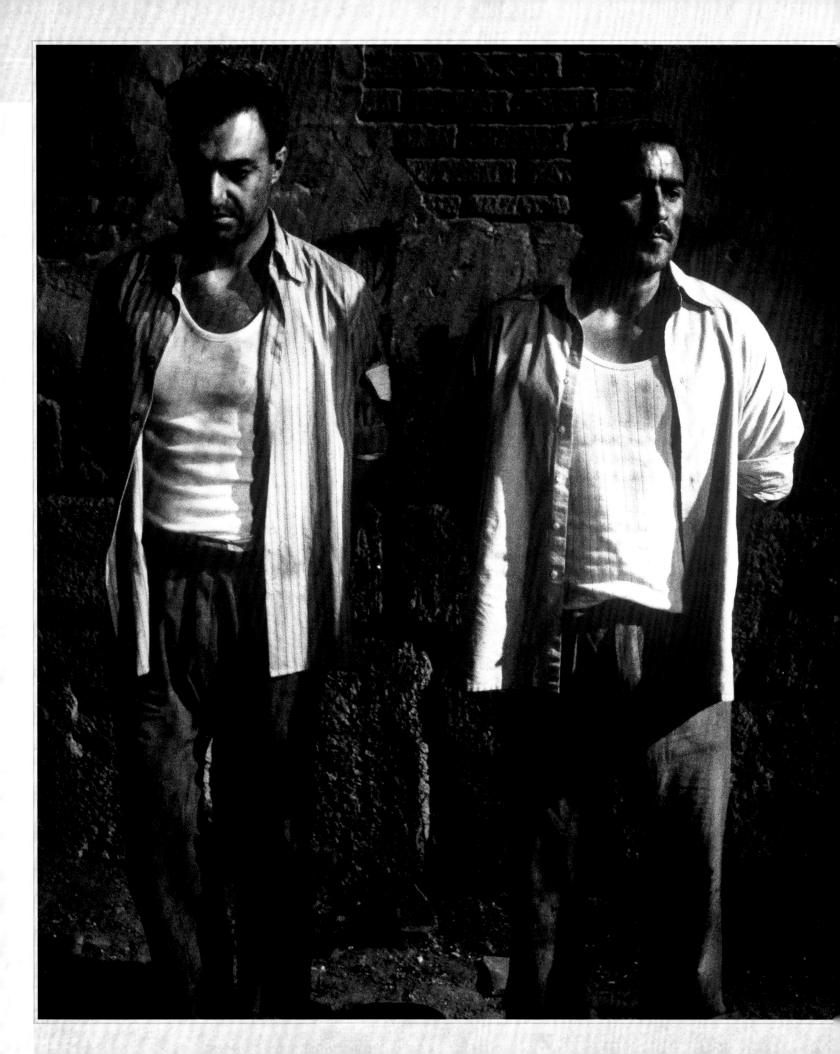

Fascism Won

G: For me, the crucial periods in the twentieth century were between 1936 and '39 and 1945 and '46. That was the time in which the modern world coalesced. The Spanish Civil War was a litmus test for the powers in the world to either intervene or not. Ultimately, it was a failed intervention, and fascism won.

And it's very well known that a lot of the tactics that were used in World War II, like carpet-bombing, misinformation, propaganda, were all tested, among many other tactics of warfare, in the fields of Spain.

For example, the Condor Legion and the carpet-bombing of towns in Spain were conducted under the supervision of, or by, the German Luftwaffe. It really was a rehearsal, and it was not accidental that Hitler invaded Poland six months after the Spanish Civil War officially ended.

M: He was emboldened.

G: Yes. He knew now that he had the tactics and the industry, and a lot of the metal that was used to build the Panzer tanks is tungsten, which comes from a thing called wolframite, which was mostly found in the mines of Galicia, in Spain. [By allying with Franco,] Hitler would have, technically, an unlimited amount of tungsten to build his tanks. Spain did not participate in World War II, but it supplied Hitler with what he needed after Hitler supported the Fascists during the Civil War. It's a prelude to World War II.

Then the Resistance, the Maquis, begin sabotaging the mining of wolframite, upsetting the balance of power of Fascists in France and Spain; we see a bit of that represented in *Pan's Labyrinth*, with little skirmishes. After the Axis powers surrendered to the Allies, the Resistance expected the Allies to come and overthrow Franco. They never did, because they wanted to make Franco a practical ally after the war, to keep an eye on the Soviets and keep communism out of Western Europe.

M: "The enemy of my enemy is my friend."

G: Yes. I think in many ways the Spanish Civil War is, along with World War II, the last war with a relatively moral, black-and-white point of view, where you could say the fight was not only between countries but between systems of values. There was a loss of innocence, or maybe morale, or certitude after World War I, which I think is the point when war becomes industrialized.

LEFT Two Republican loyalists steel themselves for execution in *The Devil's Backbone*.

M: Yes, with the deployment of the modern machine gun.

G: The modern machine gun, chemical warfare, tanks, literally war machines that have to come from an industry. The use of many of these weapons was rehearsed in Spain and then put into use in World War II.

And yet there was, after World War I, a sentiment in the Western world of *Let's not get into a war like this ever again*, right?

M: Right. And then all these nations that swore they'd never get involved in a world war again had to convince their people that they should, because Hitler and the Axis powers posed such a threat.

G: Yes. In World War II the Allies had to reforge a moral compass, so that the world could reengage against the Nazis in Germany, the Fascists in Italy, and Imperial Japan. They needed to have a reforged moral compass that came from propaganda but also from saying, *This is a just and moral war. We cannot rest about having prevailed in World War I. We have to go at it again or we will lose the world as we understand it.*

This is the crucible of the modern world that is now being dismantled.

I think all the conflicts of the Civil War in Spain are still unresolved in the twenty-first century.

M: Well, the Civil War in the United States is still unresolved, too. If you visit the South, you see statues of Confederate generals, and they look like victory statues.

G: They do. The Spanish Civil War left behind wounds that have never really closed. When you defeat another country, whether by strategic and overpowering victory—like Germany—or by a massive act of violence—like Japan, with atomic explosions enacted upon the masses—you have a palpable victory. But when the murders occur within neighborhoods and families, the healing must be as complex as the killing. The violence is so enmeshed in the fabric of what used to work that it is almost like you need a whole country to go through counseling, you know?

M: [*Laughs.*] And counseling is less exciting than war. People are not as interested in it for that reason, because there's no adrenaline rush from peace—at least not for most people. Anger and resentment are more exciting, and occupy the mind.

G: They're arousing.

A Prince Without a Kingdom

M: So let's bring it back to *The Devil's Backbone*. Set the stage for us.

G: The idea was to show that war comes to places where there is no war happening close by. You never see a massive amount of troops. You see men, Resistance men, being shot against a wall. You see the Fascist military shooting them in the head.

M: Guys hiding in the woods with rifles.

G: Yes, in the case of *Pan's Labyrinth*. But in the case of *The Devil's Backbone*, I wanted a landscape with nothing around it. Literally, *nothing*. Distant mountains, if any at all, and a single building in the middle of it all, so that you understand, visually, that war is far away. It is nowhere near that building.

And yet, it's in the hearts and pulses of every character in that orphanage. The character of Jacinto, for instance, is representative of the way I understand nascent fascism.

M: What does that phrase mean, "nascent fascism"?

G: It's like what you see written on the back of the photograph of Jacinto late in the film: "a prince without a kingdom."

M: He's an angry young man who feels unappreciated.

G: Who feels entitled. And instead of empathizing with and recognizing himself in the other orphans and saying, *Holy shit, I'm an orphan, I should treat these kids well*, he talks about hating the orphanage and wanting to burn it to the fucking ground.

M: And he gets his chance.

G: He gets his chance and he tries. He feels entitled to something better. He is completely dissatisfied with his situation. The entitlement goes beyond just aggression.

Nothing is ever enough for a discontented heart. That is the root of fascism. That and the lack of a father figure, the love of a father figure, the mythical stature of a father figure.

M: Jacinto wants to *be* the father.

G: Of course, which is an impossibility. Fascism is all about fallacies and fathers. There's a moment where the fat guy who's called the Pig in the movie asks, "Where are you going to go that's better than

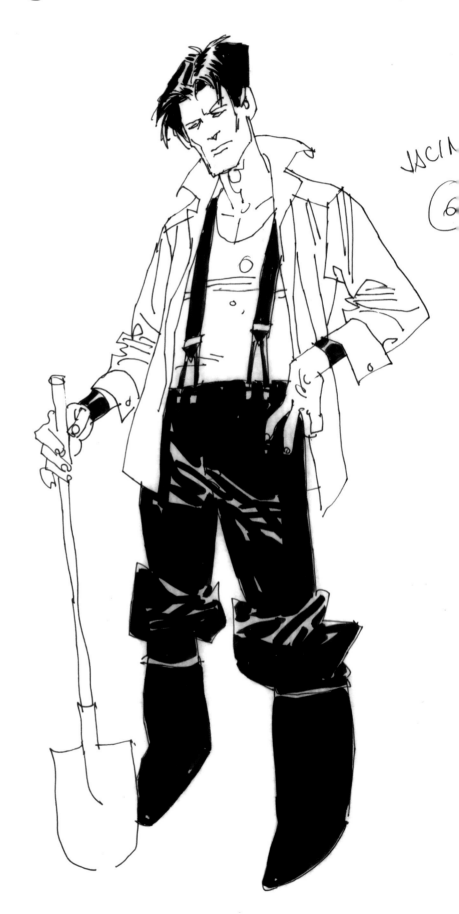

JACIN
6

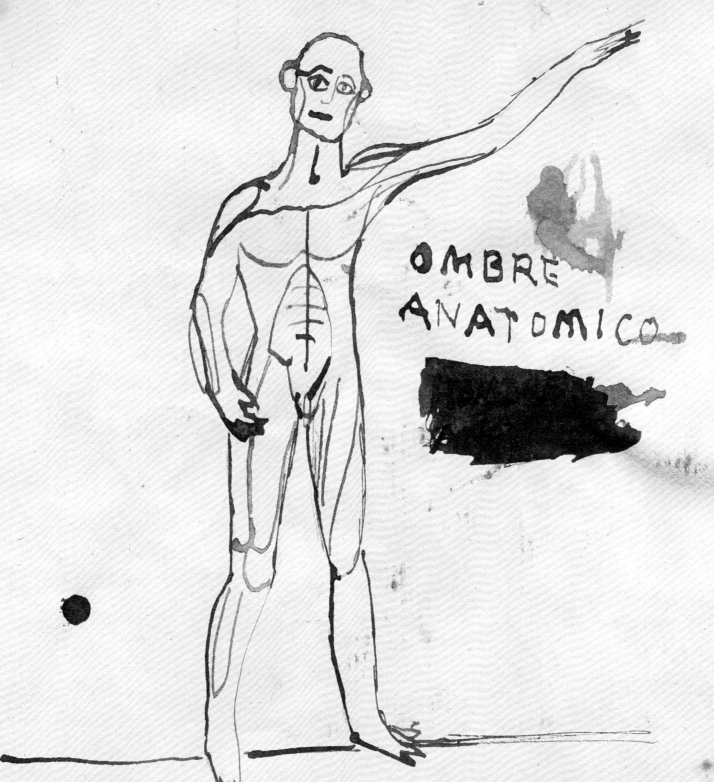

OMBRE
ANATOMICO

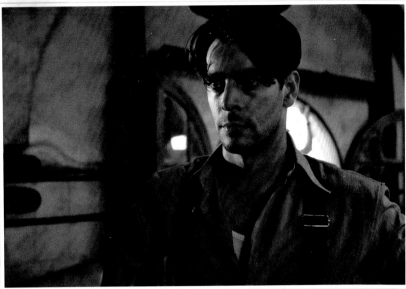

here? You have food, a girl who loves you, a roof above your head," which is ultimately, patently true!

M: He gets laid.

G: With the mother figure. He has a young girlfriend. He's the king of the roost. He's well fed. He's a caretaker. But he feels that's below his station, and then you have the noble professor [Casares], who is all theory but is incapable of acting. He's a liberal humanist, but he's impotent.

M: And he's a representative of a specific type in Spanish history. I guess today he'd be like the mainstream Democrats in the United States.

G: If you put all the characters together in *The Devil's Backbone*, they would be a complete human being.
 But this is also true of the characters in *Crimson Peak*. It happens in a space that contains all the aspects of the human psyche.

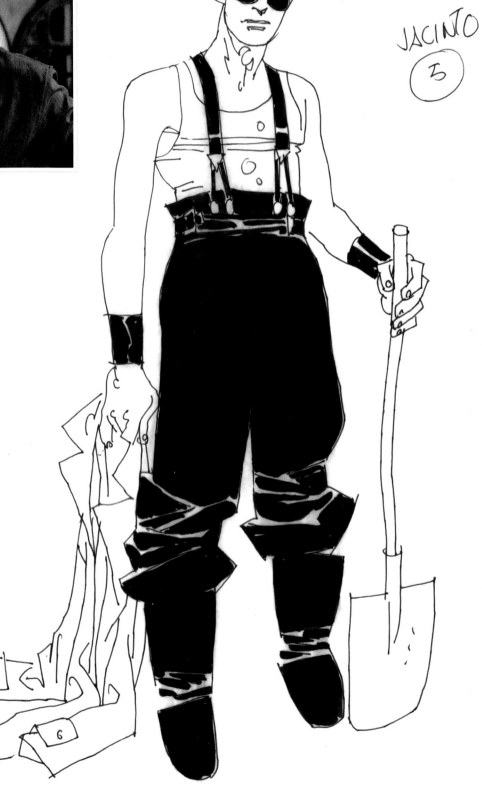

THESE PAGES Concept art for Jacinto.
TOP Eduardo Noriega as Jacinto.

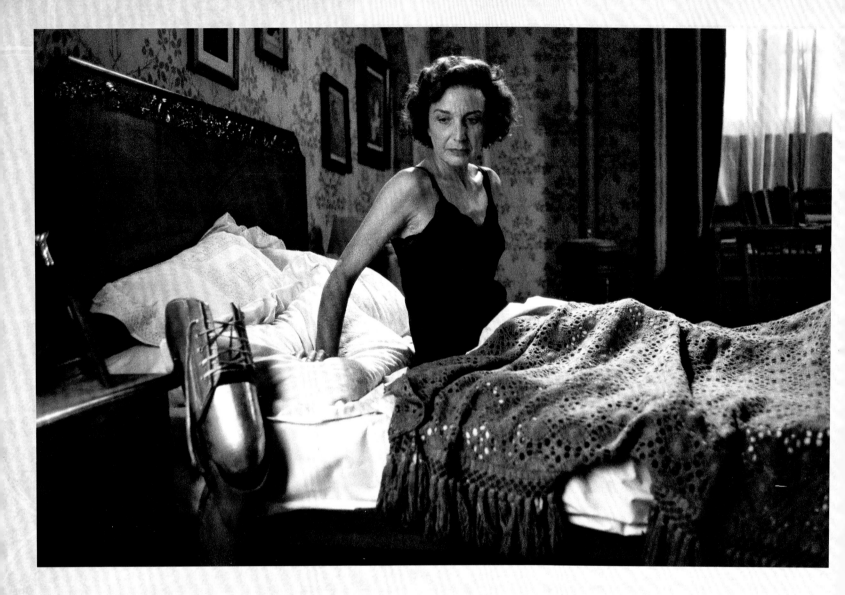

M: You have Carmen, the headmistress, whose husband was killed, and she's missing a leg. When people have lost a limb, they feel a sensation of the body part still being there, which is called phantom or ghost limb. And almost everybody in this movie has lost somebody to the war and is dealing with that loss. The ghost that is haunting that place is a stand-in for all of their ghosts.

G: Of course, of everything that is missing. A ghost is always a presence that represents an absence. And it is what could not be, because that character is objectively gone but is represented there.

Carmen is an adventurer and a woman with a gigantic heart and brain, but she's missing a leg. The professor is a humanist, but he's impotent, and he presents himself as a savior but he never fires a gun or defends anyone. He's just a symbol that you put by the wall.

M: Or that stares down from the window, which is a lofty, detached, visual position.

G: [As you might] after death.

M: That's true! It's like he's already dead in some way!

G: And then Jacinto is young, handsome, and strong, but he doesn't have a heart, you know? All these components make up the world within the orphanage, which represent different sides of the war going on outside.

At the end of the day, it's about the kids, and for me the kids are also incomplete. You have a bully, a new guy, the young kids, and they only become strong when they come together.

M: Battling a Fascist.

G: Battling the Fascists.

When we were starting to write the screenplay, I said, "I want a huge explosion in the orphanage, but I want the bomb to not explode." You know, like—you see the bomb and you say, "Oh, it's going to explode at some point," but it never does.

TOP Carmen (Marisa Paredes) leaves her bed after a tryst with Jacinto.

OPPOSITE Carmen with Casares (Federico Luppi).

PAGES 36–37 Storyboards for the opening sequence of *The Devil's Backbone* drafted by Carlos Giménez, writer and illustrator of the comic book *Paracuellos*, a key influence on the film's look.

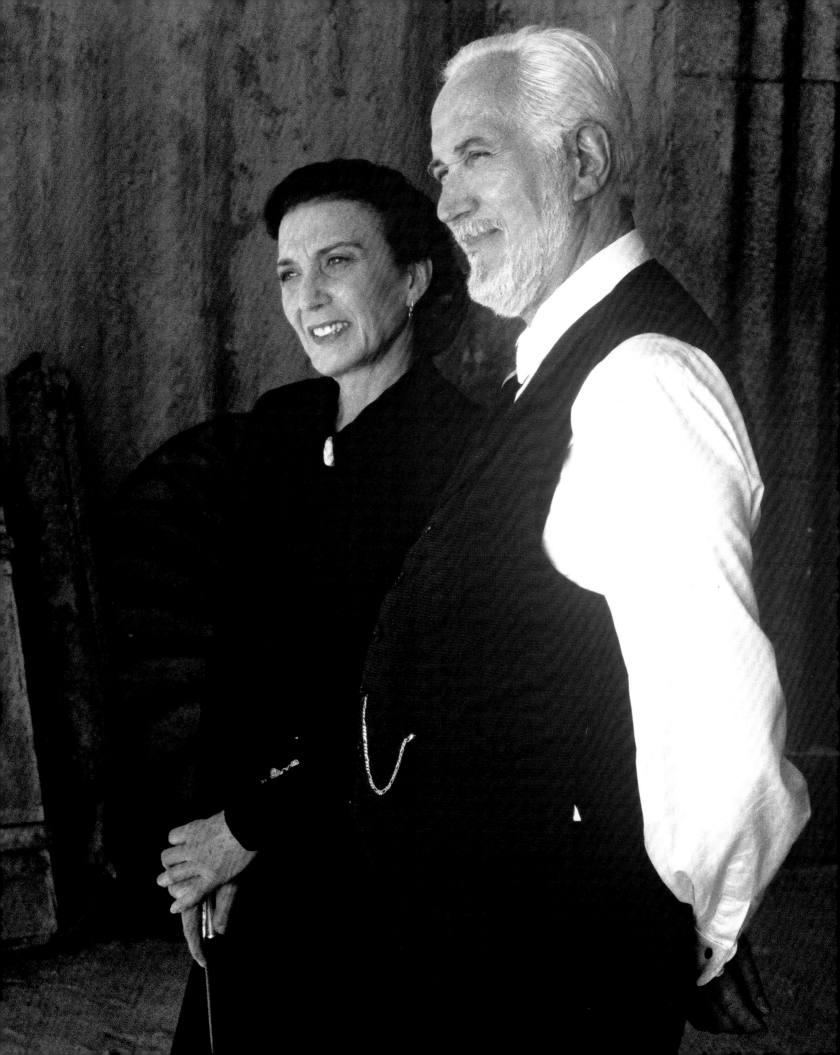

①

RUIDO DE LOS MOTORES DE UN AVIÓN.

②

RUIDO DE MOTORES...

VOZ.- ¡VENGA! ¡SUÉLTALO YA...!

③

RUIDO MOTORES...

- ¡SUÉLTALO, COÑO!
- ¡YA VOY, HOMBRE...!

RUIDO DE MECANISMOS, HIERROS QUE SE ROZAN, ALGO SE ABRE...

④

RUIDO DE MOTORES...

- ¡AHÍ VA!

⑤

SILBA LA BOMBA AL CAER... SUENAN SIRENAS de ALARMA...

⑥

EL RUIDO de los AVIONES Y de las SIRENAS SE MEZCLAN CON EL SINIESTRO SILBIDO de las BOMBAS AL CAER.

⑦

MOTORES... SILBIDOS... SUBE EL VOLUMEN de las SIRENAS de ALARMA...

⑧

EL SILBIDO CHIRRIANTE de las BOMBAS... EL ULULAR de las SIRENAS...

⑨

FRAGOR DEL BOMBARDEO. EXPLOSIONES...
RESPIRACIÓN ENTRECORTADA Y DOLOROSA del NIÑO.

10

EXPLOSIONES, SIRENAS, SILBIDOS...
EL HORROR de la GUERRA...

11

EXPLOSIONES... SILBAN HORRÍSONAS
LAS BOMBAS MIENTRAS CAEN...

12

EL SONIDO del HORROR.

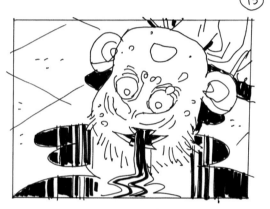

13

LOS FOGONAZOS de las EXPLOSIONES
ILUMINAN A INTERVALOS LA CARA del NIÑO.
— JAIME...

14

— ¡NO, JAIME...!

15

EL RUIDO ES ATRONADOR, NOS PENETRA
LOS OÍDOS... SILBA LA BOMBA CON UN
INSOPORTABLE CHIRRIAR...

16

— NO, JAIME...

17

EL RUIDO de la GUERRA... FOGONAZOS,
EXPLOSIONES, SILBIDOS, SIRENAS...

18

EL SILBIDO de la BOMBA ES COMO UN
GRITO. AUMENTA de VOLUMEN...

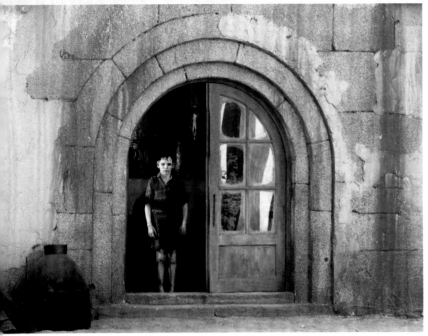

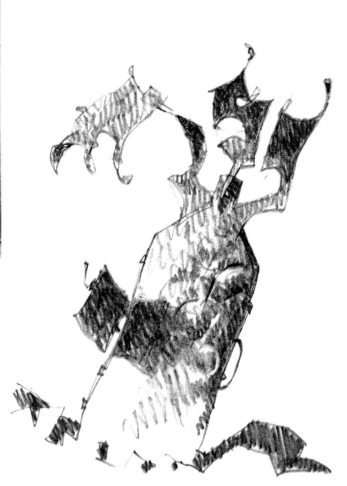

35

The Unexploded Bomb

M: I want to talk to you about the opening of the movie. I actually wrote down the sequence of shots here. First there's a shot of the entrance of the basement—

G: The door.

M: The door, right. Then comes the falling bomb, then Santi on the floor, and Jaime covering his mouth, and Santi sinking behind him by the water. Then the title image of the fetus with the devil's backbone floating in amber. You have a lot of metaphors at play here, and that bomb is the biggest one of all.

G: That's exactly what it is. The bomb is omnipresent in the middle of the courtyard much like the war, you know? Like, it just says, "The war is here," you know? And it's watching over you. I wanted it to be almost a mother figure to the kids. They plant flowers around it and put ribbons on it, like it's a fertility goddess, a totemic figure. But I wanted it to look over them the whole time.

If you have a bomb in your backyard, unexploded—which I've never had, but [*laughs*]— basically it becomes the north of your entire geography. You know? Whether you sleep close to or far from the bomb, or you cross the bomb to go to the well, it's always there at the center.

But even if you live with a bomb, it's still a bomb. That's the essence of a civil war. You live with a conflict and it can become matter-of-fact, everyday, but you're still living with this bomb at home.

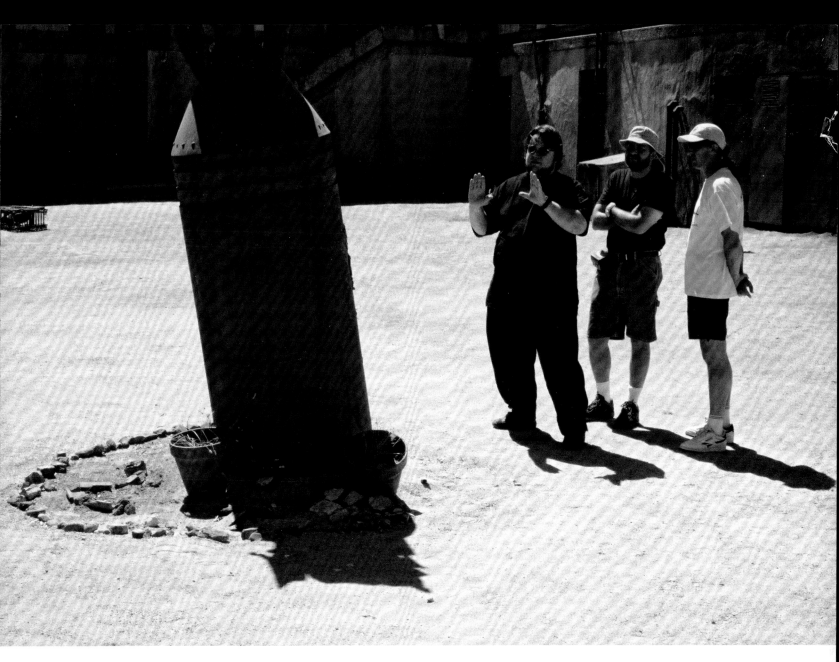

M: I like to think of that bomb as Chekhov's bomb, except it doesn't go off.

G: Never! [*Laughs.*] It's not funny in a comedy way, but it is ironic that everything explodes except the bomb.

M: That's true! [*Laughs.*] There is an explosion, but it's not the bomb. There is no victory. Some people get out alive; that's the only victory.

M: Yes—and, connecting the political to the personal for a second, the bomb is a resonant image for all the major characters. When we meet them, there is latent potential—sometimes destructive, sometimes not—that hasn't been tapped yet, and it's going to be tapped as the story goes on.

G: You see Carlos put his ear to the bomb.

OPPOSITE TOP LEFT Santi in the doorway, as Carlos first sees him.

OPPOSITE TOP RIGHT AND RIGHT Concept sketches for the bomb in the courtyard.

OPPOSITE BOTTOM RIGHT Eduardo Noriega prepares for a scene costarring the ever-present bomb.

ABOVE Del Toro frames a shot of the bomb.

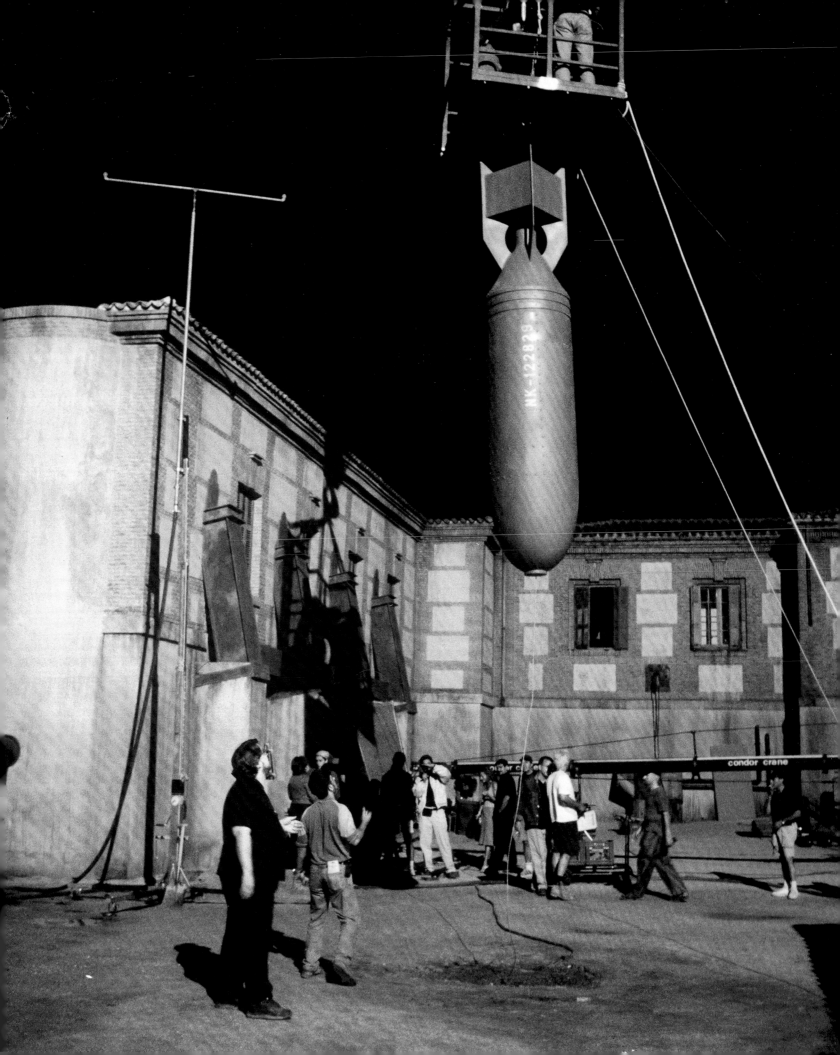

M: Yes. And the first time we see Carlos is right after he has been orphaned. He's just lost his parents. This is a kid who's in shock. This is a kid who's depressed and withdrawn. In essence, Santi is him.

G: He is.

M: This is a story about Carlos coming back from the dead, which is the story of grief and trauma for anybody who goes through it.

G: If you watch [*The Devil's Backbone*] again, you'll see that I try to give you misleading clues in the beginning. I think that every movie gets better the second time around if you love it. And sometimes you don't understand why, but it has a pull on you and you want to see it again. Some of the movies I like most, I liked on the second and third viewing, and disliked on the first viewing, but something kept bringing me back to them.

M: Can you give an example of one of the clues?

G: The movie opens like it closes, except at the end of the movie I add one more line: "A ghost, that's who I am." That's the doctor recognizing that he's narrating the movie—that there are two ghosts in the movie, one doing the narration, and Santi.

But that line shows that Casares has made peace with his reality: This is who I am.

Spain is a very haunted country, and it's mostly haunted by the Civil War. So I open with images that, even if you don't know the story, you think you just saw a kid murder another kid. You see Jaime killing Santi, because Santi's on the floor bleeding. You see an act of war—the bomb falling. You don't know you're going to see that bomb again in the middle of the courtyard. You see the kid with the blood coming out of his head, which was important for me to set up because it's a visual characteristic of the ghost [that's] very strong once you see it.

Then we come back to all these little snippets in a different way at the end of the film. At the end, you understand how the ghost—the kid that you see get killed—was killed.

And you see the floating memories of Jacinto in the water, his photographs that he had in his pocket. And you see the professor trapped within the frame of the building, and the kids going into the distance. Santi has caught Jacinto, but he's still standing in the middle of the pool. Santi was not liberated. He didn't fly to Heaven. There was no release.

OPPOSITE AND BELOW Del Toro and crew prepare to drop the bomb.

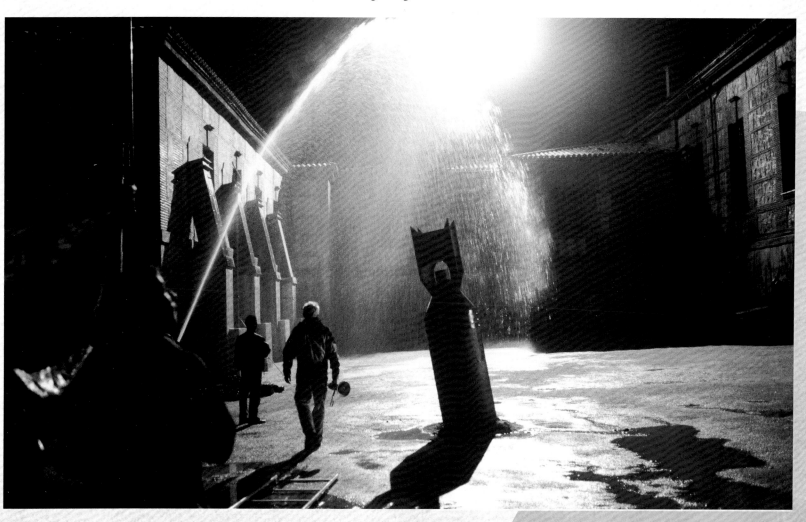

LUIS DE LA MADRID

Highlights from editor Luis de la Madrid's career include horrors and thrillers like *Faust* **(2000),** *The Machinist* **(2004), and** *Inside* **(2016). However, when he was brought on to** *The Devil's Backbone*, **de la Madrid had worked on only four other feature films. Based in Barcelona, de la Madrid collaborated closely with Guillermo del Toro throughout shooting, and then later during postproduction.**

LM: First of all, the most important thing was that the movie was filmed [in sequence], with respect for continuity. Guillermo laid out the whole movie. The choreography of the characters within the camera got very elaborate, and that creates a significant amount of work for me. When we made

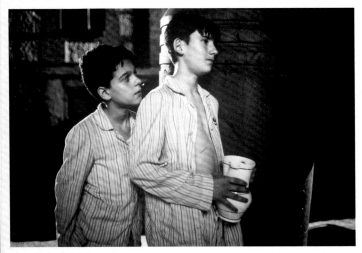

the first cut, I had to compress the movie a bit because otherwise it would've easily lasted up to two and a half hours.

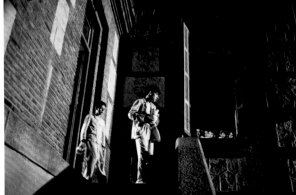

It was a very intense process from the start. We started [editing] during the first week of shooting. On weekends, when Guillermo didn't have to film, he would come in to supervise the editing. It was interesting working with Guillermo.

The movie was shot on film, which was normal, back in the day. Every day, we saw what had been filmed the day before. There was no sound; it was muted. We only had the image. . . . Guillermo would say how he would imagine the scene, he'd do the pre-editing blocking, and on the weekend we would finalize the editing process and brush up what needed to be brushed up. That was every day over ten to twelve weeks of shooting, about nine months total work.

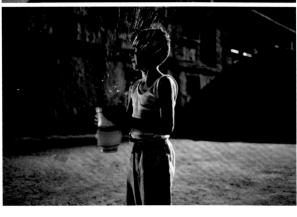

I learned a lot. The producer, [Pedro Almodóvar], came to the editing room a lot. Listening to conversations between Guillermo and Almodóvar was incredible, because I [got to be] among two of the biggest people in the movie industry. Guillermo has incredible energy. He was having the time of his life, but the pressure put on him was absolutely amazing. He was left without any energy whatsoever, just completely drained. Working on weekends he'd come out of the editing room at 10 p.m., 11 p.m. every day.

Getting the editing just right was crucial. We didn't want to take you out of the storytelling process through the frame. When we had to transition between one scene and another, we were very fluid, so you would hardly notice there were cuts in the middle of a scene. There are two styles of editing. Normally, in drama, the mise-en-scène and the position of the camera ensures that the editing must be invisible. But then there's a style where the cuts are more clear to the viewer in order to provoke tension, like during the scene at the very end by the pool, where the kids are killing Jacinto.

The underwater scenes in the movie, like the flashback to where Santi is killed and the scene where the kids kill Jacinto: Those were especially difficult to film. Obviously we couldn't do a lot with the camera inside the tank. We were very limited in our movements, so we had to edit more than we initially thought. The main objective, when selecting one take over the other, is that you have to consider what leaves the biggest impact: violence, special effects, children, makeup, prosthetics. And you create the scene based on those choices.

For the scene where the orphanage explodes, the most important thing to communicate was a feeling of catharsis. That explosion is a point of ignition. Everything starts to evolve from that moment forward: emotions that will never subside. The rhythm of the editing speeds up according to the intensity of the scene that you're watching. It's the climax of the movie: All the characters are there, and all of them have their own plot. That is why the scene just had to be perfect.

INTERVIEW BY SIMON ABRAMS

THIS PAGE A sequence of shots from the scene where Jaime and Carlos sneak out of their bunks to fill their water pitchers.

OPPOSITE A page from one of del Toro's sketchbooks featuring an early concept for the bomb.

42

de la esposa del maestro. Héctor?
es ante todo un tipo noble y primitivo.
—Qué difícil es alegar con cualquier
Español sobre el Espinazo del Diablo.
Los diálogos en Inglés me son más
accesibles que en Castellano de la nedre
patria. Sin embargo estoy seguro de
la universalidad de la fábula que
estoy contando. Los personajes son
muy pero muy icónicos: Leuppi
con su pelo "Negro" y su corbatita y
su pañuelo, es un dandy viejo e
impotente, Marisa, rubia, de negro y
con dos bastones y gafas amarillas.
Los niños de uniforme todos ellos
el colegio formado por arcos
el paisaje, vacío y nuestro
y Dios, como el sol, lo
puede todo y lo que no,
lo quema por completo.
—Realmente me encuentro
conque hablar con mi
padre vale 100 veces
menos que simplemente
estar con él. Mi mamá en cambio
_____ tristísima _____ en su alma

The Politics of Horror

M: "The ghost is frightening but not evil." That's a big thing for you. One of the movies you produced for another director, *Mama*, is a thematic variation on that idea as well. I really like it.

G: Me too. And you know, in terms of investment to return, it's the most successful movie I've ever been involved in. It was done for nothing, and we made over $130 million!

M: *The Babadook* was a good movie, but I think *Mama* is a better movie on the same subject. I prefer it in part because of the ending. That's what really puts it over the top for me.

G: I think so, too.

M: *The Babadook* is therapy that actually solves the problem, to some degree, whereas in *Mama*—

G: There's a loss.
 We strategized up the wazoo about that ending.
 Actually, we talked about it, and we ended up deciding it's much more anarchic and iconoclastic if the happy ending for one character is inconceivably wrong for the other. The little girl in *Mama* was raised by the ghost. The other girl was five years old when she lost her mother. The older girl had a sense of right and wrong. But because the little girl was raised by the ghost, she wants to go with the ghost. To live with the normal couple would be incredibly boring for her.

The result is one of those endings that is rare in commercial cinema. I said, "Look, if we make the audience cry, the ending will stay. But if they are outraged about the kid going with the ghost, we're gonna be in *such* trouble." We were bracing ourselves when we tested the movie because it was the only testing we had. The entire audience was weeping at the end.

M: One of the many reasons I love horror so much is that it's the only commercial genre left where people go in knowing there's a chance of an unhappy ending, and they accept it. I mean, so far they do. It might eventually get to the point where science fiction is now. I think audiences have lost that openness to unhappy endings in science fiction, for the most part. Once in a while you get a sci-fi film with an unhappy ending that makes money, but it's pretty rare now. The action film has succumbed, and I think thrillers have succumbed. Even the paranoid thriller, which in the sixties and seventies was defined by ambiguous or unhappy endings, has succumbed.

G: Most of them. You don't get a *Parallax View* or *Three Days of the Condor* nowadays.

M: Truly paranoid movies have to leave you feeling uneasy. They can't end with the corrupt official falling off a ledge and getting impaled on the American flag and everybody goes home. In 1998, Gene Hackman played essentially the same

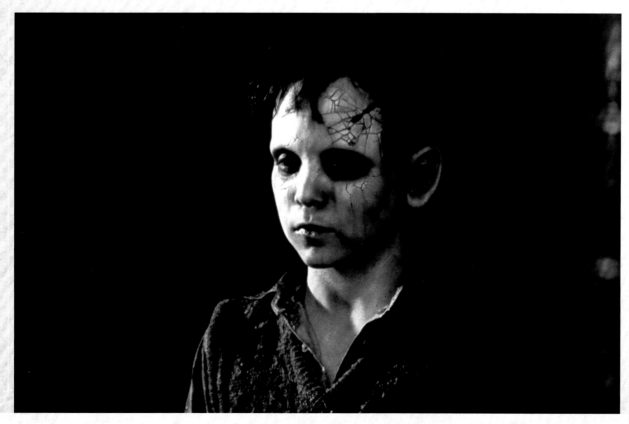

LEFT A close-up of Santi reveals the carefully rendered decay and damage on his head wound.

OPPOSITE An illustration of Santi from a del Toro sketchbook showcases the porcelain-doll-like fragility of the character.

Parte en El Espinazo del Diablo

Damasquinos conservó su
corazón humano en un
pequeña urna de vidrio.
... ... los mira para

6 * Alguien ve "Telenovelas y reacciona "en ave" a todo (Sería mejor si este personaje es el villano).

* Una mano como pinza de cangrejo.

6 * Hablar c/el retrato de su difuntito.

6 * Donde puse mis lentes? los trae en la frente.

*EL VIEJO DE LA AGUJ

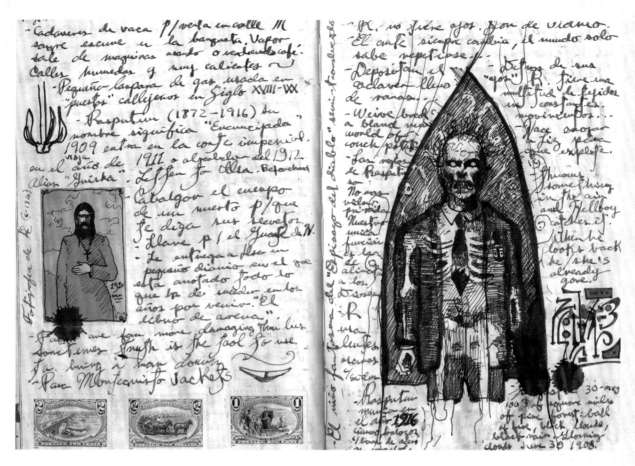

character in *Enemy of the State* that he played in *The Conversation* a quarter century earlier. *The Conversation* has a downbeat, ambiguous ending where the faceless, sinister institution is still in control. In the other movie, Gene Hackman exposes the bad apples and the good guys win. That's not a paranoid thriller; that's escapism.

G: There's always a senator who is honest and a senator who is dishonest; a cop who is nice and a cop who is bad. It's not so honest, it's not so black-and-white, in real life. And you know, textually, some of these movies are very real. You watch them and think, *That's very gritty and real*. But anecdotally, no. They're very, very simplistic.

Look, the genre I love and the genre that influences me, even if I don't do straight horror, is the fantastic. It is what I want to do, and it is not a prestigious genre.

That's why almost every single movie about drug dealing in American cinema is completely hypocritical, because the attitude is, *Yeah, if we can just get the bad guy . . .* There *is* no bad guy. The fucking *system* is what is the bad guy. Drugs are used to pay for black-book operations in America. The participants in the Iran-Contra scandal were using cocaine to pay for a dirty war! All the billions of dollars that go into the black books of the CIA to finance infiltrations, you know—it's not happening because of "bad guys." It's systemic! And no one in movies addresses this.

Somebody broke down all horror movies into three structures: the horror within, the horror from outside, and the horror that either gets within from outside—or goes out into the world from within. That's every horror movie ever made. In *Alien*, the threat is from the outside in.

M: And yet, the Xenomorph also reflects the sickness in that society. This corporation wants to use the alien as a weapon.

G: Yes, and the monsters are more valuable to the company than the humans.

M: The alien stands in for the capitalist system that runs everything in the galaxy.

G: And wants to devour it all.

M: It's a remorseless, devouring creature that just wants to replicate more of its own kind. *Alien*'s a political film!

G: It is! Every film is a political film—

M: The good ones are!

G: And the bad ones, momentarily, too!

OPPOSITE An early version of the *Devil's Backbone* story involved a terrifying, needle-wielding character, seen here in a page from one of del Toro's sketchbooks.

ABOVE An initial concept for the ghost that would evolve into Santi, drawn in one of del Toro's sketchbooks. Although the final version would be less fearsome, the translucency and doorway framing would remain.

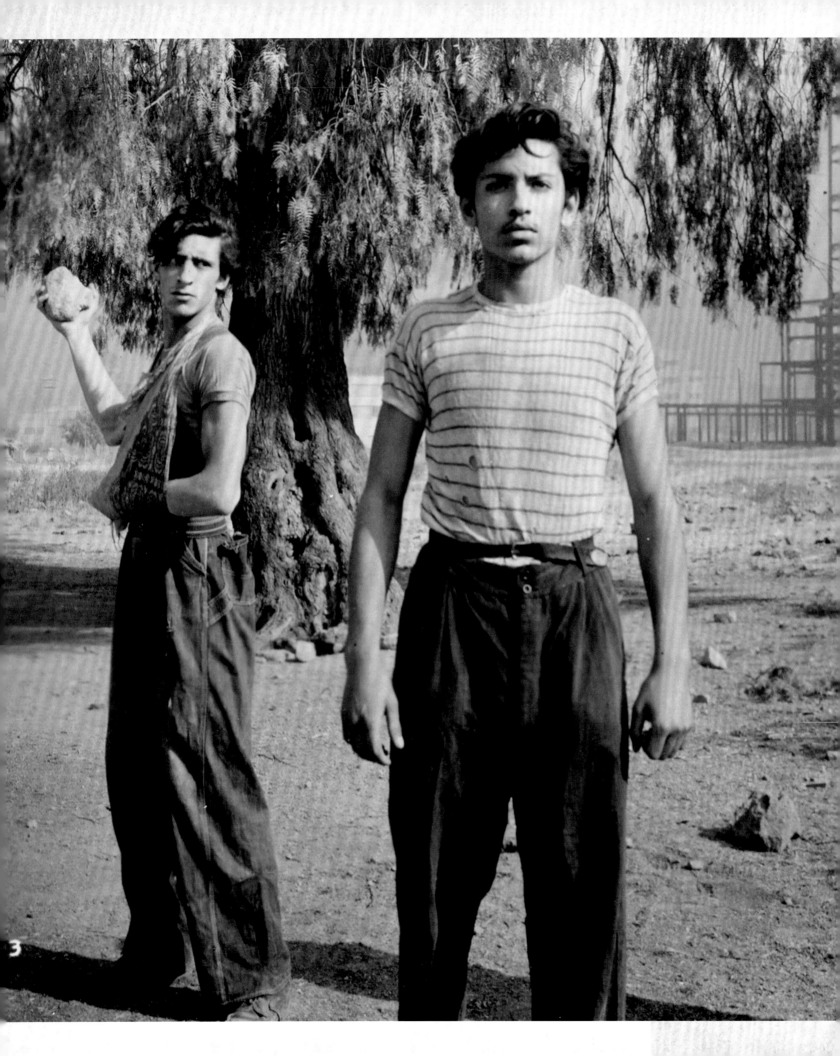

Hitchcock and Buñuel

M: I want to talk to you a little bit about Hitchcock and Buñuel. They're two of your favorite directors.

G: Hitchcock and Buñuel interest me in that they are completely opposite technically, but very similar thematically.

M: In what way?

G: Buñuel is fascinated by male desire and fascinated by strong women and weak-willed men. Hitchcock is less [sexually] experienced than Buñuel, which is why he tends to put his women either on a pedestal or destroy them. Buñuel had a lot of worldly experience and Hitchcock didn't.

But ultimately, Hitchcock is fascinated by the way virtue transverses the real world, or virtue unseen, and the possibility that we are surrounded by darkness. Famously, a lot of both directors' images and their obsession with crime and murder and brutality and erotic desire sort of tangentially touch each other.

But they are complete formal opposites. Hitchcock is mannered, and Buñuel, I'd say, is sometimes completely sloppy. So Buñuel is a savage, like a Fauvist, and Hitchcock is a very experimental classicist.

M: They seem to me to be the two primary influences on *The Devil's Backbone*, and on you as a filmmaker generally.

G: They're the two filmmakers I find most powerful, and they are both interested in cruelty, in the same obsessive, Catholic way. They are both *very* Catholic. They are both obsessed with sexual hunger, sexual power play, and sexual possession.

But the difference is you can see that Buñuel lived a lot, and therefore he understood that there was an immense primal force in women. That realization is an elemental force in Buñuel. His men are almost either airheaded Puritans or bumbling sinners. In Hitchcock there is a contemplation of that. I would argue that in *Notorious*, Hitchcock is as in love with Ingrid Bergman as he is with Cary Grant. He has an admiration for male and female energy that is a lot more sublimated and a lot more perverse, in a way, than Buñuel's.

Until *Frenzy*. I think *Frenzy* is where he goes, "Fuck it."

M: I think so, too. I think if Hitchcock had lived to be ninety-five, he would've eventually turned into [*Dressed to Kill* director] Brian De Palma, and that would've rendered De Palma largely unnecessary!

G: *Frenzy* is a bitter, misanthropic film.

M: It's an ugly movie.

G: An uncharacteristically ugly film in a way that is very purposeful, because Hitchcock cast the movie with [Barbara Leigh-Hunt and Barry Foster], the anti–Ingrid Bergman, the anti–Cary Grant.

M: Hitchcock was also conscious throughout his career of what other filmmakers were doing, and he was determined not to be one-upped. *Psycho* was very much a response to [director Henri-Georges Clouzot's] *Les Diaboliques* a couple of years earlier. Hitchcock saw it and thought, *Goddammit, I wish I had done that.* Hitchcock wanted to direct *Les Diaboliques* before the French adaptation was made, but he never nailed down the rights because he was notorious for underpaying for his material. And ironically, *Les Diaboliques*, of course, is hugely inspired by Hitchcock, in particular that climactic fake-out with the bathtub. So when Hitchcock made *Psycho*, there was a sense in which it was him saying, *I'll show these* Diaboliques *motherfuckers.* And he did.

I think *Frenzy* is really a response to movies like *Straw Dogs*.

G: It probably was.

M: In the late sixties/early seventies, the level of violence in movies like *The Wild Bunch* and *Point Blank* and *Straw Dogs* and *A Clockwork Orange* must have had an effect on Hitchcock.

G: He was obsessed with staying current. Hence the fallout with [composer] Bernard Herrmann on *Torn Curtain* when he kept telling him, "I want a jazz score," and Herrmann kept saying, "That's not you and that's not me."

Hitchcock was not open to suggestions in the later years. He resented . . . I think he resented Herrmann, you know? But Herrmann was one of his greatest collaborators.

Vertigo is my favorite score [Herrmann] did, for me it's the most moving of his Hitchcock scores. It has a doomed romanticism that is great.

LEFT Roberto Cobo, Javier Amézcua, and Alphonso Mejía in Luis Buñuel's *Los Olvidados*.

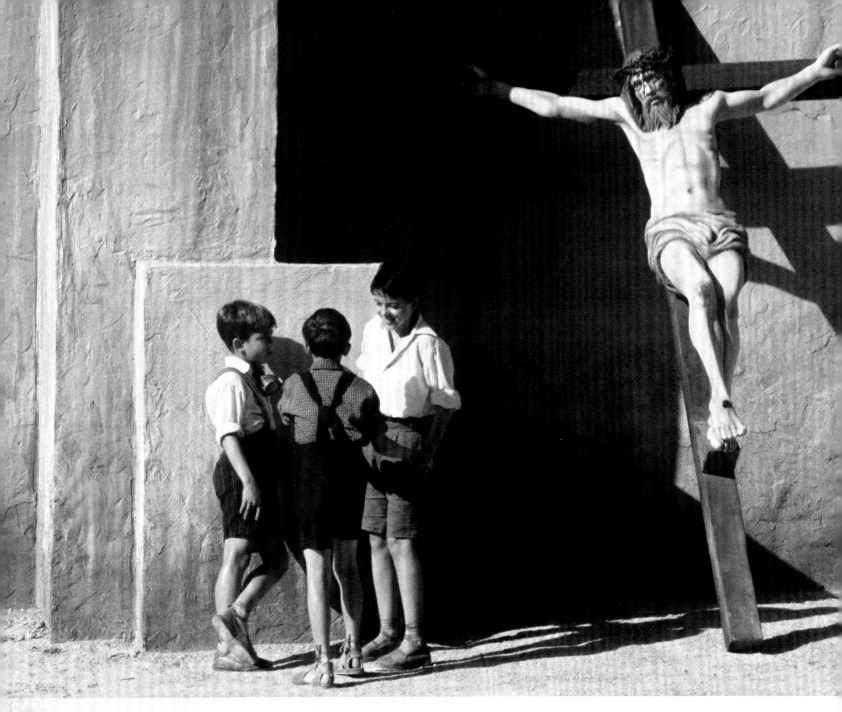

The Soul of the Movie

M: Tell me about your collaboration with Javier Navarrete on *The Devil's Backbone*.

G: Originally the score was going to be done by Alberto Iglesias, who had been Pedro Almodóvar's composer for a while. I met with him and he said yes. Then he got busy with another movie and said he'd be unable to do it. There was another guy I met with, but we didn't see eye to eye. Then I went to see a movie called *El Mar*, and the credits start, and this melody comes in. and I said, "That's the guy!" And it was Javier.

So I contacted him. He's a genius. I said I wanted to do it. And with him, both in *Devil's*

Backbone and *Pan's*, these are the two best experiences I've ever had with a composer.

M: What about his work method made it good for you?

G: It's incredibly emotional and cerebral. There is a sense of loss and sadness in his music that is incredibly profound.

M: What is your sense of how a score should be used in a film? Do you have an overriding philosophy?

G: The great soundtracks, the great scores in movies—I don't agree that they are invisible. I don't agree. You come out of a Krzysztof Kieslowski film with Zbigniew Preisner's score in your head. You come out of a [Federico] Fellini movie with Nino Rota going like a merry-go-round in your head. You come out of Sergio Leone's Westerns whistling Ennio Morricone. So this idea that a score should be invisible is bullshit. You come out of *Jaws* going "*da*-da-*da*-da," out of *Star Wars*, so forth. Music is the voice of the soul of the movie.

M: I believe that's true.

G: I can speak of surface, the actors can speak of emotion, but the ultimate varnish of a film is when the music comes in and it feels of a piece by providing you with an insight to the emotions of the film. As if it was an entity.

M: It's often said that films are written three times: the first time when the screenplay is being written, the second time when the actors are on set, and the third time in the editing room. But I think that the score constitutes a fourth and final draft, and it's an opportunity to not only maybe try to save a scene that's not working or communicate an emotion that's not quite coming through but also to make the tone a little more exact here and there.

G: I've been blessed only a few times with great scores. When I have the right composer and I hear the right score, there's a moment in which the movie exists outside myself. The visual process is an area where I'm so involved, so controlling day to day, that nothing surprises me. I am happy about it, but I don't get a thrill from it. Rarely do I get a thrill. But when you hear the music, it literally is somebody who takes your baby and it comes back fifteen years later graduating from high school and you meet him or her again and say, "Wow, you have grown!"

That's what happens with a score. The composer comes back and goes, "What about this for that?" and you go, "Oh my God!" If it's a bad composer, you're done. You're never going to survive. You might as well fire them.

M: You're a very active participant in every area of filmmaking, but not with music?

G: No. In music I meddle with the themes, and I say, "Give me this and that," but I don't like to go to scoring because I want to be fresh, I want to be new. That's why I normally don't like to go to scoring sessions. I've only gone to one or two scoring sessions because I want the music to surprise me.

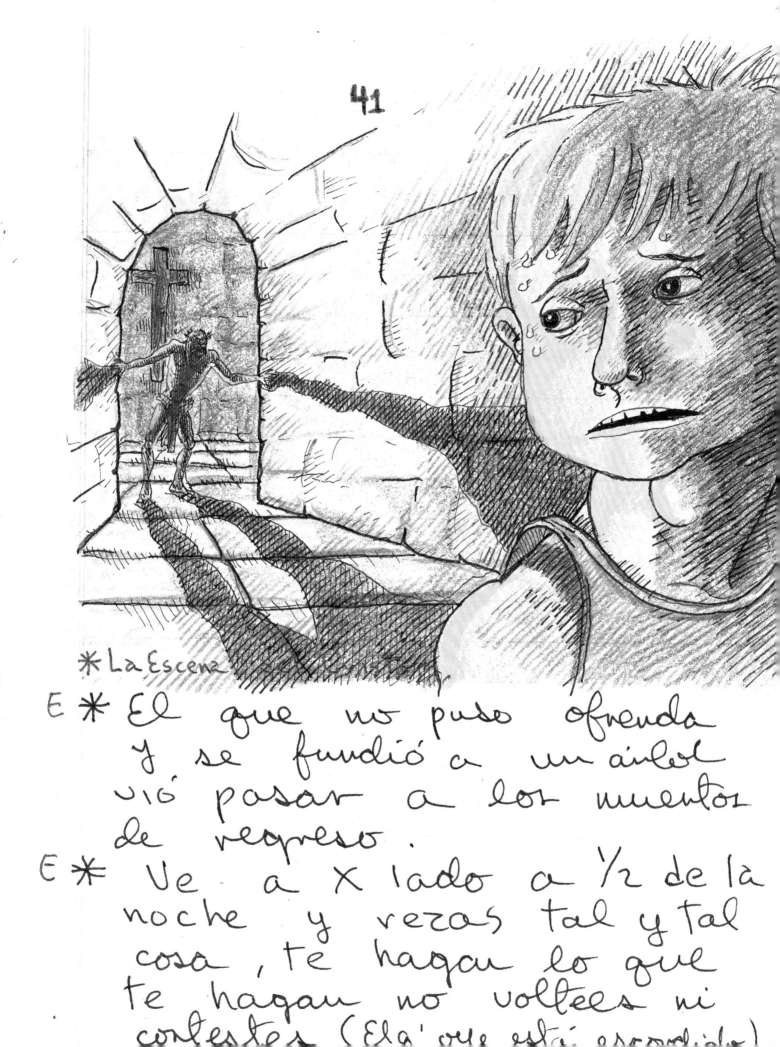

*La Escena

E* El que no puso ofrenda y se fundió a un árbol vio pasar a los muertos de regreso.

E* Ve a X lado a ½ de la noche y rezas tal y tal cosa, te hagan lo que te hagan no voltees ni contestes (Ella que está escondida

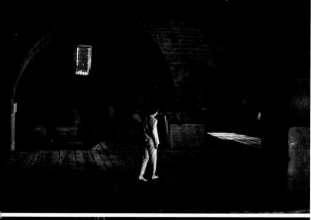

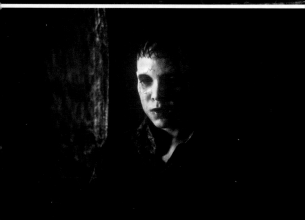

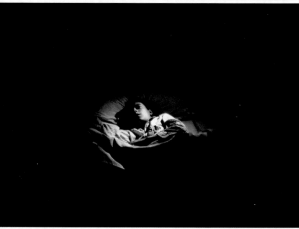

OPPOSITE From one of del Toro's notebooks, a very early *Devil's Backbone* concept where Jesus Christ is the figure haunting the story's hero.

THIS PAGE (from top) Carlos goes in search of Santi; Santi warns Carlos, "Many of you will die"; Carlos tries to sleep; wet footprints in the cistern.

JAVIER NAVARRETE

The Devil's Backbone was composer Javier Navarrete's first collaboration with director Guillermo del Toro. But it was not his first, nor his last, horror film. Born in 1956, Navarrete was introduced to del Toro through El Deseo, Agustín and Pedro Almodóvar's Spanish production company. He had previously worked on Spanish horror films including *In a Glass Cage* (1986), *La Banyera* (1989), and *99.9* (1997) and jumped at the chance to collaborate with del Toro. He would go on to collaborate with del Toro on *Pan's Labyrinth* and score several other stylish horror films, including *Mirrors* (2008), *The Hole* (2009), and *Byzantium* (2012). Still, Navarrete's score for *The Devil's Backbone* stands apart from his other film music partly thanks to the circumstances behind its creation.

JN: I was on holiday in Tunisia when I got a message from [production manager] Esther García of El Deseo. Esther asked me to go to Madrid as soon as possible to meet "Mexican director Guillermo del Toro." I had seen *Mimic* a couple of years before and was very impressed. I remember looking at that film's main titles and thinking, *Guillermo del Toro is an impressive name!* That may be a stupid memory, but there is still something impressive about a Spanish name filling a Hollywood screen even now, twenty years later.

I remember a friend complaining, "Well, this is just like another Hollywood movie." I also remember my answer: "Not really. If you think about it, the most educated person in the film is a woman." She's a biologist, if I remember correctly, and her husband is just a technician. I asked, "Doesn't this make the movie different?"

Of course, I didn't really care about this, interesting as it was. My main interest was the fact that insects and men were interacting in a new, fabulous way, an idea that transports me to dreams of hybridization and mutation. An idea that also reminds me of one of my favorite books: *Metamorphoses* by Ovid, a classic Latin book that follows the transformation of men and women into everything—clouds, water springs, animals, even an echo—because of their games with gods, their fates, and their transgressions. *Mimic* could have been one of Ovid's stories. As with all fables, it belongs to the deepest part of our unconscious, where all glory and horror lie inextricably mixed together.

And here was Guillermo del Toro, asking me for music for *The Devil's Backbone*, which, as we all know, is about the ghost of a child. In a very real way, I've been haunted by a child's ghost my whole life: I lost a young brother in a fire before I was born, a tragedy that marked and still marks my family life, my personality, and probably my music.

The Devil's Backbone was made at a time when I was musically and personally unprepared to travel the beautiful world of Guillermo's script, the beautiful light and camera movement of Guillermo Navarro's cinematography, and the strong performances that Guillermo got from Marisa Paredes and the rest of his cast. And yet, *The Devil's Backbone* was my story. I was every character in the film: My brother was the ghost, and I was the ghost, too. I was talking to myself through this movie.

I got seriously sick during the making of the film's music, and I hid my illness from Guillermo and the producers. I experienced a private kind of penance during this time, throwing myself into bed, mute and desperate for weeks while the phone kept ringing and ringing. I still wonder why they didn't fire me. So, not surprisingly, I can't remember much of the making of the music, or even the music itself. Perhaps a good ninety percent of the score is seriously improvable, but perhaps the other ten percent is what it had to be, what the soul of the movie demanded of *my soul* in order to come into being. I don't do pride, or I do as little as I can, but that ten percent might be enough for me, now that music and filmmaking have become rather mechanical provinces of moneymaking. I mean, I've done some good scores with the sole purpose of making a good score. That's a very different business than making a score with the goal of talking to someone who is dead, and is still, at moments, alive.

That little ten percent of the score is from my blood, the part of me that cries to make music. Thanks to Guillermo, I managed to express that part of me in an enduring way. And thanks to Esther García, there was fun at the end of the creative process: a very professional recording set in Prague under conductor Mario Klemens, with the pianist Jaroslava Eliasová. Jaroslava, who is now retired, performed the score for both *The Devil's Backbone* and *Pan's Labyrinth*. The only way I can describe her playing is that you can feel her joy and her pain in every finger! God bless her.

To cope with the difficulty of naming the music cues, I dismembered the poem that opens the movie: "*¿Qué es un fantasma? / Un evento terrible / Condenado a repetirse / Una y otra vez / Un instante de dolor / Quizá / Algo muerto / Por momentos vivo aún / Un sentimiento / Suspendido en el tiempo / Una fotografía borrosa / Un insecto atrapado en ámbar / Un fantasma / Eso soy yo.*"

Guess what my favorite cue is called? "*Eso soy yo.*" This is me.

INTERVIEW BY SIMON ABRAMS

Misanthropy and Humanism

G: But . . .what were we talking about before?

M: [*Laughs.*] Buñuel. Hitchcock. Politics. The politics of genre.

G: I think that there is no more political genre than the fantastic. Whether it's sci-fi, fantasy, or horror, they are all ultimately very political films. When does your innermost nature come out? When you lower your guard. And with fantasy, everybody tends to lower their guard: "Oh, it's just a fantasy." To me, whether it is *Blade Runner*, *Alien*, [Steven] Spielberg's *War of the Worlds*, whichever way you can go—

M: *War of the Worlds* is a remarkable film, and one of his great dream films, in the way that sometimes you'll have a dream, and it will start out meaning one thing, but by the end it will mean something else. *War of the Worlds* is like that because at the beginning, it's 9/11, and the East Coast of the USA has been attacked by literal sleeper cells. It's a fantasy nightmare of 9/11. But by the end of the film, we have become the Iraqi occupation fighting these tripods that are basically the United States. It's not quite that simple, and it's open to interpretation, but we definitely switch from being the people defending [against] the terrorist threat to the ones resisting an imperialist force.

G: Yes. That's the way I feel about it.

You know, you cannot control every possible reading of a film, because critical analysis of film or any art is not scientific. It's an instinctive approach. As a filmmaker, you can organize your symbols to be for or against whatever you want, if you're tricky enough. I try to decipher them in a certain way. But if somebody wants to read them the opposite way, they can. But I cannot control that.

M: Does it upset you when they do read them the opposite way?

G: No, because I've done it as an audience member! I mean, I was a film critic for a decade in Mexico. I used to write for a small newspaper; I did criticism on TV and radio, I wrote a book on Hitchcock, and I was the one doing the interpretations of other people's movies. I know that movies are protean creatures; they keep transforming with you, so a movie is never still. A movie changes with you. A movie that I find deplorable at age seventeen will be a film I rediscover at age thirty-five and go, *My God, it's a great movie!* And vice versa. The movie I see at seventeen I go, *Wow, that's a mature*

masterpiece! But when you're thirty-five, it's obvious and tacky.

M: What did you think of Spielberg's *War of the Worlds*?

G: I have enormous admiration for late-period Spielberg.

I love *War of the Worlds*. I love *A.I.* I think *A.I.* becomes more and more painful with every viewing. I find it deeper each time.

But I'm obsessively in favor of *Catch Me If You Can*. That is a complete musical masterpiece. It is symphonic, always in motion, always elegant. It's sort of a Stanley-Donen-on-steroids type of movie.

I think sometimes it's more interesting when a director does a diversion than when he does a serious film. Sometimes I find the filmmaker's personality more clearly in their diversion. John Huston is the perfect example of this. When he was tackling a "serious" subject, he was too earnest. I am not as taken by him when he's doing a serious film. But when he does a diversion, a purely entertaining movie, he seems, to me, to become more profound.

M: Give me an example.

G: *The Treasure of the Sierra Madre* is a profoundly political film that speaks more deeply about human nature than *Wise Blood*, which is one of his more serious films. With Spielberg I love *War of the Worlds* and *Catch Me If You Can*, which are both incredibly moving.

M: In what way would you say Spielberg's fantasy films are political? I think mass audiences don't see

BELOW Tom Cruise and Dakota Fanning witness the destruction of a ferry by Tripods in Steven Spielberg's *War of the Worlds* (2005).

OPPOSITE Early on in development, del Toro considered making the caretaker character the ghost at the heart of *The Devil's Backbone*, as seen in this page from one of his notebooks.

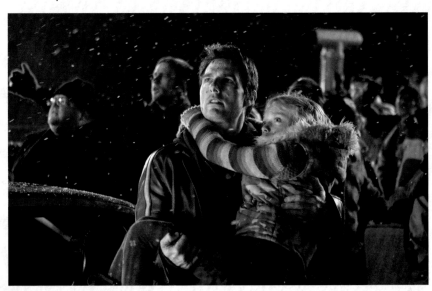

them that way, which is one reason those films make more money, usually, than his historical movies.

G: If you are a humanistic filmmaker—if you are ultimately in favor of individuals—it comes across in your films. If you see every John Carpenter movie, they are misanthropic meditations, all of them. They are ultimately the work of a very deeply disillusioned but very angry, two-fisted, red-blooded American. He has a feistiness in him that is undomesticated.

M: What's an example of a political John Carpenter film?

G: *They Live* is the easiest one, but even *The Thing* counts. It ends in a completely nihilistic way: *We're all fucked, so let's drink to that!* He's a tough hombre. Tough, two-fisted reality, you know? Carpenter is the horror genre's Howard Hawks.

M: No surprise that Hawks produced the original *The Thing*.

G: David Cronenberg is, inevitably, political, too. All his movies have this very dark, existential pallor. In *Crash*, there is no more political thing than to talk about the human body being subverted against you. He is in favor of entropy, he knows that the ultimate goal of everything is disintegration and betrayal of the structure, and the ultimate betrayal of the structure is the betrayal of your body.

I feel Spielberg, like William Wyler, is a humanist. He really believes profoundly in American values—

M: Idealized American values.

G: Yes—but I think that they are easier to read in the more mainstream films Spielberg does, because when you tackle something like *Munich*, you are tackling a political reality, something that really happened, and it can get very slippery.

M: But that's one of the brilliant things about *Munich*. You have said to me that the structure you choose for a movie can be a political statement. A lot of people complained that *Munich* loses focus and slips as it goes along, and that during the final third, you don't even know where they are or what the mission is. Given what a control freak Spielberg is, I think we can assume this is not an accident. It's like Wim Wenders's *The American Friend*, which is an ahead-of-its-time statement about what was

about to happen to society in the age of globalism—that the individual characteristics of countries were going to start to ebb and everything would start to seem like part of one gigantic airport.

Similarly, when you get to the last section of *Munich*, you don't even know what the hell's going on, and these guys don't, either.

G: That's exactly how I see Ridley Scott's *The Counselor*!

M: Yes, which you're a big fan of!

G: That's the only American movie about drug trafficking where I feel someone truly knows the profoundly banal and profoundly evil stakes of the conversation that come with drug dealing. There are no white hats and black hats! No one in particular is the problem. To me it's immoral to say, "Oh, if you get one bad guy, drug dealing would be gone." It's an endemic social decomposition problem. And that movie basically tells you, "Evil permeates everything." What you're saying about *Munich*, that's the end of *The Counselor*, too.

That's why the speech Rubén Blades makes is so brilliant: "The world you make is not the world that you're in. And life will not take you back. Period." Your decisions transform your universe and you cannot go back.

M: This part of the conversation connects with something we were discussing earlier, which is this idea of the fantasy of the kind of world you would like to live in as not materially any different from the fantasy of a world with fairies, fauns, and sprites in it. Whenever you make a decision, whether it's a political or a personal decision involving laws or a decision in your own life, you're trying to transform a fantasy into reality. And if you succeed, there is an impact, not just for you but for other people.

G: Yes, because that's what Rubén Blades says in *The Counselor*: The world of ideas transforms the material world. It has a direct consequence.

M: Can you give me an example from your own work of a political or personal decision that transforms fantasy into reality?

G: People who watch *Pan's Labyrinth* often ask, "Was the faun real or not?" But it doesn't matter. It is real. Why? Because the girl is faced with three choices, three tasks. Each time a task is executed, the faun looks better and nicer. He looks younger;

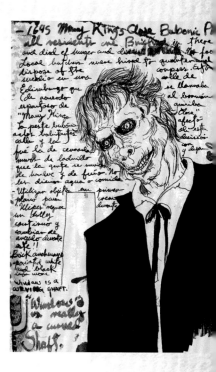

en roca! Rupestre.

* Lluvia de
ceniza ardient
en c. lento
* lento
viaje por
los cielo
de
José
Mª
Velazq
hasta
descub
la
manad
allí
a lo
lejo
c/nube
de polv

he's more attractive. And the worst possible choice comes with him looking like a handsome young faun, when he says, "Give me your brother, we'll draw a little bit of blood and you'll be on your way."

In life, those choices can seem easy, and you go, "Yeah, why not?" But if you take that choice, your world transforms.

Some people say that in *Pan's Labyrinth*, the fantasy world is good and the real world is bad. And I have to ask them, "What movie did *you* see?" The fantasy world in *Pan's* is oppressive! The frog, the Pale Man, the fairies who are grimy and eat raw meat—it's not exactly Jim Henson, you know!

M: It's Grimm, with one *m* and two *m*'s.

G: Yes, and the choices made in there reflect the real world. The greediness of the frog eating the tree from within is not a very subtle metaphor. And the Pale Man, who represents church, state, or both, mirrors the Captain and his banquet table. He has a table full of food but will only eat children, so it's the most perverse, institutionalized evil.

M: The Pale Man removes his eyes when he wants to attack.

G: And the heroine has to choose between three doors: One is silver, one is wood, one is gold. The fairies all point to the nice one and she chooses the humble one, which is a very tried-and-true device from fairy tales.

M: To bring that back to Spielberg: He does something like that at the end of *Indiana Jones and the Last Crusade*. Indiana Jones has to choose which cup is the Holy Grail, and he chooses the one that a carpenter would use.

G: Yes. In fairy tales, you might have the prince who finds the golden bird, and he can put it in three cages: One is made of gold, one of wood, and one is silver. And he chooses the wood one, and the bird doesn't escape.

But with *Devil's Backbone*, the choice is divided within many characters. Jaime and Carlos choose each other. All the adults are divided, but the kids choose each other and say, "Together, we can do this, we can survive."

When 9/11 happened, and *Devil's Backbone* showed at the Toronto International Film Festival on September 9, I took a plane the next night. I went to the editing room on *Blade II*, and I arrived in the editing room, and 9/11 was on the TV. I got up and

I said, "Let's go home. The world just ended." And I went home and my wife and I cried, because we just felt the world will never be the same. And it isn't.

M: No, it's not.

G: And it will never go back to that, not for a couple hundred years, I think. You can feel the fracture. You can feel the shift in the space-time continuum.

M: That's one of the reasons *Devil's Backbone* made such a huge impression on me: because I saw it in the fall of 2001, after the attacks. Although the story and the historical context don't have anything connecting it to 9/11, there was something about the mood of it, I think particularly the claustrophobia of the setting, that mirrored that three- to six-month period after 9/11. I don't know how it was for people in other cities, but in New York City it felt like everyone was living inside a very small shell. Like, you were aware of the smallness of your house, of your neighborhood, of the world, in a way that you hadn't been for a while.

G: That's the idea of the movie. The idea of the movie is: *If we could only fucking get it into our head that we are all in the same orphanage, that none of us belongs anywhere else.* The moment you say, "I'm not one of you—you is you, and me is me," it's a moment of division. The possibility of a social pact disintegrates the moment you point your finger at someone and say, "You are the other. I don't care about you."

Something that it's impossible to say anywhere but through art is, "Let me explain to you why you should care for others."

When a movie decides on surface, color, texture, and how it presents violence and sexuality and power, those are all formal and political decisions.

There's a moment in *Devil's Backbone* when the bad guy, Jacinto, prefers to stab the girl rather than look ridiculous in front of these two buddies who don't give a shit about him. But he is that much of a coward. If you executed that moment to make a set piece where he enjoys the violence, that's a political decision. If you snap back to a master shot and the characters are little figures in a landscape, it's political. You are making a decision not to enjoy that violence.

M: You remind me of a story about Jonathan Demme working on *Silence of the Lambs*. At the first public screening of that movie, when Clarice Starling shoots Jame Gumb, the audience cheered and Demme was horrified. So he had the editor reedit the sequence.

The timing of the cuts is very odd. You don't get the standard "muzzle flash/cut to the guy getting hit with the bullet and falling out of the frame." Demme's intent was to deny you the usual satisfaction of the FBI agent shooting the serial killer.

G: Hitchcock did that with the murder of the Russian spy in *Torn Curtain*. It's so slow that there's no real release. It's completely on purpose.

You can enjoy a balletic action movie, though, and that's a different political stance. If you're doing *The Fast and the Furious* or *John Wick*, you're entering what more closely resembles a musical with Gene Kelly. The violence becomes choreography.

M: John Woo's films are that way. Busby Berkeley with guns.

G: They are the bastard child of Busby Berkeley and Jean-Pierre Melville. I do not think all screen violence is created equally. A splatter movie from the eighties has a completely anarchic effect depending on who was directing it. George Romero is an incredible political filmmaker, and you can figure out how to distinguish where he's coming from. The politics of his zombie films are different from the politics of many zombie films that have been made recently.

The birth of the zombie genre under George Romero [in 1968's *Night of the Living Dead*] is very simple, and it stated very objectively: *They are us.* [In 1978's *Dawn of the Dead*] they come back to a place that's important in their life, the shopping mall. There is an absolutely critical, self-reflective, empathic nature to that train of thought. What is the modern genre of zombies? It's turned into a redneck hunting expedition. The zombies are now game.

M: They're hunting the Other, and that's why I don't like so many modern zombie films.

G: There's no empathy.

M: It's a little bit too close to turning a black man loose in the woods and hunting him, or going to the border to shoot Mexicans.

G: That's the transformation of the zombie genre that gives it a different political stance.

M: The zombie film has become a right-wing genre in which the only possible response to the world is violence.

G: Ultimately, it's a survivalist, end-of-the-world

wet dream for people who've been owning guns for twenty years and haven't been able to properly use them on others. So you see Romero on one end of the spectrum, and on the other end—

M: *The Walking Dead.*

G: That show and Romero's zombie films are two completely different political stances. Within the same genre, with almost identical scenes of violence, the political value is completely different.

It's the same thing if I do a ghost movie and I say, "Be afraid of the ghost," that's one political stance. When I say, "Look, the ghost is not going to harm you; you should be afraid of the guys who made the ghost," that's another.

M: I'd say yes, and I'd also say that the only bad ghost stories are the ones where the ghost is the Other.

G: That's why my favorite ghost stories are things like *The Uninvited* with Ray Milland, where the ghost is revealed to be a saving ghost, or *The Changeling*, where the specter of the boy is the victim.

M: *The Sixth Sense* and *Poltergeist* are both about people trapped in limbo. Ghost stories are often about people who have unfinished business.

G: It's always unfinished business.

M: Thus the phrase that you use in *The Devil's Backbone*, "limbo water."

G: As I said before, the entire Civil War is a ghost that still haunts Spain. The characters don't want to see it, they don't want to talk about it, they've talked enough. They avoid it, they look the other way a lot of the time—certainly the right wing does.

To the profound horror of the right-wingers, the road to peace is to fuck each other's brains out regardless of race. The moment you love people of another race—literally fall in love, have an affair, a family, eat their food, live with them—you understand there is no such thing as a separation between us and them. We are all in the same fucking orphanage, and if you fall in love, and you absorb each other's culture, you become one single race. That is the panic of "the purity of blood"— that we have to stay white and we have to stay supreme—that is such a sad, sad affair, because no, we should truly all just be one race, the human race, and marry and get together in whichever way love points you. People are so afraid of that. Why?

(Continued on page 62)

OPPOSITE Another early ghost concept from a del Toro notebook.

FOLLOWING PAGES One of several biographies written by del Toro to flesh out the backstory of key characters from *The Devil's Backbone*. These biographies were given to the actors to help them master their roles.

s.m. ✳✳✳ ✳ Hay gente con mentes insaciables
y cuerpos hambrientos. Pocas veces
hacen lo que quieren. Viven como pueden.
Esclavos de sus enormes apetitos.

✳ Los
Espíritus
de la
pared
de
"Q" en
Spirit
Moves
Son manchas
borrosas co
algunas
característic
humanas
visibles.

s.m. ✳✳✳ ✳ El historial de "Q" se encuentra
en "chip-cards" y lo ven en
s.m. enormes pantallas de formato 1:85.
✳✳✳✳ Q pone una sillita enfrente de

CONCHITA

CONCEPCIÓN GARCÍA HUERTAS BLACK HAIR
19 YEARS OLD SLENDER
5' 2"

What she likes: Dancing, feeling useful, feeling loved, fresh fruit, dreaming about her future, the smell of food, a shawl that used to be her mother's, dolling herself up to "go out," the idea of buying something that she likes (although she never manages to), such as perfume or new shoes, resting her feet in hot water, paying a visit to her siblings, talking to them about Jacinto, not having ever to attend mass, resting on Sundays, reading the magazines that her father brings her from the city.

What she doesn't like: When Jacinto has that distant air, when her father reprimands her, to stumble on her Catholic mores and prayers, being denied a future, being told that what she wants is impossible, taking over for Alma when she falls sick with asthma.

BIOGRAPHY by GUILLERMO "Corin Tellado" del Toro

Her name tells her miracle: Concepción—Conception. The baby girl who arrives early; the one who is born alive when they expect her to be dead.

From the time she is very little, her mother tells her how she had fallen off a horse when she was pregnant with her; how she had seen her little girl born after only 7 months in the womb, crying out loud like a wild creature, when the doctors had warned her she would give birth to a stillborn.
The accident had been brutal. The amount of blood she had lost had permanently stained the floor tiles of her room in the García Huertas's small family home.

The miraculous Concepción is the last one to be born. Her mother names her that because her fertility ends right there, in what is at one and the same time a miracle and a terrible accident.

Conchita, having been born prematurely and being the only daughter after two boys, is protected by everyone, always "the little one." Her mother is very religious, which makes her father lose patience, as he is a Republican worker whose head is full of revolutionary ideas. Her mother takes care to ensure that all three children (Miguel, Pedro, and Conchita) have been named after saints and fulfill all the Catholic sacraments.

Each Sunday morning, she toasts small grains of chicory and puts them in the sleepy children's mouths while preparing them for morning mass. "A grain of strength," she says, as she deposits the toasted seed on their tongues: chicory and host, a double sacrament, the taste of Sundays.

A year after her mother's death, Conchita's father, the Red One, the Atheist, takes her to church to be confirmed. This is the first—and last—religious ceremony during which they will cry together.

Conchita insists on staying very active, on being the lady of the house, the Snow White who is missing four dwarves. She works all the harder every time someone reminds her of her fragility.

Conchita first encounters Santa Lucia when she is only 14 years old. Her father repairs one of the awnings that has fallen down. Carmen finds Conchita indispensable during her early convalescence—she is getting used to a prosthesis made for her due to a recent accident.

Conchita is, for all of the children, both an older sister and the object of secret romantic desires. From her point of view, they are a multitude of new brothers to take care of, children who are her responsibility because their mothers are gone.

After a few years in Santa Lucia, Conchita witnesses the return of Jacinto. For her, it's a case of love at first sight, and she fantasizes that he loves her back. Before the war erupts, she takes him to meet her father and brothers. They think he is an intolerable thug, and because they are men, they know his type. They try to gently warn Conchita, but the moment she senses their negativity, she defends Jacinto as if he were the perfect man.

The truth is, she herself is unsure, because Jacinto is frequently distant and cold. A lot of the time she catches a glimpse of what she suspects are a terrible callousness and resentment, but he is her first love and the only one she will have in her brief life.

Conchita pins all of her hopes on the possibility of a perfect future with Jacinto, in the promised country house in Granada, and all that that entails . . .

She blames her disappointments on the world, the orphanage, her brothers, everything and everyone, except for Jacinto. He is full of promises, of hope. He's a living "if only . . ." A prince. Without a doubt, a prince.

She's not the first one who calls him that.

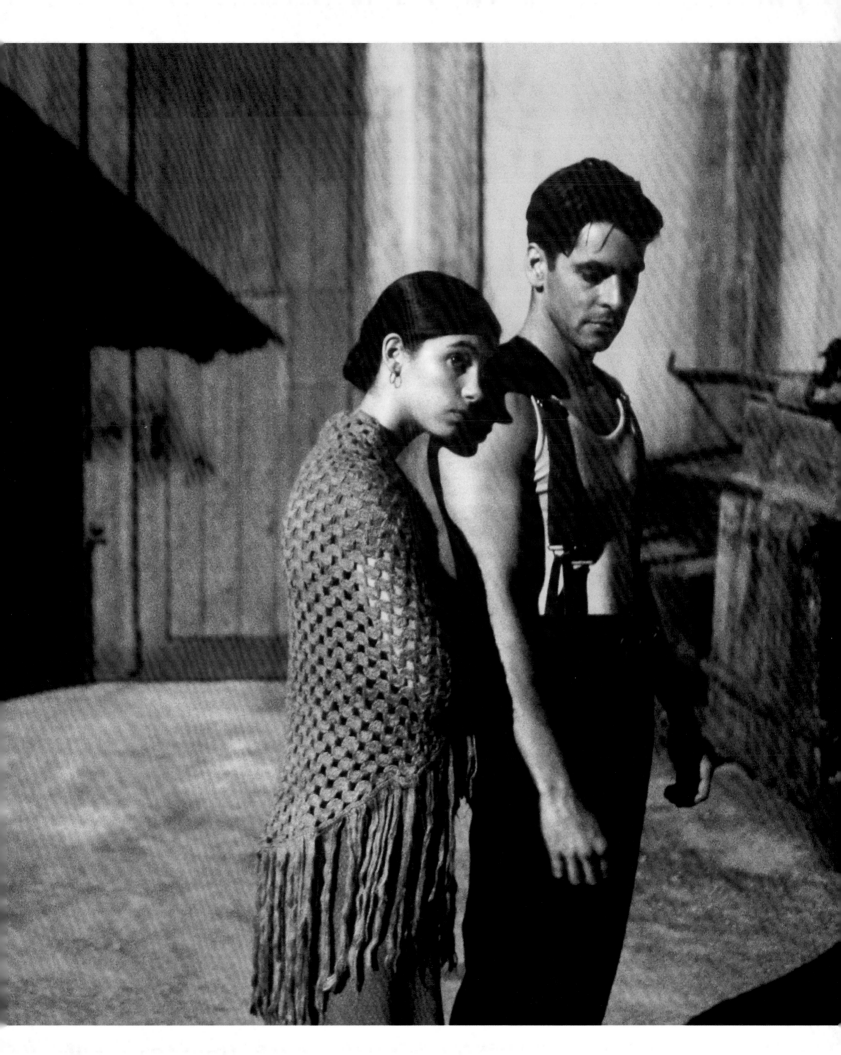

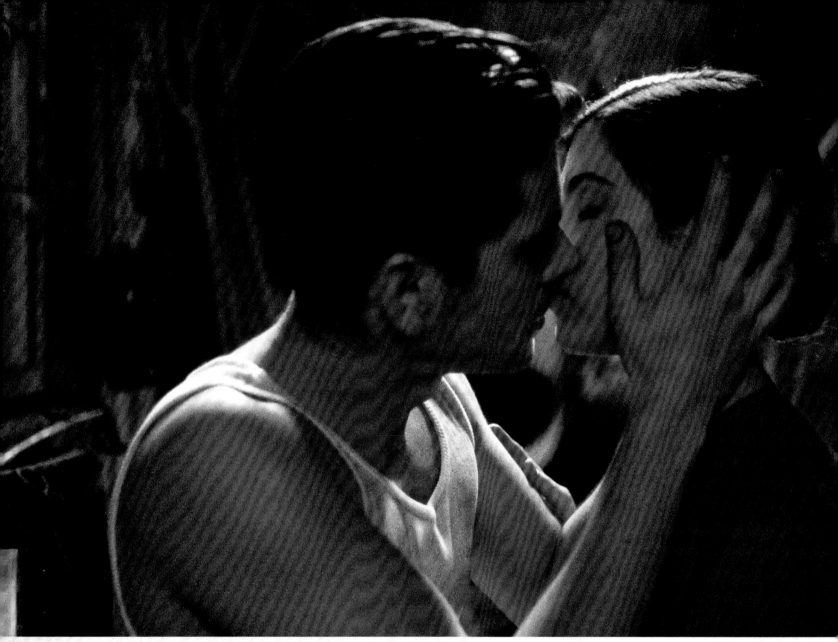

(Continued from page 58)

M: People tend to be afraid of love generally. We see that in *The Devil's Backbone*, which is filled with people who have difficulty accepting love.

G: Jacinto is profoundly loved by Conchita. That's the most heartbreaking thing in the movie for me. When I cast Irene Visedo as Conchita, I cast her because she had this air of being the person who could believe the best in him. The way she looks at him, caresses his head, you understand that she hopes he does a little better when they marry. There's a moment when she says, "You're so complicated."

M: That's not meant as a laugh line, but it always gets a laugh from the audience.

G: It's the understatement of the century! But the tragedy of Jacinto is ultimately, everybody hopes that he would be a little better, but he can't be.

Carmen expects him to be a little nicer, but at the same time, she knows . . . there is something fundamentally broken in him.

I think that we are made in the first five years of our life. Our psyches are fully formed when we are four or five, and if there is a fundamental absence in our lives, you know—somebody says "a well-loved child can do anything" and it's true, but if there's an absence of a mother or father, it's very hard to fill it. No matter how much money you make, how many awards you get, how well regarded you are, there is a hole that will never be filled.

I think Jacinto is that type of guy, who had something fundamentally broken.

M: Eduardo Noriega really puts that across.

G: Originally, Eduardo's part was written for someone much more brutish, like Javier Bardem. I spoke with Javier back then, but we didn't see

ABOVE Conchita and Jacinto share a tender moment.
OPPOSITE Conchita and Carlos bid farewell to each other.

62

eye to eye and so he ended up not doing it. Then I thought, *I'm gonna go for someone who has physical beauty*, because I think fascism often comes with a great uniform. It's always beautifully tailored, and there was this obsession with purity of form.

You know who was really aware of form? Hitler.

M: [*Laughs.*]

G: If you see Nazi propaganda, it's a propaganda that says to the individual, "You belong to a great nation." It's Fascistic if you invoke this classicism, if you invoke this elevated "art," or aesthetic sense of grandeur, which includes Wagner, neoclassical buildings, marble statues—you know, something above human.

Then you have the counter-propaganda from America made by Frank Capra in *Why We Fight*, and it's the opposite. It champions the individual. Capra tells you, "You see those uppity fucking Nazis who think they're better than us? We're gonna show them, because you're a great guy, and great guys make a great nation! Your nation is not grander than you; it's as grand as you make it. You

are a force of one." It's Wagner vs. Gershwin—you know what I'm saying?

M: You're right.

G: So form is content. The way you formally present a work of art has political content. With Jacinto, I wanted to have him be a beautiful guy that Conchita would fall in love with, and not be able to see past until the last moment when she says, "You're a fucking disgusting human being and I'm not afraid of you," which is the final confrontation between them, which would be echoed in *Pan's Labyrinth* where the villainous General Vidal is told [that his infant son] will never know his name.

M: Jacinto and Vidal are like the same character at different ages.

G: They are, and not only that, [Íñigo Garcés and Fernando Tielve] from *Devil's Backbone* show up in *Pan's Labyrinth* as the [two guerrilla soldiers who are executed by Vidal]. They play the same characters in *Pan's Labyrinth*, only a little older. They survive one film and die in the other.

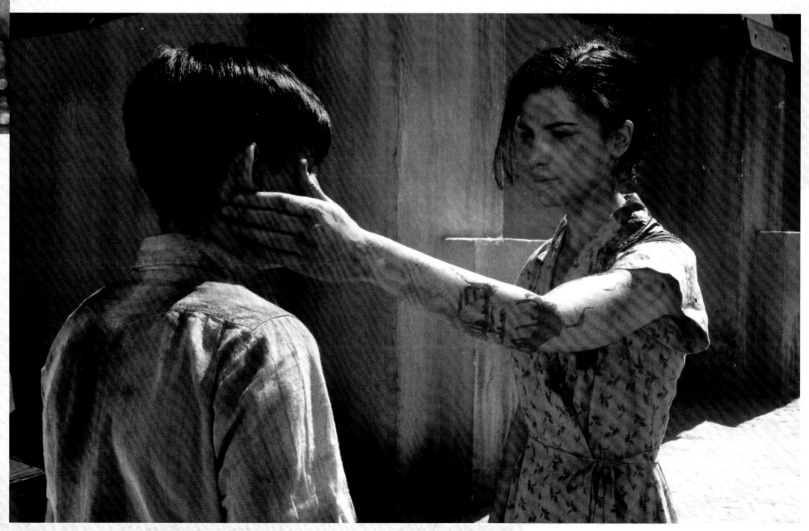

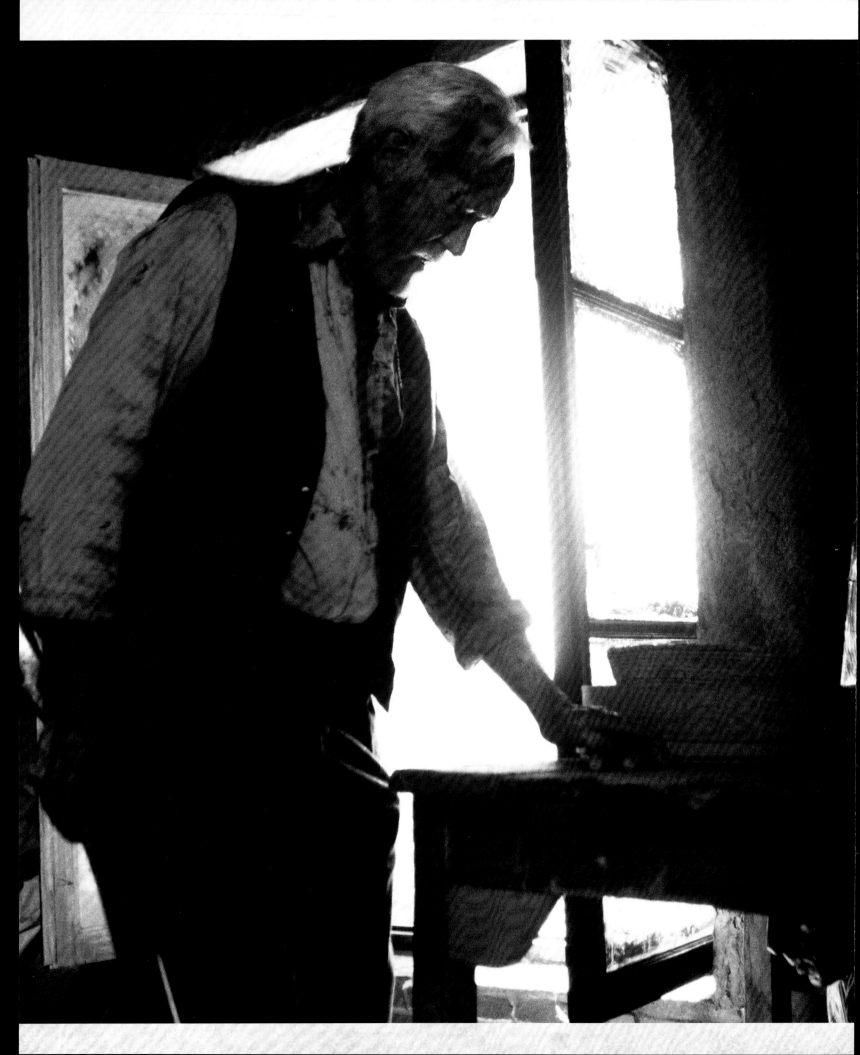

M: You started your filmmaking career as a makeup artist or prosthetics artist, didn't you?

G: What happened was I started directing, doing Super 8mm films. The more elaborate they became, the more I started to need to do effects. I started doing effects for my shorts, and then other friends started to ask me to do them for their shorts, and eventually features started to call me. I'd finance my short films by doing effects for other people, and I collected a shitload of favors and cashed them all in on *Cronos*. That was the last time I did makeup and effects. I sculpted the tail of the insect that is inside the Cronos device, and a few pieces of the [interior of the device], but my company Necropia did all the effects.

I love effects, but I got an allergic reaction from all the chemicals. Now I get an instant allergic reaction to talcum powder and gypsum.

M: How did you get from doing makeup to directing *The Devil's Backbone*?

G: I was at the Miami Film Festival with Federico Luppi showing *Cronos*, at the tail end of the *Cronos* tour. I was by the pool sipping a Diet Coke and I heard a voice that said, "Are you Guillermo del Toro?" And I turned around and it was Pedro Almodóvar!

He said, "I'm Pedro Almodóvar," and I said, "Of course you are!" And he said, "I liked your movie *Cronos* very much and if you ever come to Spain my brother and I would like to produce a movie for you."

M: Federico Luppi was in *Cronos*, and you brought him back to play Casares in *The Devil's Backbone*. But you didn't act on Almodóvar's offer?

G: Not right away. I went off and did *Mimic*, and suffered. From the get-go, it was a bad experience. I was in postproduction on it for two years, and coming out of that I honestly thought, *Maybe I'm not made for this*, because [Miramax cofounder] Bob Weinstein was very tough to survive. It was the time where they were kind of golden in the industry, so anything that went wrong at Miramax was your fault, not theirs. Eventually, over the years, more information emerged. But at that time people said, "God knows what happened on *Mimic*."

And no more work was coming from the States. I was preparing a bunch of movies, like *The Count of Monte Cristo*. I was starting to write that with

L. M. "Kit" Carson. I also had a movie I wanted to make called *Mephisto's Bridge*. But nothing was happening.

M: I started to worry about you a little bit after *Mimic*, to be honest. I thought, *He's two movies in, and the system already ate him alive!*

G: It was pretty worrisome for me and I didn't know what to do, because the Mexican Institute of Film had rejected my *Devil's Backbone* [proposal], saying it was too big a movie.

Anyway, in about 1997, I took a chance and wrote to Pedro and said, "Remember that conversation we had?" It was three or four years between his generous offer and my taking advantage of it.

Pedro is a producer who is also a director, so he gave me what is, for me, to this day, the best producing experience I've ever had. He'd say, "If you need me, call me, but unless you need me, I'll be nowhere to be seen." That's the way I try to produce.

And then when Pedro came in, I said, "OK, let's do it." My movie, at four million, cost $600,000 more than Pedro had ever spent on a movie of his own, which is incredibly generous and exemplary.

The second thing he gave me is complete confidence. He really was fascinated by the methodology of my work, by the preproduction and the storyboarding and the fabrication of the makeup effects, because he had not done anything like that.

And that was like an antidote to *Mimic*, which was five producers around me at all times, you know, to the point where in *Mimic*, I put rearview mirrors on the sides of my chair that read, "Producers may be closer than they appear," and they resented it.

M: What movies did you have in your head while you made *The Devil's Backbone*?

G: I always had the idea of a Western, because I knew it was a Gothic romance and I asked, "What's the opposite style of Gothic? Can I do Gothic in daylight?" That was the question, and I said, "Why don't I shoot it like Sergio Leone? In daylight where the wardrobe is all sepia, brown, and earth tones? And at night, it becomes a Mario Bava horror film, with cyan and gold," which I started doing on *Mimic*. We did it once in *Cronos* and I asked, "Why do I like this shot so much?" and I realized it's because it's cyan and gold.

So for *The Devil's Backbone*, [director of

LEFT Casares (Federico Luppi) prepares to confront Jacinto and his cohorts.

photography Guillermo] Navarro said, "Why don't we bake in some of the color? We could try three filters: two tobaccos and one chocolate," which are the names of the filters. And I said, "Well, I'm going to art-direct the whole movie in warm colors, but the walls are going to be cyan, which is very close to green, and green contains blue and yellow." So it can work in both codes. If I go to a greenish cyan, it actually reads well at night when you use the cooler cyan, and it reads well in day because it contains a little bit of gold.

[We] shot the test with the wardrobe and the filters. We used "tobacco one" and "tobacco two," and we used the chocolate filter for very extreme, bright days, to try to make the blue of the sky a little denser and a little less plain blue. It really gave it that Western look.

M: You have a number of shots in the movie that are pretty explicitly Western movie shots. You even have one or two shots that are basically the closing shot of *The Searchers*.

G: I like the architecture framing the characters. That closing shot was done on the last day of filming. It was a crazy fucking day. That day we shot the stabbing of Conchita in the middle of the field, we shot the ending, we shot the bomb in the [orphanage] patio. We shot the arrival of Carlos in the car, too.

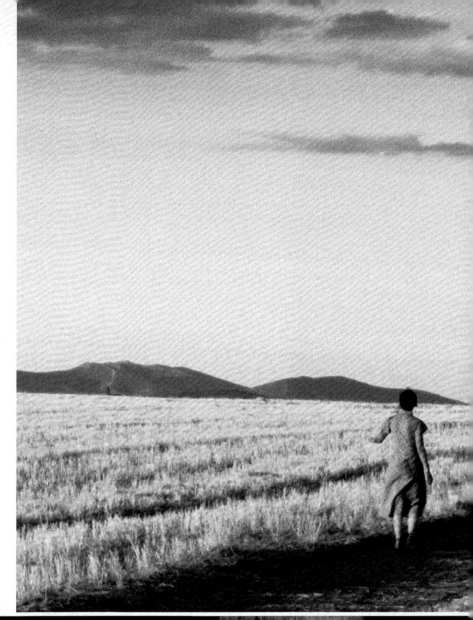

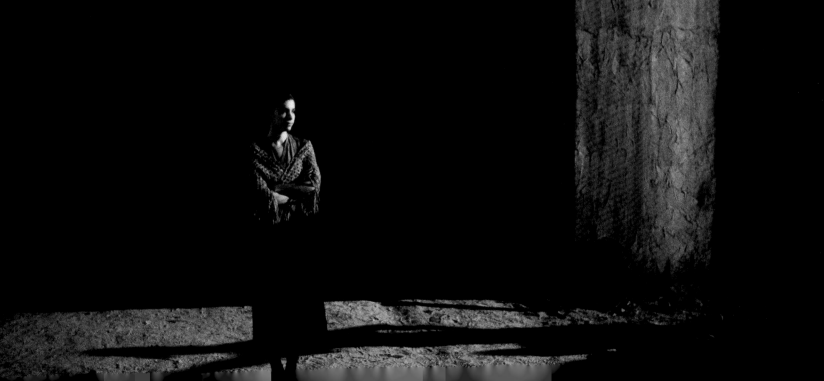

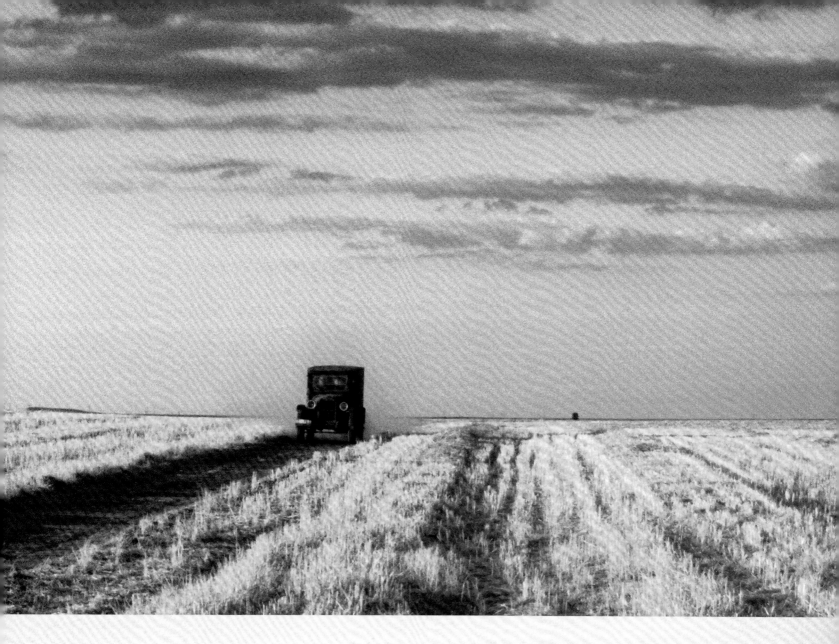

ABOVE Conchita goes to plead her case to Jacinto.

OPPOSITE BOTTOM Conchita waits for Jacinto.

M: That's a lot!

G: Too much. I was going crazy and the sun was setting. We knew we needed Luppi silhouetted in the door, so we had forty-five minutes to sundown. I had storyboarded six shots for that scene: [I was going to start by shooting the master shot] and then I was going to go to a close-up of Carlos looking mad; an over-the-shoulder shot of Carlos looking at the door; a close-up of Casares half in shadows, half in daylight; and another reverse shot where they walk away, blah blah blah.

And I'm watching the master shot, and Guillermo Navarro says, "Let's move to the next shot because we'll lose the sun," and I said, "No, that's the ending. That's all I need." It's the most beautiful ending I could have had.

A director of photography will always tell you this: Put it in the bag. If you don't need it, you don't use it, but let's get it in the bag. And I said, "No.

We don't." And we actually wrapped a little early.

M: I would never look at *The Devil's Backbone* and think some of the scenes were shot quickly. It plays like a deliberate film where everything was fussed over.

G: Sometimes we were losing days. And there was one kid who used to burn slugs. He cost us a whole day!

M: You mean the kid who puts the slugs on his arm?

G: Yes, that's the murderous kid. What happened was, we had a slug breeder on the movie to supply slugs for that scene. I asked him for very specific slugs; they had to have red in them. Every time we'd do a take, this kid would take the slug off his arm and throw it into the fire.

M: Into the stove? That's horrible.

67

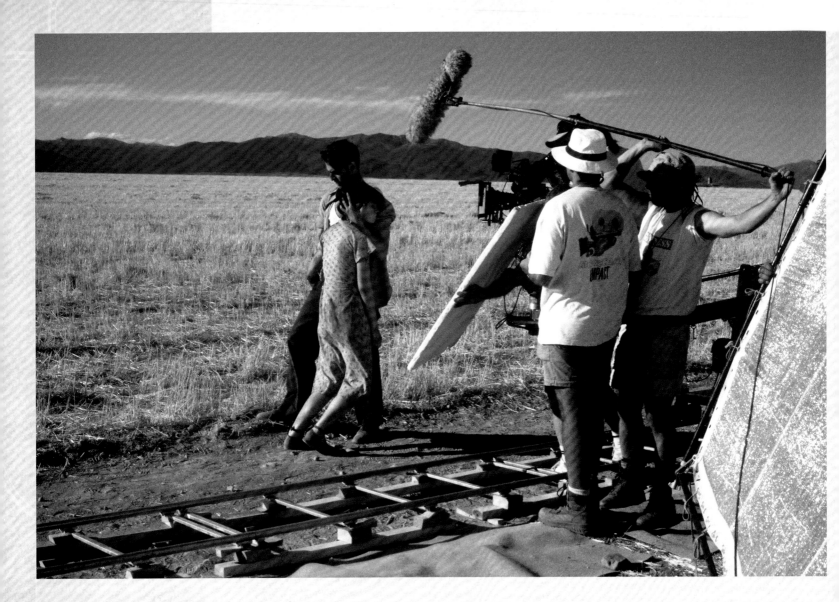

G: After the first take I said, "It smells like burning meat!"

The kid said, "I threw the slug in the stove!"

"Why?"

"The scene is over!"

"But there's another take coming!"

In between every take, the kid would throw a slug into the stove!

M: Why?

G: Because he was a very crazy kid! I mean, that scene was supposed to be quick . . . We were so worn down, Navarro and I, because the movie was long days, very ambitious. We made a mistake and we had to adjust because of it. We were shooting the scene where the kids are talking about killing Jacinto and they're removing the glass from the window and preparing the lances. We were in the middle of shooting that scene and I turn to Navarro and I say, "This should be night."

He said, "No, it's daylight."

I said, "No, no, no. remember, this happens when . . ."

Oh my gosh! We realized we'd forgotten that we were shooting daylight, and it was supposed to be night!

And I said, "The scene before and the scene after haven't been shot, so let's change it." And we changed it, but that change came about as the result of an accident, because we couldn't go back and re-shoot those three shots and make them night shots. We didn't have the time.

M: Do you ever feel like the universe is conspiring to force you to abandon your plans?

G: Oh yeah. That's fifty percent of directing. People think that directing is control, and I think it is—fifty percent of the time. The other fifty percent is taking the accident and making it better.

I'll give you an example. On *Crimson Peak*, the scene where [Tom Hiddleston] dances with [Mia Wasikowska] was originally a huge dancing scene

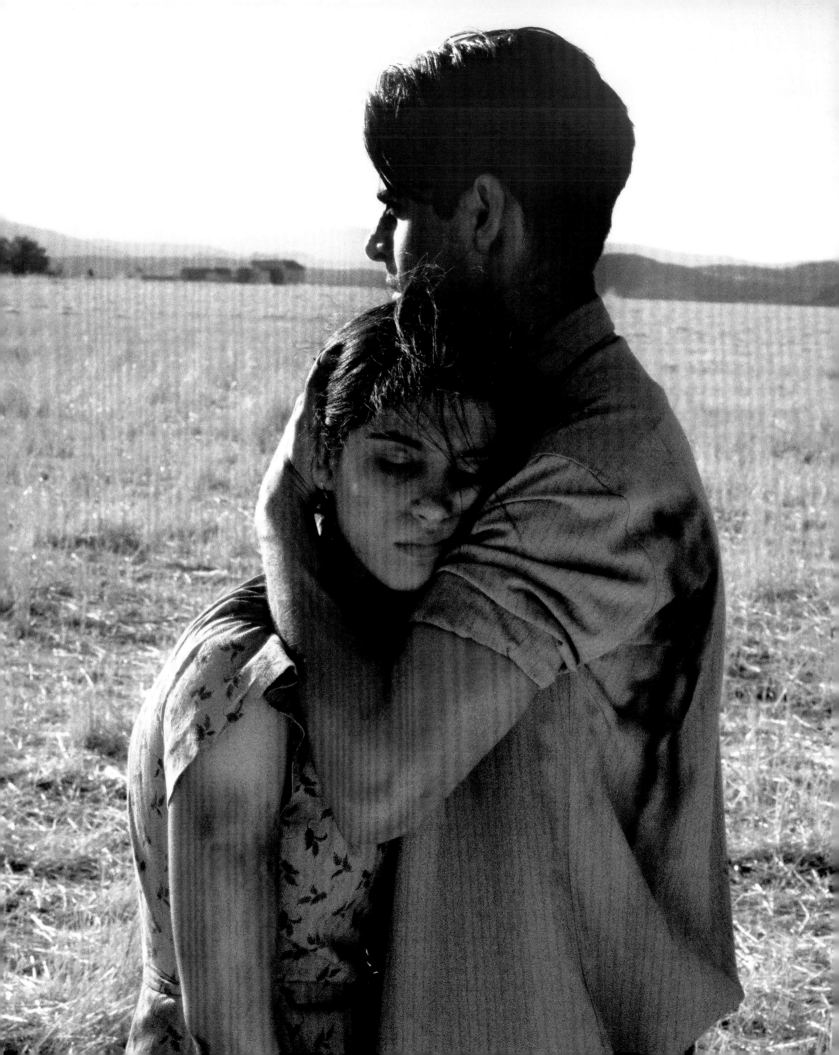

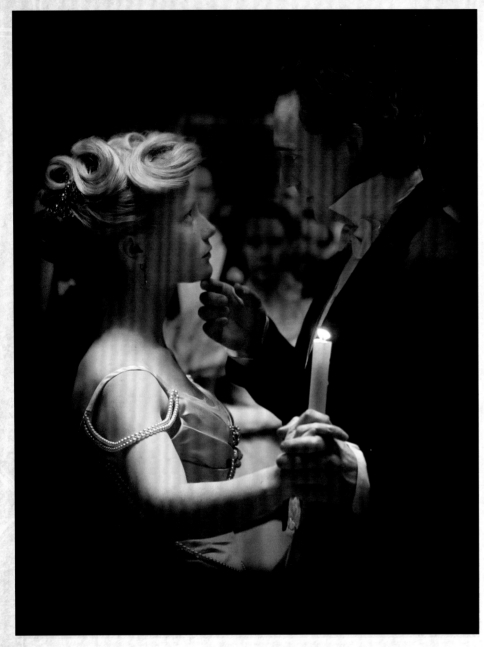

it to be a demonstration of what the waltz was, European style.

Directing is compromise as an art form. Since Erich von Stroheim or Charlie Chaplin or Buster Keaton or D. W. Griffith, we've enthroned the idea of the autocrat: the director who controls *everything*. The reality is that every director knows that it's about saying, "Oh, this accident happened, and it's better."

M: *Jaws* is a good example of that. Spielberg originally wanted to see more of the shark, but they couldn't get the big mechanical shark puppet to work. And it didn't look convincing when it did work, so it ended up being represented by a fin most of the time.

G: Perfect.

M: I think Orson Welles had a line to that effect, that a director is someone who presides over accidents.

G: I befriended Tom Cruise about ten years ago. I mostly interrogate him about working with Stanley Kubrick on *Eyes Wide Shut*, which is one of my favorite of [Kubrick's] films. I'm in the minority there! I asked him, "Do you think he controlled everything? Or was he able to create opportunities for accidents?" And he said, "Absolutely, he left room for accidents. In fact, sometimes you had the feeling that he was waiting for that accident to present itself so he could recognize it."

There's a beautiful, amazing accident in *The Devil's Backbone*. Utterly amazing. We're doing the sequence where the car explodes in the middle of the patio, the one where the fender hits the camera, and Casares wakes up, and gets up, and everything is kind of dizzy. We were given an hour and a half to shoot that scene. Him waking up, the car exploding, everything . . . It was incredibly tight.

So, the sun was setting again, and I shot the close-up of Casares getting up after the explosion, and I said, "Let's do the entire thing in one shot after the close-up of him getting up, where the camera is kind of dizzy around him."

And by a miracle—purely a miracle, because everything needed to be fine: The kids needed to be there crying, Conchita runs to him and says, "An explosion, an explosion," and then he goes into the kitchen—the light hits the smoke at the right angle.

And without any of us being aware of it, by blowing out the [kitchen] doors, we have created a vacuum, like an actual chimney within the building. And the smoke moves in and out of those doors in a beautiful way, and the sun hits the smoke at the

of all the couples dancing together, like forty couples, each with a candle. The music stopped, like musical chairs, and everybody blew out each other's candles, and the last two candles were him and her, by accident, moving in an Ernst Lubitsch kind of way. By serendipity, they were changing partners, and they ended up together, and he allowed her to blow out his candle in a gentlemanly way.

And then my producer, Callum Greene, comes up to me and says, "You cannot shoot the scene."

"Why?"

"Because when an extra dances, it becomes a performance, and we have to pay him three times more. So the entire day is a million-dollar day if you want forty couples dancing."

I say, "What about twenty?"

He says, "It's still half a million. We can't have a half-million-dollar day on this movie." So I said, "OK, I'll rewrite it tomorrow," so I rewrote

right angle. And all of a sudden we're shooting, and
I'm having chills!

M: I'm getting chills hearing you describe it,
actually. I had no idea that was an accident.

G: It happened in one take. *One take*. And in the
right take. We did more than one, but in the right
take, we were screaming and shouting, and all of a
sudden the wind hits and moves everything the
right way, and we went, "*Wow*."
 There's another accident in *Devil's Backbone*
that's beautiful. Conchita opens the door and goes

outside to try to find out who opened the door,
and she discovers the empty gas cans and there's
a dust devil in the foreground. That's a real dust
devil!

M: It sounds like you had a lot of lucky accidents on
this movie.

G: It's the most lean and the most beautiful
experience I've ever had. It was very difficult to
shoot, but there were great partnerships. The
wardrobe was beautiful, the set design was
beautiful. Navarro and I were clicking beautifully.

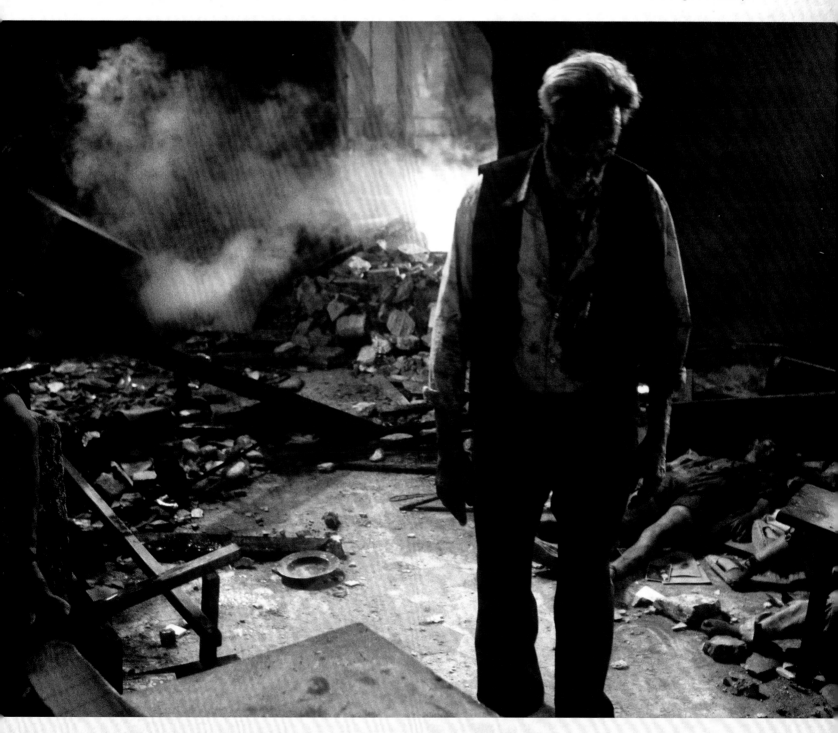

GUILLERMO NAVARRO

Guillermo Navarro has worked with director Guillermo del Toro on six films, stretching from 1993's *Cronos* through 2013's *Pacific Rim*. He also shot *Desperado*, *Jackie Brown*, *The Twilight Saga: Breaking Dawn Parts 1* and *2*, and *London Fields*. His work as director includes the TV shows *Damien*, *Hannibal*, and *Preacher*.

GN: I met Guillermo del Toro working on a couple of movies where he was the prosthetics and makeup guy. We worked on a movie I shot called *Cabeza de Vaca* and a couple others. We were young then. He was a very smart guy, full of ideas. He wanted to do things, and he was very upbeat about becoming a filmmaker. He wanted to make that his life.

The first movie we did together was *Cronos*, his first feature. My sister Bertha [Navarro] produced that movie after I put him in touch with her. We've had a pretty solid friendship and collaboration since then.

There was some resistance within the Spanish film community to us doing *The Devil's Backbone*. Those filmmakers are very close, so they think we are taking something away from them when foreigners come on their turf.

But the Spanish Civil War is not a random fascination for us. It was a very strong influence on Mexican society. The Mexican national composition is a mix of Spain and Mexico. We don't feel like Spain is detached from us, or foreign.

Mexico was one of the very few countries that accepted Civil War refugees and kept its relations with the Republic, the losing side in the Civil War. We acted very generously toward the refugees. I went to schools that were run by Spanish refugees. Mexico never had relationships with the Franco regime. It [maintained] a commitment to the elected regime of the Republic. We considered Franco's regime a coup d'état, and his government was never recognized politically. That was one of the very strong positions the Mexican government took, and as a country we were behind it.

I prepared for *The Devil's Backbone* remotely because I was shooting another movie at that time. I finished shooting that other movie on a Saturday, then flew to Madrid, landed on Sunday, went to scout that same day, and started shooting on Monday. Ridiculous! But in the schedule, we [prioritized] things that were pretty straightforward during the first days of shooting. I actually had a set that I pre-lit remotely, and a lot of things were in place so I could just start going at it. Then as we went forward we would continue prepping. I had a pretty clear idea of what to do with the story, just as [del Toro] did. There was no dark cloud hanging over us. It was not an issue.

As for the look . . . well, first of all, in both [of Guillermo del Toro's Spanish Civil War] movies, there is this concept of a parallel reality. We have done that in many movies together: the color palette where we go into very cold or warm worlds. These are movies seen through the eyes of children who are in the middle of the drama, so our staging had to be seen through the eyes of children. The world of the adults is one [perspective], and the world of the children is another. So it was about creating a bridge between objective reality and the subjective experience of being a child, where you can believe in things that adults don't allow themselves to imagine.

We had a very limited budget and worked with lot of children in the cast . . . We had a lot of challenges, like the fact that we were constantly exposed to the sun, and how the shadows changed throughout a film narrative where everything happened in sequence. We shot at an existing location where some sets were built . . . But generally speaking it was a big outdoor stage with this incredible bomb at the center.

In TV, the name of the game is coverage. In a lot of Hollywood movies, all of the decisions are made in the editing room. There's a general attitude that it's better to have [a shot] and not need it than to need it and not have it. So, many directors make movies by saying, "OK, we'll put together a shot, then change the lens, and do the same thing tighter, then we'll change the lens and do a close-up, and then we'll do the coverage, and maybe we'll have to create another master here, and then a crane move." Suddenly, there's a salad of shots that an editor can put together.

But there is a lack of intention in how you're telling the story. You're just documenting what's happening in front of you, and that's different. That's just photographing something, just using the camera like a stenographer uses their typewriter.

We didn't do a lot of coverage for *The Devil's Backbone*. Coverage demonstrates a misunderstanding of what film language is. When you have your sequences well thought out, and you have the ability to move the camera and allow it to be your storyteller. Then you execute the shots, and they come alive from one shot to another. Really, you do not need to solve things in editing, because you should be solving it on the set.

Here is my take on cinematography: There is no film without images, correct? If you can't see it through the lens, it doesn't exist in the movie. If you *respect* that the camera will tell the story, then the camera now has a role [in the story].

So what I'm calling the exercising of film language is really allowing the cinematography to be the storyteller. Cinematography is a language like any other, with its own grammar and rules. Being fluent in that language requires a strong understanding of cinematography as part of the storytelling process. It's not just people saying things while the camera registers what they say.

INTERVIEW BY MATT ZOLLER SEITZ

OPPOSITE TOP Director of photography Guillermo Navarro.
TOP The two Guillermos: Navarro and del Toro.
LEFT A high-angle shot of Carmen (Marisa Paredes) crossing the courtyard.

Cinematography

M: What is Guillermo Navarro like to shoot with?

G: Well, we've always been really good friends. Like, I know all his secrets and he knows all of mine. And my deal with him is, I choose lens and staging and camera movements, and he is completely in charge of light. If he says, "I need forty minutes to light," we discuss it in preproduction but never again.

It's very seamless, the way we work. When we were shooting *Cronos*, one time I said to him, "I think this is the wrong lens, let's go wider," and he said, "I'm not sure we should go for a wider lens," and then I said, "Let's do it with both lenses, watch dailies, and if you're right, you're right."

And we did both lenses, and he was right.

[At the start of production] he says to me, "What do you want?" and I say, "This feeling, high contrast/low contrast, single-source lighting, chiaroscuro," whatever language we establish. And then we don't ever talk about it again, because I write for his light, and I design—well, I think cinematography is not a single discipline.

M: How do you mean?

G: Cinematography is set design, wardrobe design, and staging.

You, as the cinematographer, look at the wardrobe, they're all in grays, browns, earths, very deep blues. And I've already designed some color, and there's only one woman with a little bit of crimson on her blouse. I've already made a decision that is going to affect your cinematography. Why?

Because wardrobe is the [movie] set of the medium shot and the close-up. It's the [movie] set that frames a face, you know?

So when somebody says, "That cinematography is great," that person is saying, "Great set design, great wardrobe design, great staging, great cinematography." And by the same token, when they say, "What a great production designer," they're saying, "Great cinematography," etc. These disciplines are inseparable.

The costume, the makeup, the hair are all set design for [the] actor. In the wide shot, you are framing a set with this actor, the whole body. In the

ABOVE Carlos hides from Santi in the linen closet.

OPPOSITE Storyboards by Carlos Giménez of the scene where Carlos stares through the keyhole of the linen closet door, and sees Santi's eye staring back at him.

medium and the close-up, you are framing this actor, the face. In the wide shot, these things are all surfaces where the light is bouncing off. The value of your light is only relative to the color, surface, and contrast of the materials that are in front of that light. Cinematography is completely different if the person is dressed in silk [as opposed to] cotton. If the wall is painted with matte or semi-matte paint, it's different. And when you discuss style with your cinematographer, you will then be alone for weeks and weeks making those decisions in his or her favor with the production designer and the wardrobe designer. Cinematography is interdisciplinary.

To me, directing is orchestrating all those elements. That way, when somebody says to me, "Great image," well, a great image is a lot of departments and *a lot* of content. Like, on *Devil's Backbone*, there is this shape—because we talk about insects trapped in amber—that is trapping

the characters constantly in the corridors, in the archways, in the doorway that opens the movie. I wanted to trap the characters in the architecture, you know? So there's always something framing the content. Then, the ending of the movie shows the ghost framed exactly with half the door open and half the door closed.

Navarro always kept telling me, "When you discuss a set, please, always think of me. Always think of where I am going to light it from." And so I always design the sets as if the cinematographer was there. I know which wall [can be moved]. In *Crimson Peak*, I designed the windows to look like an eye so that the characters were constantly being watched.

In *Devil's Backbone*, there are a lot of things framing things. The eye of the ghost is framed by the keyhole. There are a lot of things that I constructed visually in rhymes, so that you feel the repetition of elements.

26

27

28

29

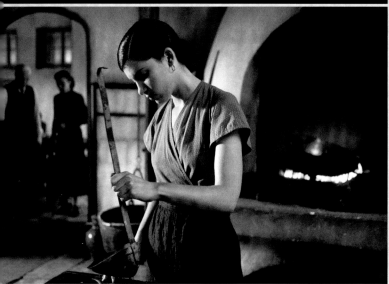

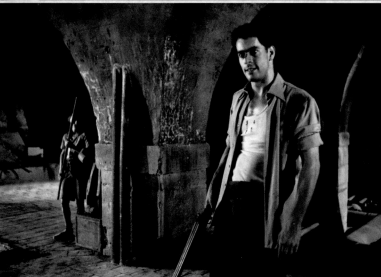

THIS PAGE (top to bottom) Santi in the window; Conchita preparing to serve the children; Jacinto looking very confident for a man who's about to die.

RIGHT An example of del Toro's fondness for using architecture to literally frame his characters, as if they were stage actors standing under a proscenium arch, or works of art hanging on a wall.

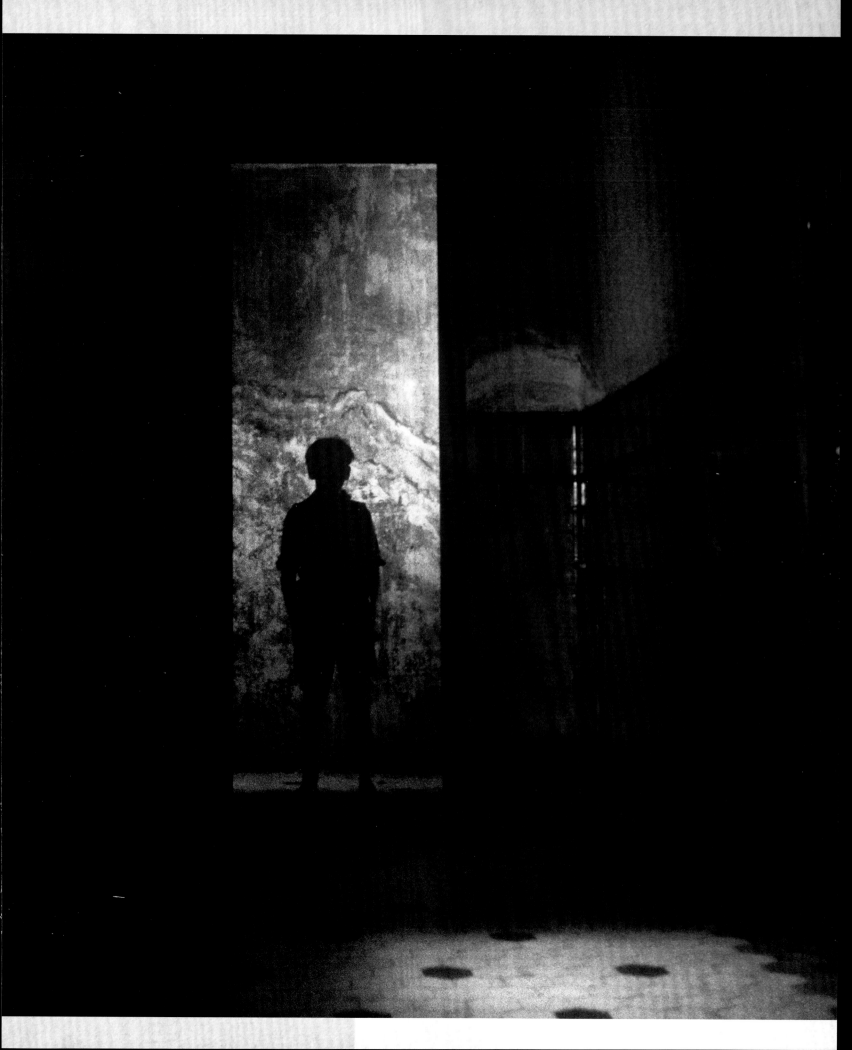

ESTHER GARCÍA

Production manager Esther García is the professional glue that holds together many film shoots. On *The Devil's Backbone* she did everything from hiring the child actors and ensuring their well-being to making sure the film's crew had the resources they needed to do their jobs. She credits working with Spanish filmmaker Álex de la Iglesia on *Acción Mutante* (1993) as a source of inspiration for her work on *The Devil's Backbone*. But García had also worked with producers Pedro and Agustín Almodóvar throughout the eighties on films like *Law of Desire* (1987), *Women on the Verge of a Nervous Breakdown* (1988), and *Tie Me Up! Tie Me Down!* (1989). García has since become an integral part of El Deseo's team and gone on to co-produce Almodóvar projects like *Bad Education* (2004), *Volver* (2006), and *The Skin I Live In* (2011). *The Devil's Backbone* was her thirteenth collaboration with the brothers Almodóvar.

EG: The long days of work made a dent in the kids' overall well-being. They felt tired and were more unruly than normal. We achieved a state of calm and assertiveness in the boys by allowing their mothers to be close to them. Not all mothers could be present; some worked, but they had nothing to worry about as there were excellent vocational caregivers present who looked after the kids with care and patience and also organized games to entertain them during the long days. Everyone knows that working with children is very difficult, and it would have been a lot more difficult if we hadn't prepared everything very meticulously.

I had never really worked with that many children and that ended up being a big challenge. We reinforced the team and organized the whole work plan around the children, giving them time to rest and play throughout the day, working with them on arrival at the set.

Another difficulty was changing their clothes when they started to shoot the film. We'd make them take their costumes off immediately when they'd start to play, to not mess up the continuity.

But what was really complicated were the five hours each day when Junio Valverde, the wonderful boy who played Santi the ghost, needed to put in his contact lenses, have his prosthetic wounds fitted, and have makeup applied to his whole body. He never complained and was a marvel of patience and eagerness. Guillermo del Toro also had a lot of patience and found a way to work with the children, obtaining extraordinary results.

We often got up early to check that everything [was] ready for the shoot. By 7 a.m., makeup artists, costume fitters, production assistants, managers, caterers, and members of the decoration team were already in full throttle. I'd go through makeup, wardrobe, and hairdressing, and check that the [day's requirements outlined] in the work sheet were all [accounted for]. I weighed the mood of technicians and actors and waited for Guillermo's arrival.

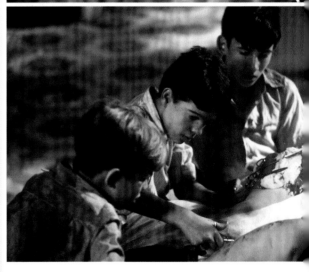

My main concern was to avoid any accidents with the children and to make sure Guillermo del Toro would be satisfied and happy with the work we were doing. I adored working with Guillermo; he was a constant source of inspiration. He knew so much about special effects, about makeup, and the story he wanted to tell. It was stimulating to see him plan and enjoy the arduous work of each day, like a kid.

His work ethic has always impressed me. He never got tired, which is very motivating and exhausting [to keep up with] at the same time. He is extremely demanding with everyone and knows the limits of each technician and actor very well. He knows how to structure his thoughts, can be single-minded and meticulous as well as funny, and very affectionate.

That having been said, it is generally difficult for directors to keep up with a work plan. Directors have the tendency to want to make more shots than is humanly possible in the hours they have available to film. I think Guillermo's desire was to do around twenty shots every day, and we didn't always manage to get them all done.

On several occasions throughout the shoot, I had to remind him that the day was over, that we had been shooting already for some extra hours, and that we couldn't continue shooting. Although he would have liked to continue, he agreed to stop.

The Devil's Backbone is one of the most important movies of my career . . . Meeting a director as interesting as Guillermo—with such a rich and different world, influenced by the most baroque Mexican and Latin American culture and with such an overwhelming and enthusiastic personality—aroused inside me a certain type of curiosity that has been a beacon in my life ever since. I feel like I'm Guillermo's friend. A distant one, but a friend.

INTERVIEW BY SIMON ABRAMS

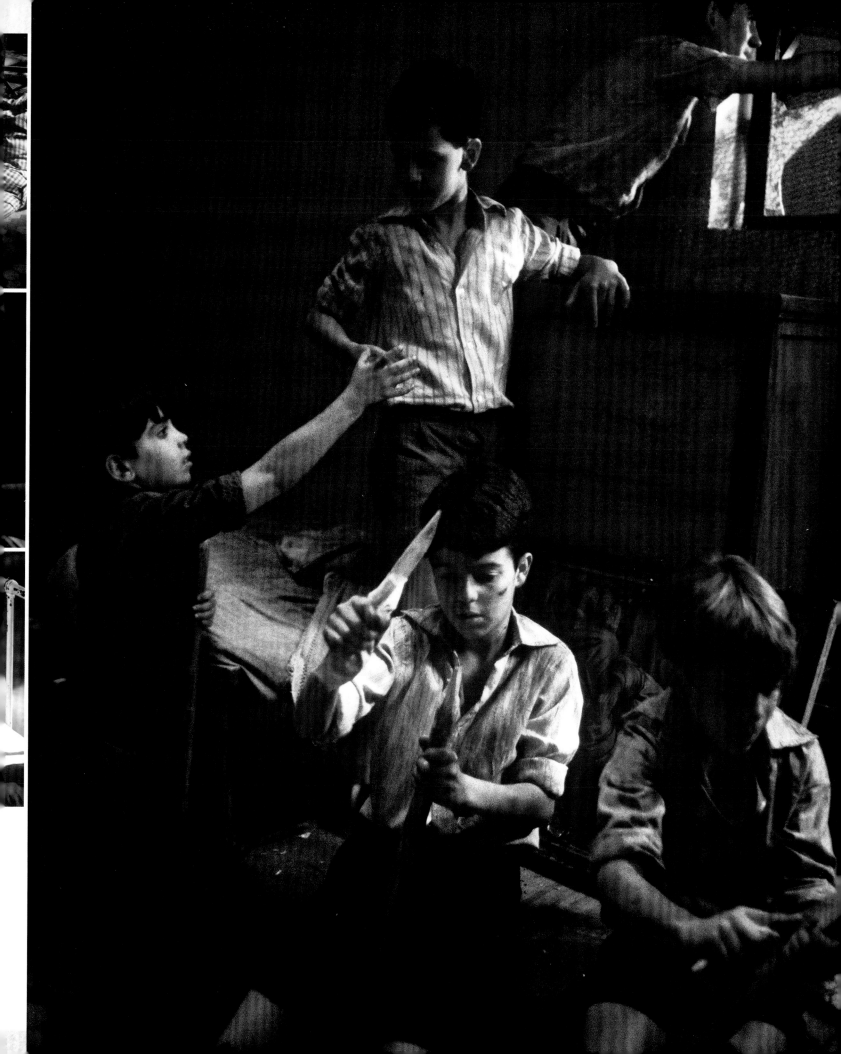

THESE PAGES Production design sketch of the orphans' barracks.

PAGES 82–83 Production design art for Casares's lab (left-hand page), the cistern (right-hand page top), and the courtyard (right-hand page bottom).

Sources of Inspiration

G: One of the bigger influences on the look of the movie is a comic book by Carlos Giménez, who did our storyboards. It's an amazing comic book called *Paracuellos*. *Paracuellos* is the greatest graphic novel in the history of Spanish comics. It follows the years Giménez spent in an orphanage. He was not an orphan; his mother and brother put him in an orphanage because the brother had to work, and she was sick with tuberculosis. I named the character Carlos after him.

There are some elements of the graphic novel in the movie, like the marbles made of mud and snot. That comes from the book.

M: That's a great detail.

G: They used to make those marbles, and the basis of the wealth system in the orphanage was trading. "I'll trade you a comic book for your photo of a girl without clothes."

M: Just like in prison.

G: Yes, it's a prison economy. So when he came in to work on the art direction—he also worked on *Pan's Labyrinth*—we did the art direction on *Devil's* the

same way we did on *Pan's*. Before the production designer arrived, we spent twelve weeks together designing everything we could. Then the production designer came in and gave it his own spin.

Carlos was like a research library, because he lived it. He'd say, "No, the haircut would be like this," or "Here, the pants would be too short because they were made for that kid when he was six and now the kid is eight and his legs are longer, so the shorts need to be ridiculously short." Casting the kids was done carefully using the comic book and photographs, to make the kids look exactly like his comic. And if you see the comic, they look like the kids in *The Devil's Backbone*.

(Continued on page 92)

CARLOS GIMÉNEZ

The influence of comics artist Carlos Giménez looms large over *The Devil's Backbone*. Born in Madrid in 1941, Giménez grew up in various state-funded orphanages during the Franco regime. Giménez is most well known for writing and drawing *Paracuellos*, an autobiographical comic based on his experiences growing up in poverty and under the dehumanizing rule of the officials who ran the orphanages, who he often depicts as corrupt, state-supported religious zealots. Guillermo del Toro was one of many artists influenced by *Paracuellos* and would later hire Giménez to help pre-visualize both *The Devil's Backbone* and *Pan's Labyrinth*. Giménez also would create the storyboards for *The Devil's Backbone*.

CG: During the Franco dictatorship, I used to tell my friends stories of the schools I attended as a child. I didn't need to do any research [for *Paracuellos*]. I had spent eight years—my entire childhood—in those institutions and remembered perfectly everything I'd lived. I gathered a group of friends—who had been my companions in those schools—and my brother, Antonio, and asked them to tell me anecdotes of what had happened to them.

We always said to each other, "It's a shame these stories can't be published in Spain." These stories couldn't be published due to widespread censorship, but I decided to draw them as soon as Franco died. Unfortunately, I found that no publisher wanted to publish them, and not because of the political content they might have, but simply because publishers didn't view these stories as commercial, because they didn't have asses or boobs in them . . . prospective editors only saw the drawings and did not bother to read them.

Before the first thirty pages of *Paracuellos* were published in Spain, these stories were published in France in the journal *Fluide Glacial*. They say that nobody is a prophet in his land, and Spanish editors proved that by only deciding to print my stories *after* they got positive reviews in France. In this profession of making comics—and especially at that time—authors couldn't afford to do our work as we wanted, or even choose the subjects we wanted. So the structure of these comics was subject to the constraints of the newspaper I was working with. I had a weekly two-page collaboration, because the editor couldn't give me more pages. Then again, I couldn't have done more pages in a week anyway. That's the real reason why I made so many vignettes per page.

Looking back on these stories, it seems obvious that these "homes," as we called them, were really prisons and functioned as such. You were locked up, and you marched to the beat of the drum of whoever controlled the institutions. In those places and at that age, anger is useless; it does not even occur to you that you can express anger. Fear covers everything. It is easier to understand what I'm talking about if we compare it to a Nazi concentration camp. None of the Nazis' prisoners could show their anger. Besides not serving any purpose, it would only make the situation worse.

THIS PAGE Character sketches by Carlos Giménez.

OPPOSITE AND PAGE 86 "Thirst," a two-page story from the first collection of *Paracuellos*, Carlos Giménez's autobiographical comic strip about life in Franco-era orphanages.

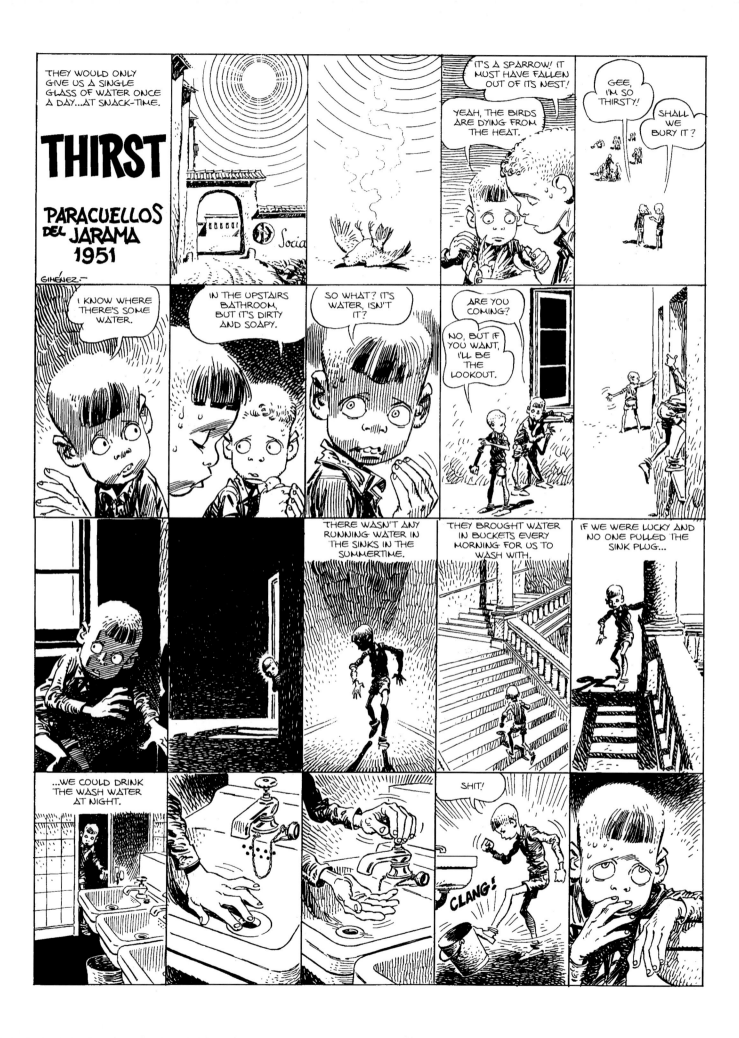

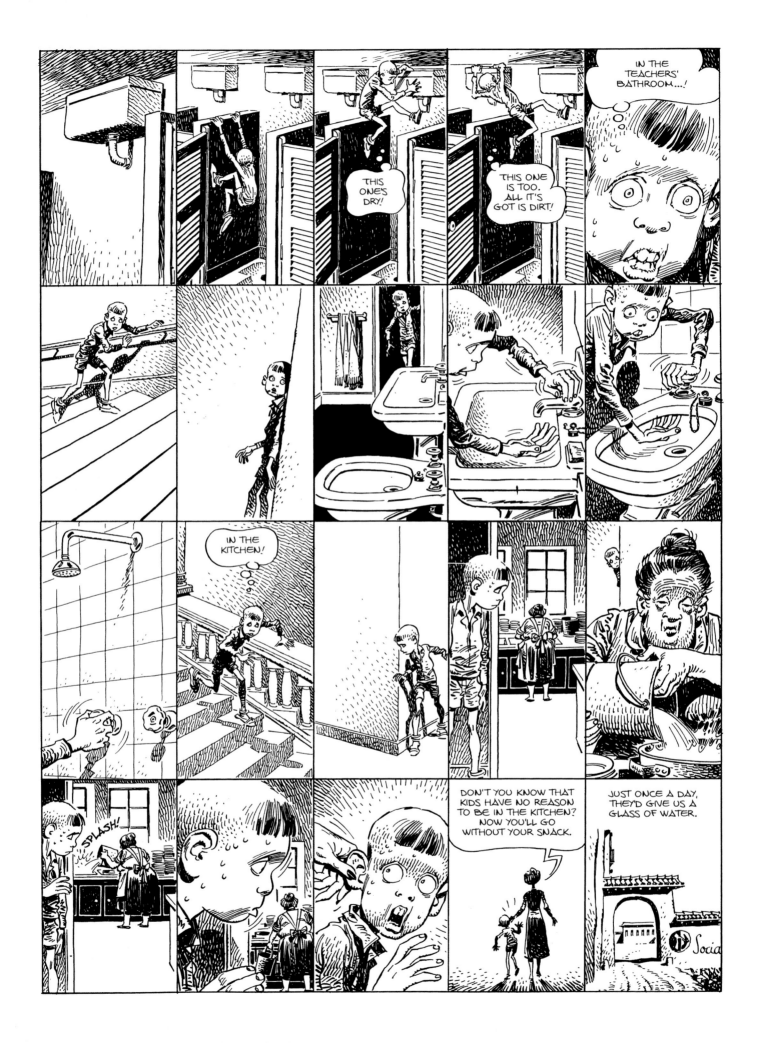

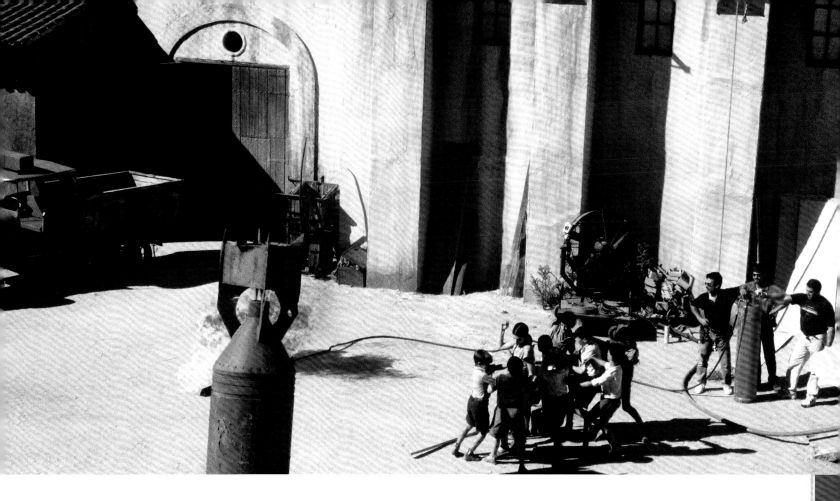

We were children and, therefore, very easy to influence. The prevailing slogan in our education was to become "half monks, half soldiers." These two concepts practically summarized the Fascist philosophy. Religion controls your mind and forces you to march through certain paths of fear and obedience, and being a good soldier makes you able to die or kill when your superiors want you to. I was able to reflect on all this, to discover the deception, and [to] get away from that garbage. That led me to become an atheist and a pacifist.

I also realized something fundamental: Children play even if they are sick, even if bombs are falling from the sky, even if their siblings are dying or they, themselves, are dying. Children play while they cry or even laugh while they cry. Play is an inevitable part of a child's nature, because a child has a concept of life limited to the present, to the now. You talk to a child about tomorrow, and tomorrow is a concept of time that's too far away to be real. Children have to play with each other, because they are social animals and need affection and company. Children love each other and stick together very naturally. We see it clearly when children are young, especially between siblings. If they can't play, children become angry.

Fast-forward a few years to when I first met Guillermo del Toro and worked with him on *The Devil's Backbone* as a storyboard artist. I recall our collaboration with great fondness because of its atypical give-and-take. The worst thing about the movie world is the amount of time you lose waiting for something to happen. You spend most of the time waiting for collaborators to have a moment to attend to you. You spend more time in the waiting room than you do drawing!

But Guillermo is a very generous collaborator. He's also a very good cartoonist. He really does not need anyone to do, for example, a storyboard. In fact, when he told me what he wanted me to draw, he already gave me cartoons that were drawn so well that he didn't really need me. He, as a big comics fan, is happy to have a cartoonist sketch out his ideas, but I really don't think he needed me. It was very different when it came to designing the sets. I enjoyed designing sets for Guillermo's films a lot.

I think *The Devil's Backbone* is a very good movie. It's one of those films that you want to watch again and again. I am happy to have collaborated on this project, to have collaborated with so many interested actors, and above all for having met Guillermo del Toro, a great person and a film director with a lot of talent. It pleases me to be able to speak well of Guillermo, if only to repay him for the times he has spoken well of me.

INTERVIEW BY SIMON ABRAMS

ABOVE Filming the aftermath of the kitchen explosion.

PAGES 88–89 Giménez's storyboards for the scene where Carlos encounters Santi's ghost for the first time.

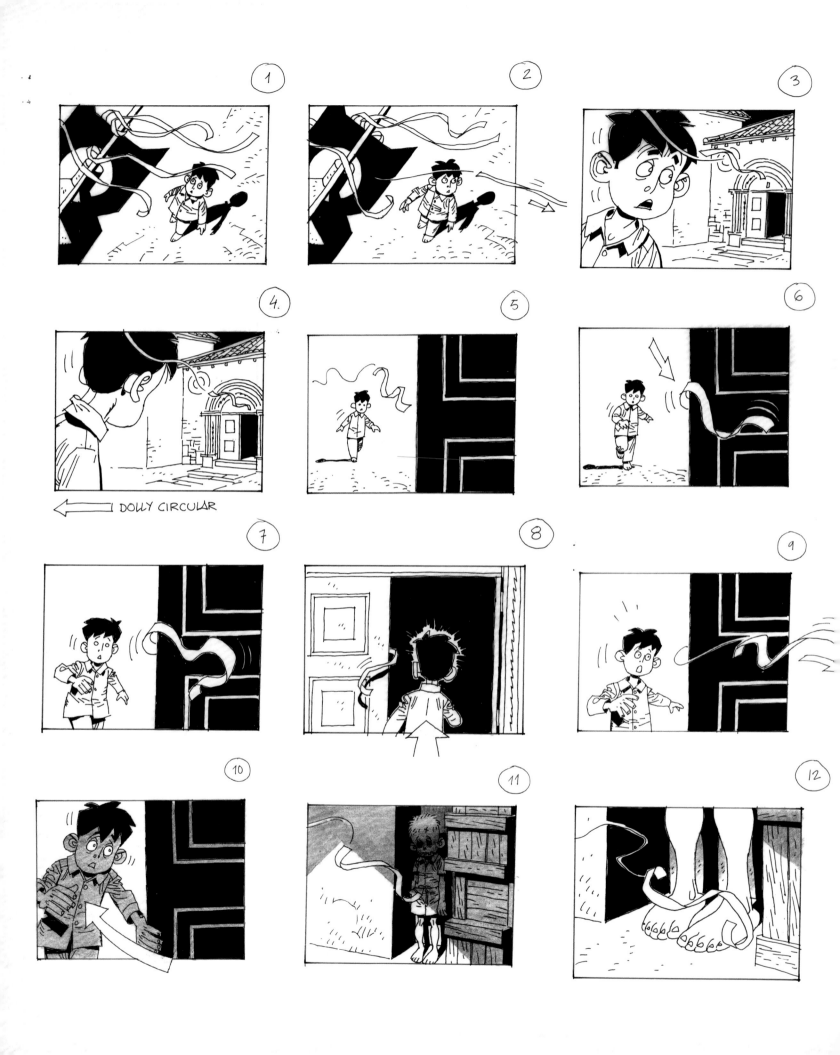

DOLLY CIRCULAR

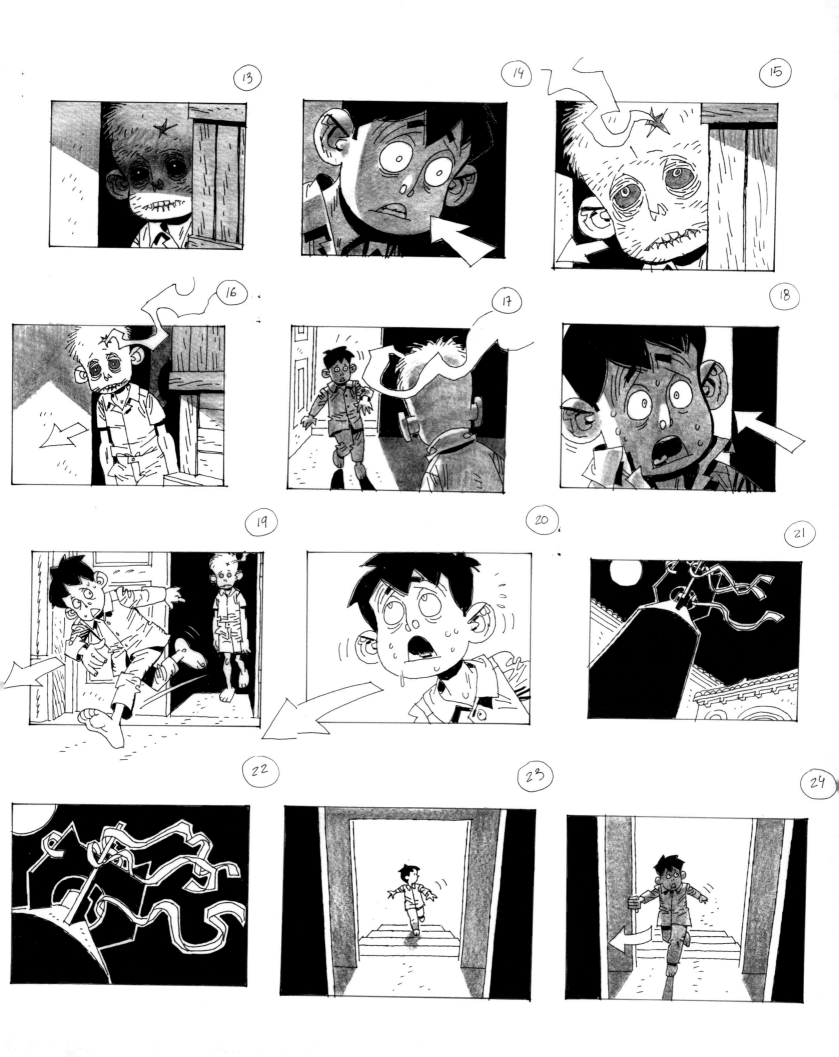

BERTHA NAVARRO

Bertha Navarro, who produced _The Devil's Backbone_, is the sister of Guillermo Navarro and one of the founding members of the Mexico-based production company Tequila Gang, alongside Guillermo del Toro, Alfonso Cuarón, Laura Esquivel, and Rosa Bosch. The Navarros had previously worked with del Toro on _Cronos_, the film that brought del Toro to co-producer Pedro Almodóvar's attention.

BN: When we made _Cronos_, Guillermo was a young guy, in his mid-twenties. He was so funny and creative. I was really seduced! He was very truthful. He earnestly told us what he thought and was so passionate and intelligent about it.

Given the specificity of his vision, working with Guillermo is challenging but also fascinating. As a producer, when you sign someone with talent, it's like winning the lottery. You've won the big prize. I read a lot of scripts, I get a lot of proposals, and they are so flat, so uninteresting. So when you meet someone like Guillermo, a young guy with all this enthusiasm and vision, then you go for it. And he shows you all the details that he has in his head for the project. When you see those details, you become more confident that you will get where you need to get with a project. Guillermo's also capable of changing his mind, or seeing reasons why he should change his mind.

Guillermo had more resources available to him when he made _The Devil's Backbone_ [than on _Cronos_], more opportunities to do things that were complicated, or that took more time. A bigger budget and a larger time frame gives you opportunities to grow. He learned more and more as he made films. For example, he now knows how to shoot on digital and how to use digital images—things like that. On his first films, we didn't use digital imagery much.

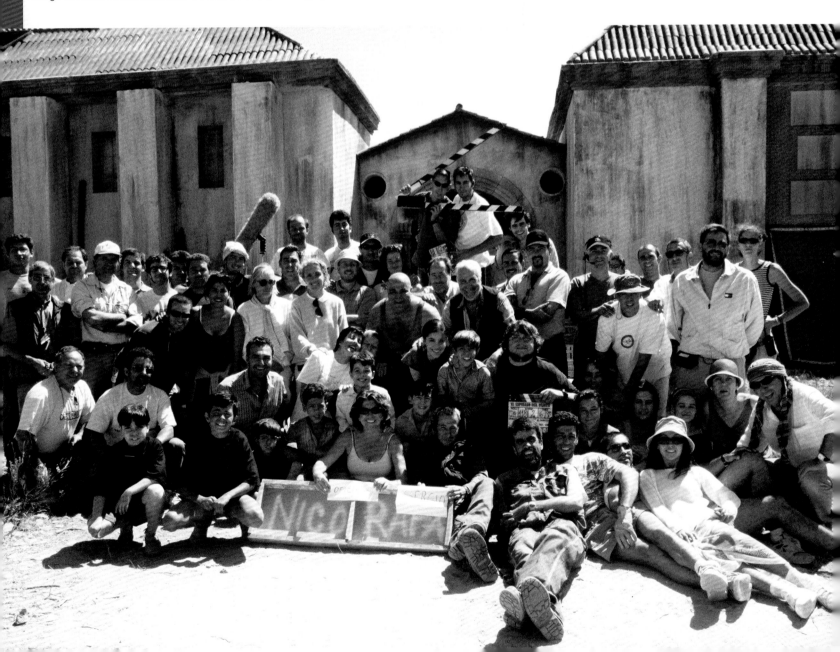

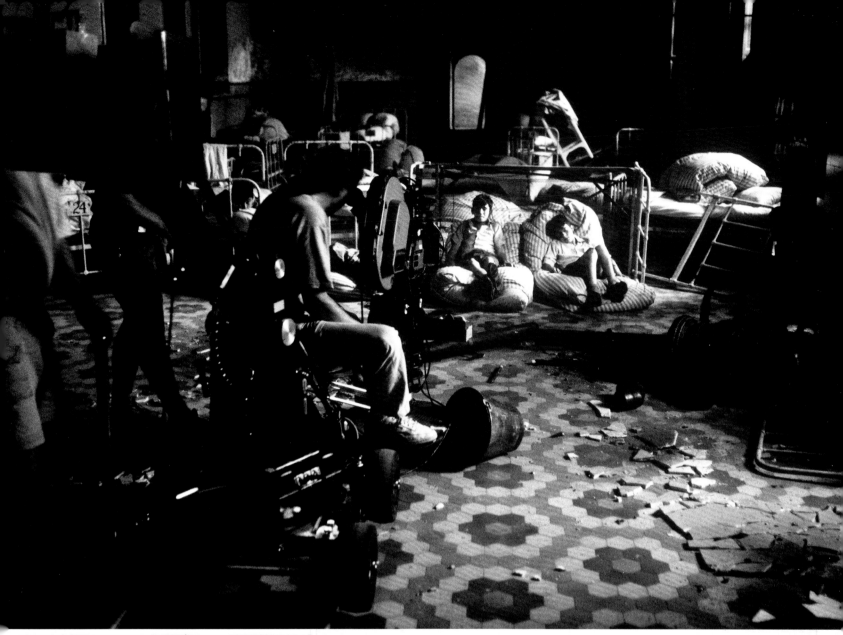

OPPOSITE TOP Del Toro and "the Seven Dwarves."

OPPOSITE BOTTOM The cast and crew pose for a group shot.

TOP Director of photography Guillermo Navarro lines up a shot of Fernando Tielve (Carlos) and Íñigo Garcés (Jaime).

ABOVE Guillermo Navarro and sister Bertha Navarro relax between takes.

Working with a Spanish crew was not difficult, but we did have to prove that we knew what we were doing. Fortunately, we all came with experience. We were very clear on what we wanted and why we wanted it. We weren't imposing, but we did essentially tell them, "We know what we need, and what we want from you."

I was with Guillermo and [casting director] Sara Bilbatua throughout the casting. I discovered the necessity of a good casting director on *The Devil's Backbone*. Many times on other films, we did that kind of work ourselves, because we knew exactly who would be the right actor. But being in Spain, not knowing everybody there, casting was so important since the majority of the cast members were children.

All three of Guillermo's Spanish-language films are narrated or introduced through the children. But *Devil's Backbone* was especially complicated because there were so many children. Spanish children are so open, so natural. Working with them was also difficult [however]. With children, it's not when you want to shoot; it's when you *can* shoot. So we were forced to only work while they were on summer vacation.

I think the hardest part for a producer is to really put the film together, and then let it be. As a producer, you work before everything else happens. On the set, it becomes the job of others to work, like cinematographers and everybody else. I mean, of course you work all the way through the process, but your main work is to put it together and let it happen.

Working with Guillermo was also an opportunity to grow as a producer, to make films that were far more ambitious than what we generally do in Mexico. We grew up together professionally— we took faith in each other. And I am very happy that I did those three films with him.

INTERVIEW BY SIMON ABRAMS

(Continued from page 80)

M: Who ended up funding this movie?

G: My partner, Bertha Navarro, has produced all my Spanish-language films. We have produced many Latin American and Spanish films together since *Cronos*. I went to her and I said, "Let's find Mexican funding to partner with Almodóvar and go fifty-fifty so we can try to keep a real co-production in the balance."

So we went to Alfonso Cuarón and his partner at the time, Jorge Vergara, who was a Mexican billionaire. I believe when I met him, I said, "You are a billionaire, and this movie will make you a millionaire." [*Laughs.*] Jorge was the nephew of a guy who had produced some wrestling movies with El Santo, the Mexican wrestler. I'm crazy for El Santo, so we started talking about that. We bonded, we had a lot of laughs, and he put up about half of the financing.

Then with the Almodóvars and Esther García, their production manager, we went to Europe to look for the rest of the funding.

M: Did the difference in national mind-set express itself during the production itself?

G: Yes. In Mexico—for example, on *Cronos*—we fabricated a lot. The approach we have in Mexico is very artisanal. I think the Mexican crews are probably my favorite crews in the world because there are no impossibilities, and at the end of the day it's about the pride and not the money. You want to get it done. We are kind of like the Japanese, but a lot less efficient! Like, we'll tie on a bandanna and go to work. And I found that the European approach is a lot more regimented than the Mexican approach. You're unionized in Mexico, but if you need something fast, anyone can do it. At least, that's my experience as a Mexican filmmaker. Maybe it's different if you're American.

M: Let's talk about the production design.

G: The production designer was a guy called César Macarrón. He had done a movie called The Miracle of P. Tinto. I thought, *This guy knows how to build, he knows construction, because everything in that movie is fabricated, and that's what I want.* I always think the best production designers were art directors first and are people who can actually build or paint or finish a surface themselves.

I find that I need a person who, ideally, is a draftsman. For me, a great production designer needs to be the one who draws, not somebody [who has another artist draw on their behalf] . . . because then you know when the time comes they can say, "This wall doesn't look good," and grab a sponge, a brush, a set of paints, and re-brush or re-finish it.

César had all those qualities. I met with him, and he was a genius, crazy man, funny. And his name was Macarrón because his family was

THESE PAGES Detailed production design sketches of the exterior of the orphanage.

Scottish and named something like Macarro, but when they emigrated to Spain, they changed it to Macarrón! Like the cookie! Like Don Corleone, it was an emigration change of name.

[César's] grandfather had been involved in the salvaging of [the Spanish national art museum] El Prado's art when the Fascists were bombing Madrid. He showed me images of El Prado where there were all these sandbags, where they had moved the paintings. It was really interesting for me that his grandfather had been involved.

M: How long does it take to design a movie?

G: We normally take six months to design a movie. I take three months alone with a conceptual illustrator, and I figure out everything before we are joined by the production designer and wardrobe designer. I just do sketches with them. And then for three to five months more, I work with the whole team.

On *The Devil's Backbone*, we had a very compressed prep because I had committed to *Blade II*

and I had to start preproduction on it at the end of the year. We went at it, and I think we got the best painter I've ever worked with for sets, Leoncio Vicente, an old-school guy who had done so many movies. We became very good friends because he would teach me how he did the layers of paint to simulate the effects of humidity. He'd blowtorch one layer of paint to put on the next one, and at the end, he did condensation drops of dew on the wall that leave little stains of calcium. Leoncio did the stains with a round little brush. He let me use a sponge a couple of times. I could ask him anything. I could ask him for a 3-D effect on the paint job and he'd do it.

M: That's amazing.

G: We built the entirety of the kitchen, we built the archways in the dormitory, we built one side of the corridor. We built the staircase to the cellar. The whole west wall of the patio was completely fabricated. We built quite a bit.

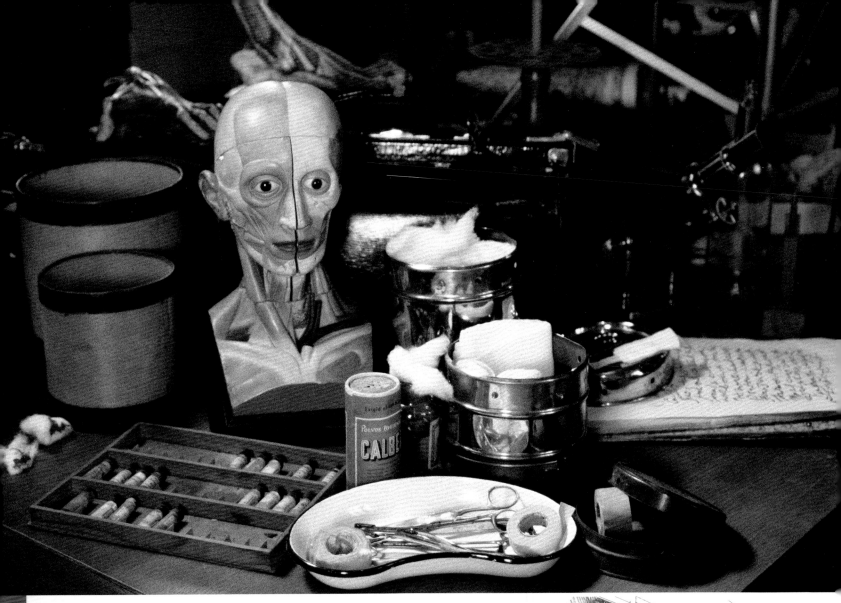

PILAR REVUELTA

Set decorator Pilar Revuelta has a very practical mind-set, a quality her job requires. Her career began in 1998 with *Black Tears*, a romantic drama that she worked on shortly before she started on *The Devil's Backbone*. Revuelta has since collaborated with filmmakers like Jim Jarmusch (*The Limits of Control*), Ridley Scott (*Exodus: Gods and Kings*), and Steven Soderbergh (*Che*). For Revuelta, working on *The Devil's Backbone* was, in many ways, a formative experience.

PR: Guillermo pays very special attention to what he needs from decorators. I do research, but I also get a lot of information just from talking with Guillermo. I also referred to *Paracuellos* . . . which gave me some very clear ideas. From then on, I worked with my crew on finding the specific furniture, and fabric . . . things that we had to make, things we had to order to make bigger things, or things we have just had to rent.

Guillermo gives a lot of importance to details like the phonograph, or the wallpaper, or the fabrics being aged. Normally, when I'm going to put up wallpaper, I look around at wallpapers from that period. I choose elements that are old enough, but then add things to them to make them look older. I'm revising the object's look, in a sense. Sometimes you just make the scenes, you build them, like the pottery for the [orphanage's] dining hall. All that we made to give the room an ambience for the actors and director, to give them the impression that they are in that period.

I got my fabrics from Spain, though some of them [originally] came from England. We were watering them, and washing them, and taking their colors off with chemicals, so they looked much

94

older than they were. In the backyard, we would dye a lot of fabrics and put them out to dry. It was very artisanal.

Creating the right ambience on-set is so important. We shot the film at a former school. It was in the middle of the country. We had a lot of sun, so we gave the location an arid, desert kind of feeling. In order to do that, we made some pieces of the construction look a little older, or more decadent. And in the middle of the courtyard was the bomb reminding us that something brutal happened there, and that the war was still going on.

We shot in different places. The cistern, for example, was shot in an old farm in Talamanca, outside Madrid. Also we shot the barn where Federico Luppi dies in Guadalajara, the same place where we shot the arches and the ladder. The cistern scenes were also shot in Guadalajara. The cistern was like a big vat where you keep water or wine. We lit it like it was an old wine cellar, so you have these arches and this area where the sun can't get in. It was like a catacomb. The place was so impressive, with all this art. But it was very humid and dark and secluded—a very scary place.

I think the main thing about that place is that there were no lights, because it's underground. You're going to the heart of the film's problem since that's where the ghost is. The pool's water is brownish, so you don't really know what's inside. Which is scary because your imagination fills in the gaps.

The orphanage is a place where nobody is an individual, where people resemble objects. Every orphan has the same costume, bedframe, mattress, and radiator. There's not many personal items in that room. It's not like a children's room; it's like an adult hospital bedroom. It's very restricted in terms of decoration. Most of the other locations are really austere, and that also gives the mood of the period when they were living.

For example: There are many sets in the movie that have a look that comes primarily from metal. If you look at most of the sets, there are many places where you can see rusted pipes surrounding the walls and the tiles, especially in the kitchen. We built the kitchen [set] entirely ourselves, so we could do whatever we wanted. We put the pipes outside the walls in order to make nice shadows, making the set more visually interesting.

We were working on the sets at night because they shot during the day. The main thing during shooting is to prepare what's going to be shot the next day and to make the new locations. We worked in an area with no electricity because when we built [the set], the electricians accidentally cut the power after they left. So I remember going with the crew to the set with all these candles, trying to prepare the set for the next day. During the nights, we used to play music and just work there outside. We'd leave the sets [in the morning], they'd shoot, and when we came back at night, we'd have to redo everything!

For me, what is interesting about Guillermo is that there are always so many layers to what you see in his films. And he has all these symbolic kinds of things. For example, in *Pan's Labyrinth* . . . the world of Ofelia is very round and everything is like a labyrinth, like a womb. The most important thing about working with Guillermo is that you see through the image that is there, though it's sometimes hard to see it. If you look, you will see connections, or parallels between one world and another, the real and the unreal, the good and the bad.

INTERVIEW BY SIMON ABRAMS

OPPOSITE TOP Some of the character-defining props in Dr. Casares's study.

OPPOSITE BOTTOM RIGHT Production design sketches taking in the totality of Casares's study.

ABOVE (top to bottom) Del Toro gets caught with his hand in the elixir jar; continuity photos of Casares's study as it appears in the movie.

BELOW AND BELOW RIGHT Deformed fetus props created for the production by DDT.

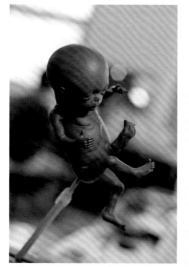

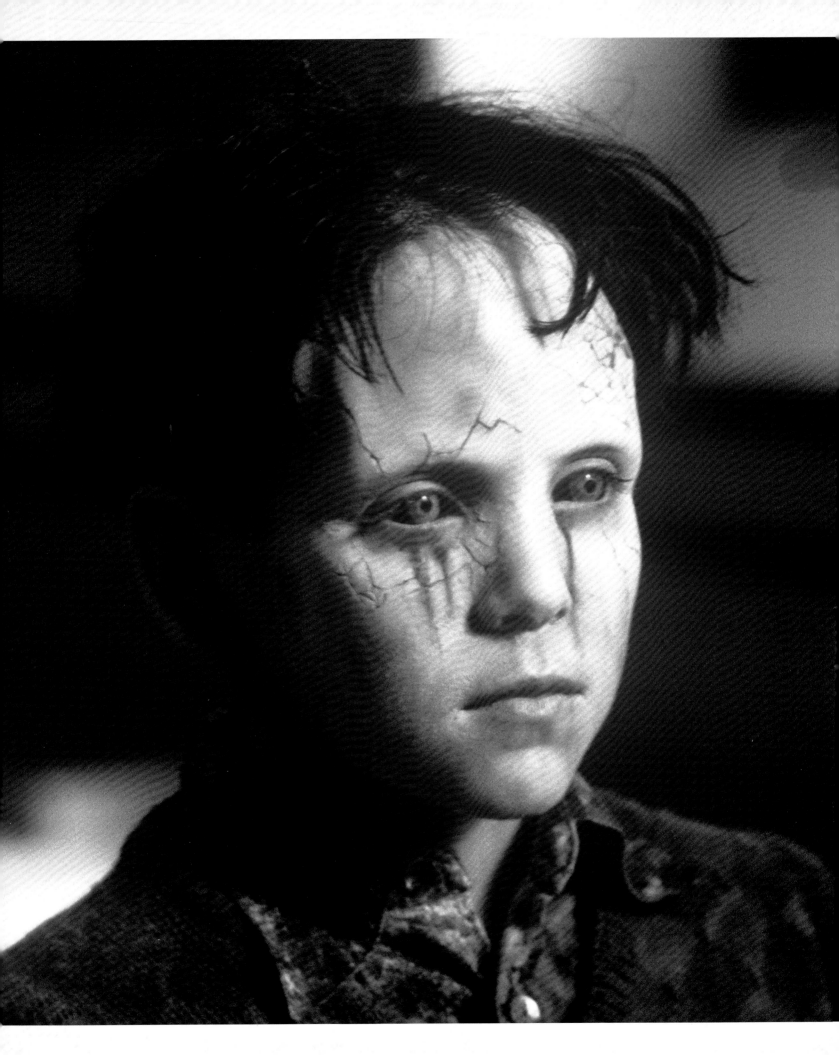

Color

M: You were speaking earlier about how cinematography, production design, and wardrobe are all aspects of the same thing, the aesthetic of the film. Can you talk about that in relation to production design and wardrobe?

G: Yes. The wardrobe designer was a man named José Vico. *The Devil's Backbone* was the only movie we did together. I offered him *Pan's Labyrinth*, but he didn't take it. Still, he did a great job on *The Devil's Backbone* because everything we did was based on period photographs. We really layered the fabric to look very well used.

 If you watch Richard Lester's *Three Musketeers* movies and look at the scenes in Milady's room, for example, with Faye Dunaway, you'll see oyster whites and pastel blues. The whole thing: the wardrobe, the walls, the furniture. And then they introduce a red gesture, for example, like Christopher Lee's uniform, and it's clearly contrasting with that. It's directing the image like a painting. You are illustrating.

M: A lot of people don't realize—even a lot of film buffs—the psychological and emotional effects color and texture have on you. Sometimes you notice when it's very obvious, like a broad strokes thing. The icy, technocratic billionaire's office has white walls and the light is very blue and you're like, *OK, that world is cold.*

G: Steel and glass.

M: Yeah, because the character is associated with cold, impersonal qualities. But then you see the

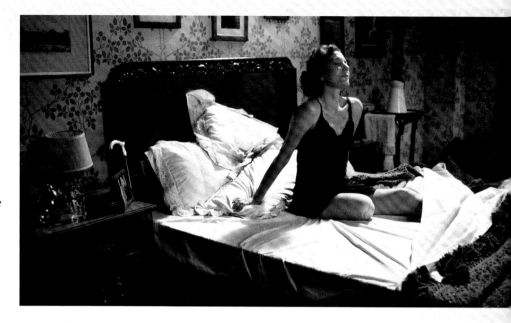

hero or heroine in their apartment and it looks all gold and brown, more organic, and there are flowers and stuff. But that's only the first level of production design, the surface level.

G: I'll tell you, one of the hardest things to do is to use a red character, which I've done a few times, including Hellboy! Red eats *everything*. Red eats every color around it. And then red needs to be exactly red.

 When people see *Hellboy* and think, *Oh, he's just painted red!*, there are at least twenty shades of red in that! It's incredibly detailed because we need to do the shading, the liver spots. A face is not pink! There's green on it, there's blue on it, there's yellow on it, there's red. But when you see, for example, a portrait by Lucian Freud, there's always an under-base of green, and he coats the sinew and the fat and the dimples in a way that makes

OPPOSITE Junio Valverde in full makeup as Santi; note the gradations in his ashy complexion, including the yellowish bruising around the cracks in his face, as well as the way that his brown-patterned clothing sets off his face more starkly.

ABOVE Carmen's ecstatic demeanor in the bed she shares with Jacinto is emphasized by the light-colored sheets and pillowcases, which create a subtle "spotlight" effect in the bedroom.

BELOW Ron Perlman's title character in *Hellboy* (2004) is nicknamed "Red," but there are many gradations of the color in his complexion; notice how the light falling on the left and right sides of his face reads as, respectively, yellow and pink.

the vigorous brushstrokes very apparent. But on a painting of a creature, the layering—if you do a good creature—is incredibly difficult! And the most difficult one is red, because red eats red eats red eats red. Like, if you use yellow in a painting and you put in red, it's going to disappear.

M: So how do you solve the problem?

G: You need to use exactly the shade of red, and find a cool color that contains it. Like, there's a [filter] called steel blue. It's a gel that I started to use on *Mimic* because of the paint job on the insects. We started using it in there and we discovered that it still looked greenish-blue, a very strong cyan, but it contained enough warmth that the red didn't react badly to it. So we needed to use that on the night shots in *Hellboy* and then have a very, very soft, neutral light following him a little. Otherwise, you have a chocolate bar with an overcoat. And if you go warm, he becomes orange. So you need to find the exact filter for your light, you know?

It's the same with the Jaegers in *Pacific Rim*. Gipsy Danger was originally going to be oyster white, because I thought it would be very striking to see that. But we put the model in a simulation at sunset, and it looked terrible, because white is voracious, too. White also eats all the details, because it's all highlight, even if you do off-white. So there's a lot of work that is entirely invisible if you don't discuss it.

M: Can you give me an example of an invisible choice that affected the entire production of *The Devil's Backbone*?

G: Navarro came up with something brilliant. He had a set of what are called "dinkies," which are little lights that are almost like little pools of light. He painstakingly arranged the dinkies around the set to make little dots of light on the faces [of the actors], on the wardrobe, on the props. It looked like the lighting you'd see under a proscenium in a theatrical play.

My favorite shot in the movie is the shot where they are eating the first night—Jacinto, his two friends from earlier in the film, and Conchita—and there's a window on the left and a warm light hitting the table. What seems like a single light on that table is many little lights hitting each character differently. It's an effect that is invisible but makes it much more painterly.

RIGHT Jacinto plots with his associates in an image framed and lit in a way that suggests we're in the front row of a theatrical production.

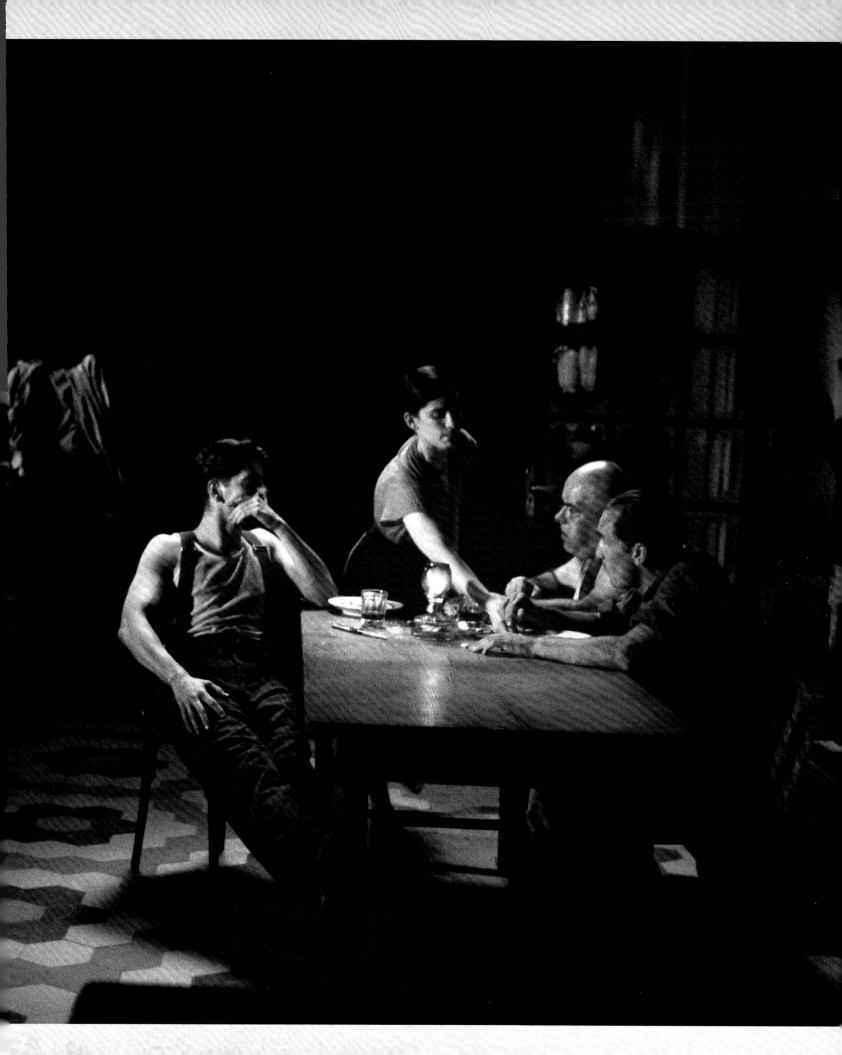

part two

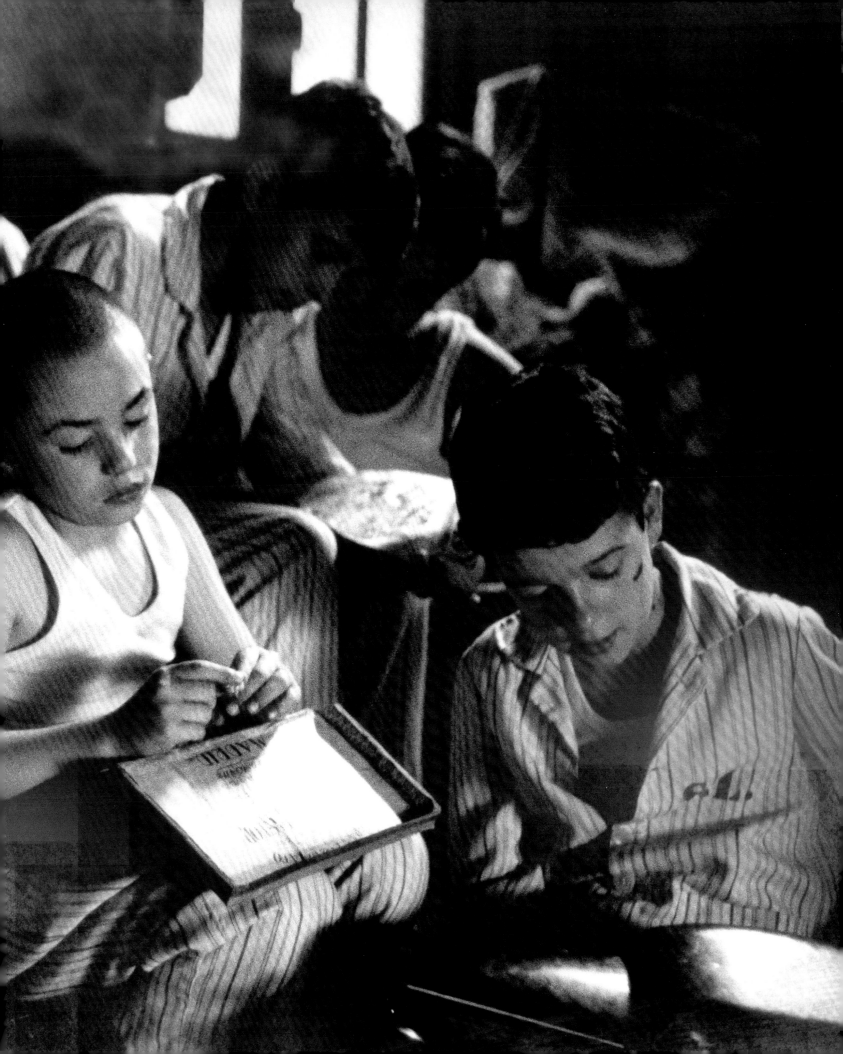

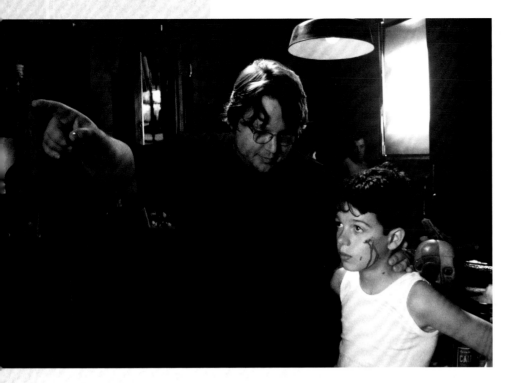

The Seven Dwarves

M: Let's talk about working with actors. Start with the film's star, Fernando Tielve as Carlos.

G: Fernando came in to read for the extras and I saw his eyes. The children I cast in my movies, I cast the eyes. If they can look at things and look like they are thinking, you know? Carlos had these big Paul McCartney eyes, and an air of sadness and dignity. He came in to read as an extra and I gave him the main character. He was so happy!

And then the other boy, Íñigo [who plays Jaime], I had seen in a movie called *Secrets of the Heart*, by a Spanish filmmaker named Montxo Armendáriz, and I thought he had this gaunt, scruffy, two-fisted, scrappy, survivalist quality to him. He was ungodly tall, and he moved with the clumsiness of a kid between puberty and childhood. He had those proportions, and I thought, *He looks like the leader of the pack*, so I cast him.

M: How do you direct these kids?

G: What I do with the kids is, in preproduction I create a bio for the character, and I give it to them. I also gave bios to Marisa and all the adult actors: "Here's your bio from birth to the end of your most recent birthday."

Well, I gave Íñigo the biography for Jaime, and I asked, "What do you have in common with this character?" That's the first homework we do with the actors: "What do you like and identify with in him?"

And then I said to him, "You don't have to

tell me what it is, but think about your saddest memory. What you are saddest about in your life." And then when we are shooting a scene where the character is sad, he goes there.

There's a great moment when Jaime has a cigar ring, and he looks at it. He looks at Jacinto and [he is specifically drawing on such a] memory.

When Carlos, at the end, cries with Casares, I did a fucking [Italian neorealist filmmaker] Vittorio De Sica maneuver there because he couldn't cry! I said to him, very purposely, "You know what? You made me believe you were an actor and you're not. I think we're gonna wrap!" He started crying, and I go, "Roll!"

M: That makes me think of Spielberg. He saved the final scene of *E.T.* to be the final scene they shot. Before they did the scene, he told the kids, "Listen, this is the last time you're ever gonna see *E.T.* I'm gonna stick him in a warehouse and he's never gonna see the light of day." So all those tears were real!

G: [*Laughs.*] The other method, which is not something I should be very proud of, but when the kid says, "I saw a ghost" and his lips are trembling, we put a pack of ice on the back of his pants with a belt, because I wanted him to be fresh out of the water and the water was supposed to be cold!

M: [*Laughs.*] That's great. Directing children is not substantially different from directing animals, I guess.

G: Well, most of the time it is. The thing I do is, mainly, I address the child like I'd address an adult actor. I explain to them what I need and why I need it.

But then there are times when you find extraordinary instances of child actors not needing that. Like the girl in *Pan's Labyrinth* [Ivana Baquero]. We did some breathing tricks where she'd hyperventilate before the take so she would be a little dizzy. But for the most part you could tell her, "This is what I need," and she would do it. She's a phenomenal actor. I didn't need to pull any tricks.

(Continued on page 110)

TOP LEFT Del Toro directs Fernando Tielve.
OPPOSITE Jaime (Íñigo Garcés) enjoys a smoke.

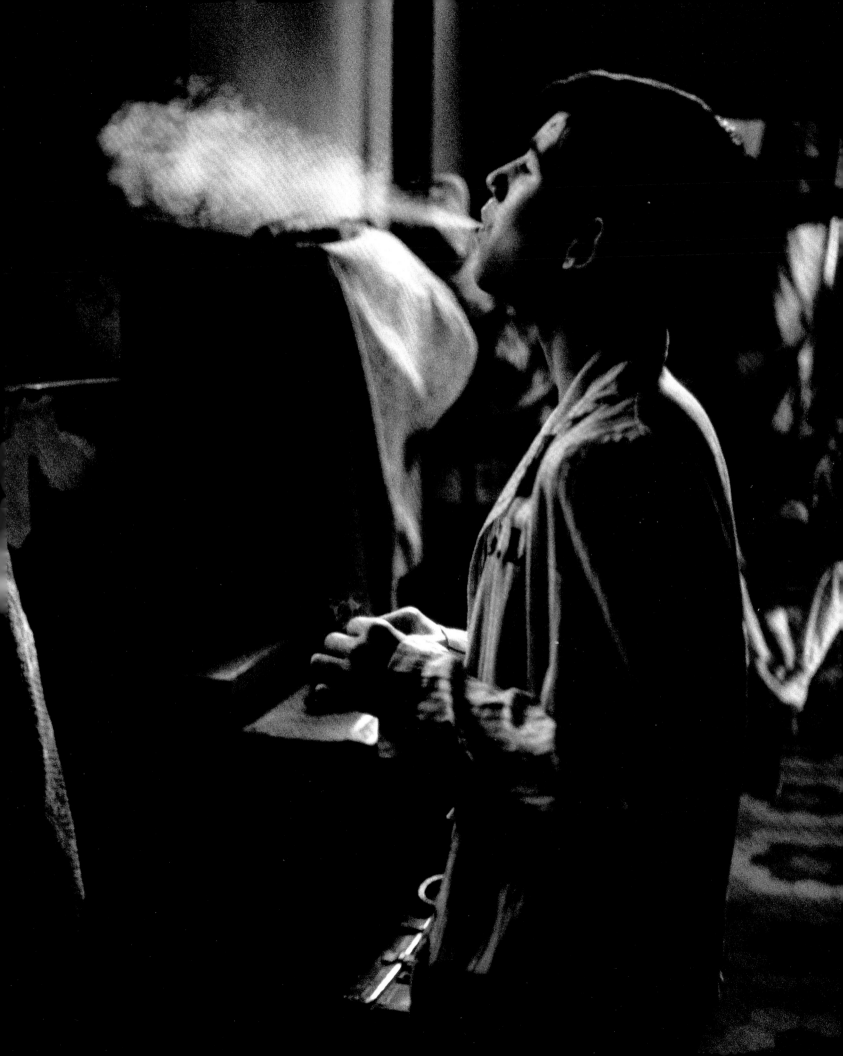

JAIME

JAIME ROLDÁN MORENO **BLACK HAIR**
19 YEARS OLD **SLENDER**
4' 9"

What he likes: Verdant countryside, the ocean (he has seen it twice), stowing food under his mattress, reading comic books, drawing (he does it really well but doesn't show his work to anyone), exotic animals, and pirate adventures.

What he doesn't like: When Jacinto reprimands him, thinking about his parents, knowing he is an orphan, the "new" children in the orphanage, working under the sun.

BIOGRAPHY by GUILLERMO "Corin Tellado" del Toro

Jaime's surnames were given to him by Mr. Casares, the teacher, and Carmen, the orphanage's principal. Jaime does not remember his parents, but he thinks about them frequently. He was abandoned at the door of the orphanage when he was only 2. He was found in the early morning with a note pinned to his chest. No one heard the sound of an engine and whoever brought the boy there didn't even bother to knock on the door. Jaime was a bit dehydrated; his cheeks were streaked with tears.

The older children receive Jaime harshly. He grows up a sullen, strange little animal, resenting everyone and everything. He is not particularly brilliant at anything, and keeps his drawing, his only talent, a secret. He copies cartoons from his comic books, and his pictures almost always depict families of wild animals: father, mother, and son.

If another child inquires about his parents, Jaime immediately picks a fight, regardless of whether the other child is stronger or bigger. Jaime will fight until he is exhausted and bleeding.

Jacinto, one of the older boys who is in charge of the dormitory, "adopts" him as his servant. In exchange, he offers him protection and the chance to help him supervise the others. Jaime uses this small measure of power to exert control over those children who are younger than he is.

Inevitably, Jaime grows up and becomes the oldest. Jacinto moves out of the main dormitory and, for a few years, Jaime reigns supreme over the other children. His ferocity and absolute control are challenged with the arrival of Santiago, a short but very clever boy. Jaime tries to intimidate Santi, but he cleverly rebukes him using only words and wit. Jaime finds himself frequently trapped in a dead-end street where Santi has outmaneuvered him without dealing a single blow. They become inseparable friends. Jaime dares show him his drawings. Santi praises his talent, and they make a deal: In the future, Jaime will illustrate the stories that Santi will write, and together they will create great comic books and become famous.

Conchita, a girl, arrives in the orphanage. Jaime immediately falls in love with her. The age difference doesn't matter to him; he believes they will marry one day. He draws her image constantly but never to his satisfaction.

The Civil War ends.

Jacinto returns to the orphanage, but this time he is the doorkeeper. Jaime tries to stay away from him, but is once again "adopted" by Jacinto. Jacinto empathizes with Jaime. He sees himself in the boy.

One terrible night—the night of the bombing—Santi and Jaime go out to collect slugs by the basement water pit. Jacinto murders Santi. Stunned and frightened, Jaime keeps silent about the crime for years. The other children whisper, some of them even think that it is he who killed Santi.

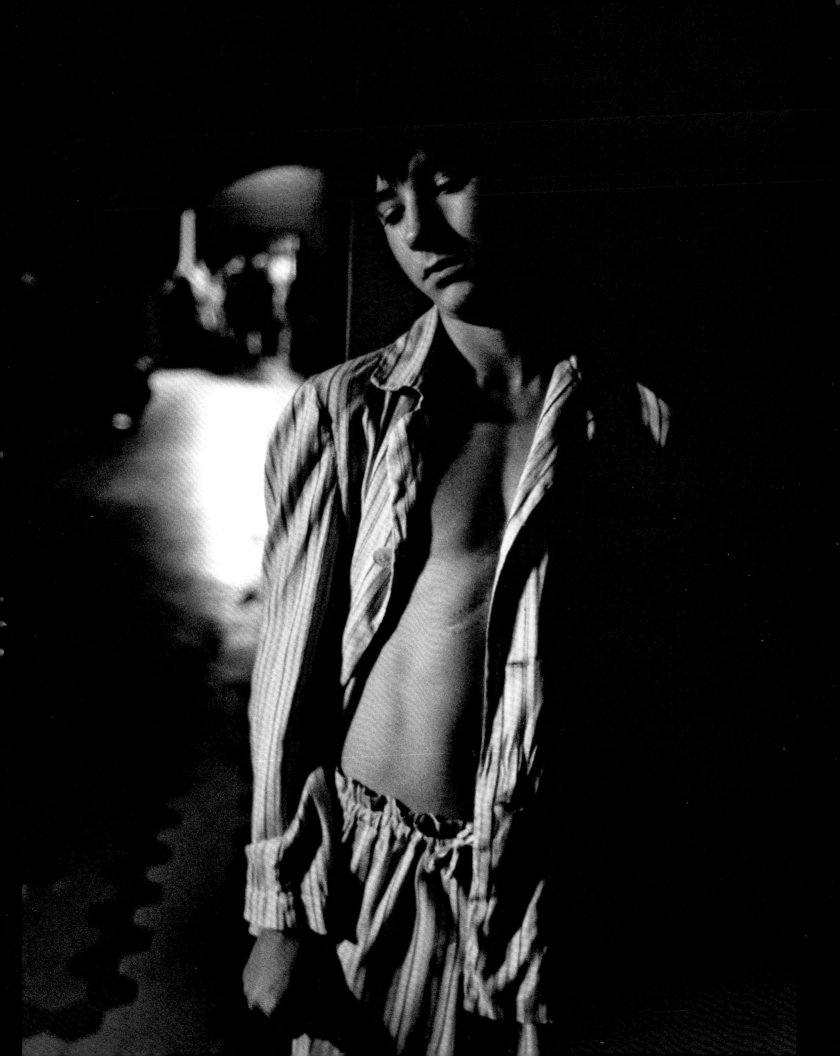

FERNANDO TIELVE

Actor Fernando Tielve was thirteen years old when he starred in *The Devil's Backbone*. He had previously starred in some commercials, including ads for Yoplait yogurt and classical music CD compilations. *The Devil's Backbone* jump-started his career and led to roles in films including del Toro's Spanish Civil War follow-up *Pan's Labyrinth*.

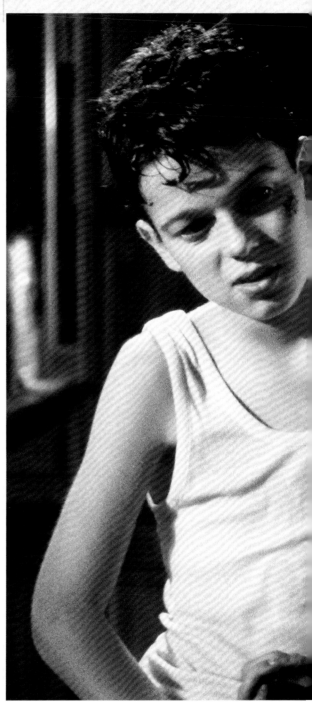

FT: Usually, when you go to an audition, they never tell you [if you got the part] in that moment, because it's not just the decision of the director, it's the decision of the producer, and of many people when you go to an audition. I didn't have to wait for a call. He told me there that he was sure. When Guillermo [decides] something, he is completely sure. He didn't even need to ask anyone else. I was completely shocked.

I remember they sent me the script via messenger since the Internet was not that common at the time. I remember the smell of the script and trying to imagine my role.

I had read as Jaime, but Guillermo told me that he wanted me to play Carlos, which for me was even better. He is the purest character in *The Devil's Backbone*, the one [who] gets to see everything that happens in the orphanage. I think I imagined my character, and all the images like you might imagine when you read a book. I was there in that script, trying to imagine what it would be like.

I didn't understand all of the metaphorical stuff or a lot of poetical things. I understand more things with the passing of time . . . what the bomb means, what the ghost means, and what many other things mean. I didn't understand everything in that moment. But I'm sure that this was great for the innocence of Carlos. As an actor, it was not important for Carlos to know everything, because his eyes see everything for the first time.

Guillermo likes to use the Meisner acting technique, so I remember in the rehearsals, he wanted us to have like, an agenda, ideas on what the characters were like, but very basic stuff: "He likes salad," "He doesn't like pork," stuff like that. And then I remember he would ask you to watch yourself in the mirror at home doing different gestures. It's the Meisner way—more from the outside, not from the inside.

During the shooting, Guillermo was very close to me. He's very precise, and I remember he would tell me where he wanted me to look at every precise moment: up, down, look there, and when you say that word, cross yourself. It was like choreography.

Shooting went very fast. At one point, I was about to faint because I had to breathe so quickly that I felt like I was dead. He yelled "Action!" right then because he wanted to retain that emotion. Guillermo liked to shoot at that precise moment when it happened. The direction was different [from what I've experienced on] other movies, but for me, Guillermo's specificity was very helpful. He was like my dad, in a cinematic way. He showed me what the film world was.

Shooting took two and a half to three months, in the middle of the summer. I started right after I finished school. I shot every single day; I didn't have any days off. This was good, because as an actor, you don't have time for anything other than a movie, so you can't think about anything else. I'd get home completely exhausted. I'd fall asleep, and when I woke up, I didn't have time to take a shower, or clean my nails . . . because they put dirt in my nails every day. [I looked so disheveled that when I arrived on set] they asked me, "You've already been to the makeup department?"

I was in a bubble. And I was Carlos for those two and a half months. I don't remember having a private life or meeting with friends. The shooting was twelve hours per day, a normal shooting time. There was a lot of makeup, so that also took time. Not as much makeup as Santi, who took something like three hours of makeup before he was ready.

You know what the Boy Scouts go through during summer camp? It was like that. I remember we had a big room that the producer made for the children, including the extras. So we had a big room where thirty children were dressed like Civil War children, and Guillermo bought two PlayStations [for it]. I *never* had time to play. Whenever I started to play, they'd call me.

The actor who played Santi, Junio Valverde, was always in makeup. He couldn't even move when he would come to set because he had so many things on him. Latex and lenses, just a lot of things. He had a lot of patience.

The scenes where I went to talk to Santi are, for me, the best scenes we shot. We shot at night, and for me it was very thrilling to be awake at 3 a.m., 4 a.m.!

The scene where Ayala, my tutor, abandons Carlos was very physical. Guillermo talked to me and asked me to think of something that would make me sad. I imagined what would happen if my real mom left me in a place at night. The scene itself was already very dramatic. I mean, I was running, following a car, so that helped me a lot. But for me, acting is not about thinking about so many things; it's about being there and feeling it. If I can feel it only within the scene, that's amazing.

Another hard scene: the killing of Jacinto. . . . We were filming at the very end of the shoot, and it was an exhausting day. We had already shot many scenes that day, and that specific scene we shot at the very end. Sometimes, I think being tired gets you in touch with your emotions better. During that scene, I just wanted to go home and sleep. I just wanted to end it that day, but Guillermo is a very hard-working director. I prayed for everything to go well on the first take.

I was very innocent during that part of my life. I love the scene where Carlos and Jaime peep on Conchita and Jacinto. I felt very dopey doing that, spying on them. I don't remember that we had much direction in that scene. Íñigo [Garcés, who played Jaime] was more mature in that moment. But for me it was very exciting, like, "Oh my God! We are spying on adult actors!"

When the movie finished, it was quite sad because I wanted to keep going forever. I thought I would be in contact with all of my colleagues forever. But of course, everyone has their own lives, so that didn't happen. But it felt so much like a family that I would still like to be filming the movie. I feel like the movie has only gotten bigger and bigger since we filmed it. That doesn't always happen when you work on a movie, so it's an amazing feeling. A lot of people watched the film around the world. I realized that as the years passed. It was a very, very good experience. I feel very proud.

INTERVIEW BY SIMON ABRAMS

ABOVE Carlos (Fernando Tielve) grosses himself out by gawking at Casares's collection of embalmed fetuses.

CARLOS

CARLOS CARDOSO MOLINA **BLACK HAIR**
11 YEARS OLD **SLENDER**
4' 6"

What he likes: Comic books, insects, having friends, helping the older boys with their chores, the strawberry pies that his mother bakes for him.

What he doesn't like: Milk, octopus, garlic, the smell of tobacco, bathing in front of other children, violence, older boys taking advantage of him, cooked carrots, watercress, being lonely.

BIOGRAPHY by GUILLERMO "Corín Tellado" del Toro

Carlos is the fruit of a literary soirée at the Gijón café.

His father, Alfonso Cardoso, born in Bilbao but established in Madrid since he turned 15, meets Josefina Molina at the small coffee shop on the Paseo de la Castellana. He is a young writer and student of literature. They talk until dawn. Carlos Molina, Josefina's father and the owner of several bakeries, forbids his daughter to see that useless young man again. This prohibition is enough for their love to strengthen.

Alfonso and Josefina are youngsters living at a time when hope is in the air. She believes in socially relevant poetry; he believes in her. Together, they edit a magazine dedicated to trade union struggles.

While they are marching in Oviedo to protest the import of British coal and the labor conditions in local mines, Josefina falters, feeling dizzy and unwell.

Nine months later, and after nine hours of labor, Carlos is born. His mother falls gravely ill but survives. Alfonso doesn't know what to do with the child. The world itself, and everyone else's children in it, seem to be more important to him than merely his own son. He becomes even more radical in his beliefs. Josefina returns to Madrid and moves into her parents' house. Carlos's grandfather adores him.

When he is nine years old, Carlos and his mother travel together by train to Seville. The train comes to a stop just as it is crossing a bridge. They hear a sound in the far distance that resembles fireworks. It is a machine gun, his mother explains. Moments later, the bridge collapses in a rainfall of stones and brownish dust. Carlos loses consciousness.

When he wakes up, his father, Alfonso, is by his side. But he is like a stranger to Carlos as the boy has only seen him in photographs. Alfonso explains to Carlos that his mother is very sick, and that he will stay by his side. Carlos falls asleep again, and when he next wakes up, he finds himself alone.

Carlos' mother dies and is buried while he's in hospital. The boy only learns this a few days later and is furious and deeply saddened because he wasn't present for the service. From that time onward he will have a recurring nightmare in which his mother leaves on a train while Carlos runs desperately after it but never manages to reach her.

Without Carlos's knowledge, his father has tried on numerous occasions to establish contact with him, but the boy's grandfather keeps him away. Carlos's grandparents are getting ready to leave for the United States when Alfonso is granted custody of his child. The boy clings to his father and a spontaneous and incredibly strong link is formed between them. Alfonso travels frequently with two comrades: Ezequiel Ayala and Dolores Ruiz. They take care of Carlos when his father dies at the front.

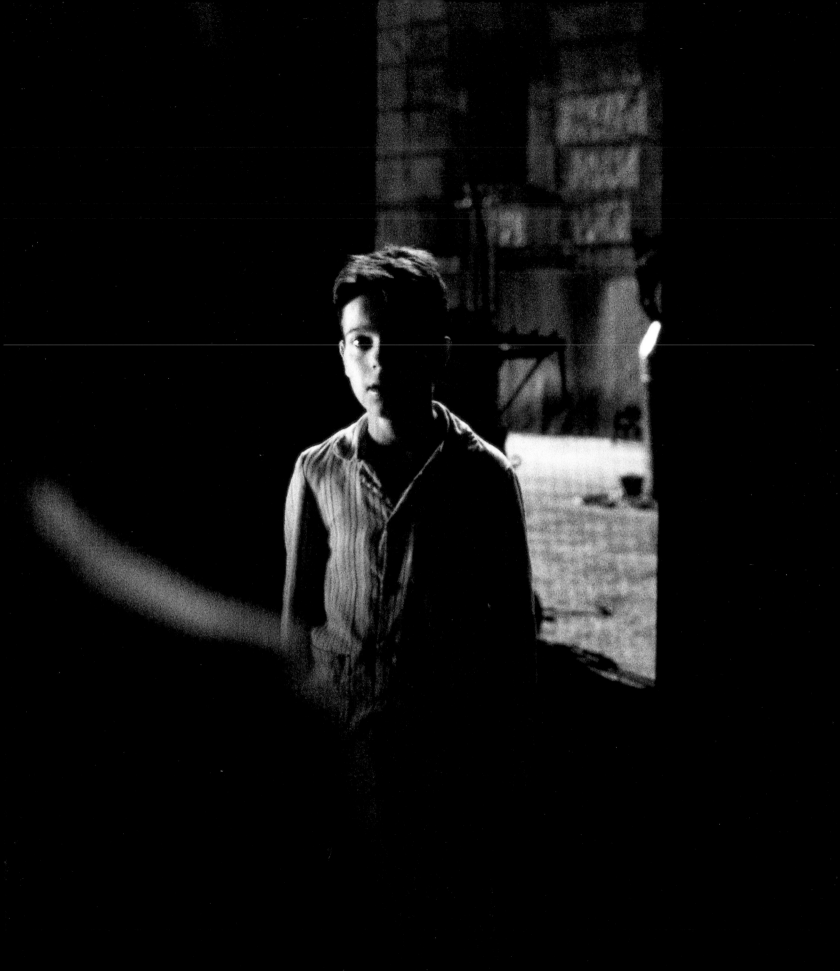

(Continued on page 102)

M: How did you do scenes at the end of the film, where child actors are around a pool or floating underwater? That seems like it must have been hard on everybody.

G: We couldn't build a tank. So what we did is we found a place where the Madrid fire department trains people to rescue somebody by sinking cars with people in them. So they know what to do if a car goes into a river. This pool was about twenty feet deep. It was enormous. And we said, "We've got to tint it amber." So we put in a little tint and a little milk to make the water denser. Navarro gets his grips to sink a gigantic silver bounce into the water—a big bounce card, basically, to soften light and make it hit the subject indirectly. It was gigantic, like, a huge aluminum frame window. Except it was silver.

We sink it on a Saturday. It takes all day to sink it. We go away and leave it there.

Now, under perfect conditions, when we shoot the scene, that light is going to come in on a diagonal angle, hit the silver, and light everything beautifully. Well, we came in on a Monday after the bounce had been submerged two days. The silver had completely disintegrated. The silver was now *in the water*. And our visibility shrank to three feet.

So now we're shooting with three feet of visibility with [Junio Valverde] and an actor with weights to help the child actor reach the bottom of the pool without struggling. And it's the most stressful day of my life! It was an impossible task.

To direct underwater, it means you have to tell the actors everything that is going to happen [before they get in] the water. Then they jump in

BELOW Carlos Giménez storyboards detailing the drowning of Santi by Jacinto.

OPPOSITE Behind the scenes during the shooting of the cistern scenes.

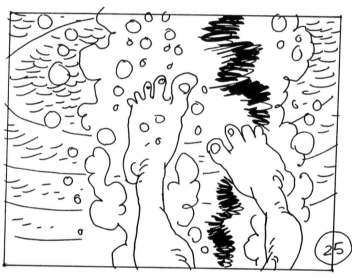

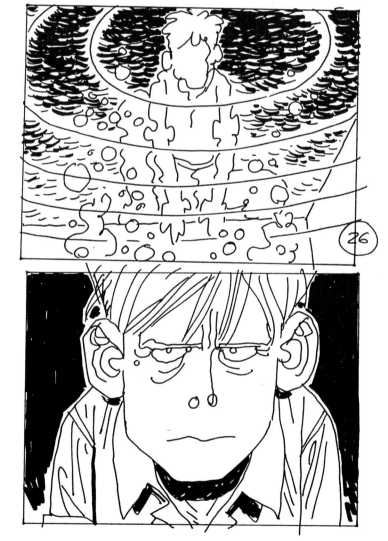

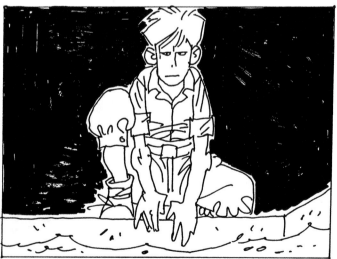

EL RUIDO de la GUERRA. LA FIGURA SE ILUMINA INTERMITENTEMENTE POR LOS FO-GONAZOS de las BOMBAS AL EXPLOTAR.

EXPLOSIONES, SIRENAS... LUCES DANTES-CAS ILUMINAN A INTERVALOS LA CARA DEL MUCHACHO...

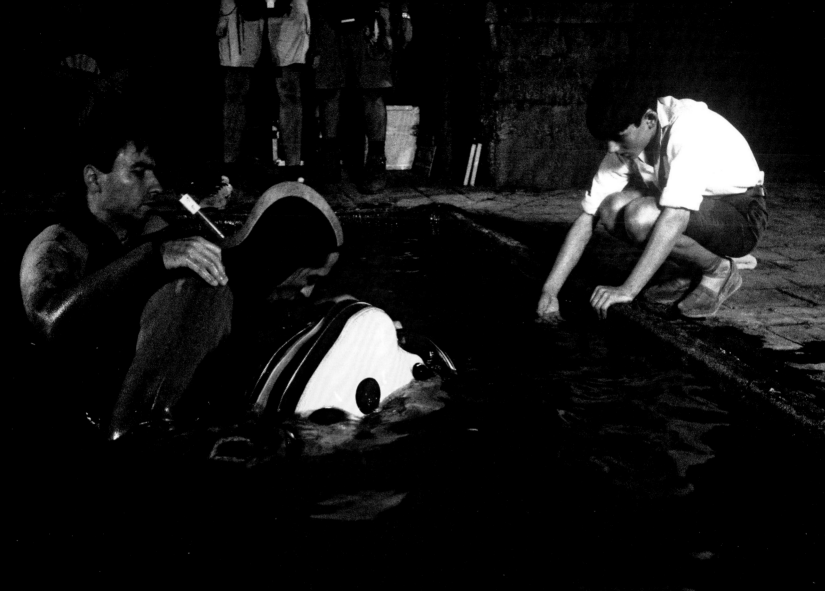

the water, and you have a second operator with an earphone in their ear under the water.

The rescue guys are there with the oxygen. And then Junio, who's underwater, with the diver giving him oxygen, he has only three feet visibility, meaning he has to come out of the haze of the water and embrace [actor Eduardo] Noriega at the right angle with the lens [but] the guy operating the camera cannot see the kid.

So to get that shot in those circumstances was incredibly difficult, and yet it's the perfect color of the water for the movie!

But what I'm trying to say is: If all your decisions get to the point where they're not working, you should pull the plug. You say, "We gotta come back. I can't do this." But if you see the action and say, "Look, the water actually looks amazing," you press on.

We had to [sink] the dummy [of Santi] with the blood coming out of his head on the same day. The shot you see in the movie is take one of us sinking the dummy, because when it went by the lens, a

couple of bubbles escaped his mouth. I saw that on the monitor and I said, "Print!"

M: What about the little boy who plays Santi, Junio Valverde? That's a very difficult part.

G: What happened was, I thought that Junio, who has since become a director of horror movies—

M: Gee, I wonder why.

G: [*Laughs.*] He was a really good kid, and we thought his face was very cherubic, angelic. He looked like the porcelain crack would be perfectly suited to his face. The special effects guys and I argued through email, back and forth, about his face. We argued about every crack on his face. I would say, "Take this one out, add one here."

I thought a long time about how this ghost should look. I decided to make him black in the foreground, in the doorway, and then as he hits the ray of light, we see his bones. We don't see his

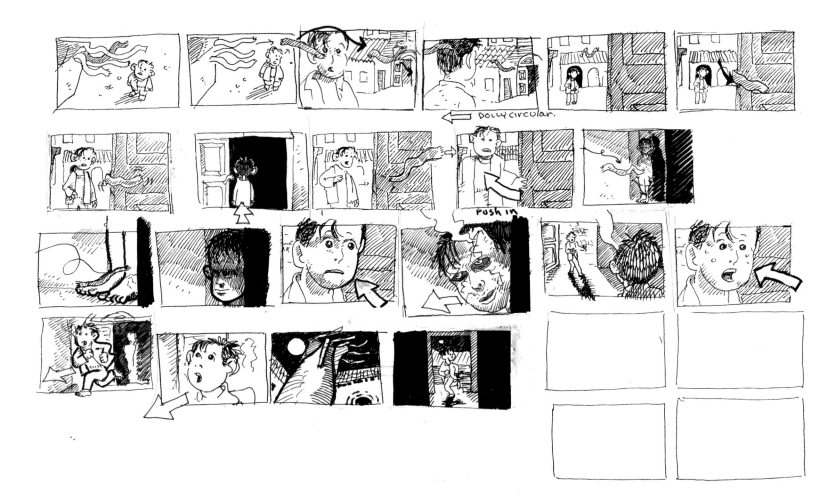

bones all the time, but we see them when he's in the light. He was originally supposed to be translucent the whole time, but I thought it was more interesting if he's solid in the beginning, and then when he hits the moonlight, he looks like a skeleton inside.

But then the day before we do our first shots of Junio as Santi, I think, *How the fuck does a ghost move?* It's one thing to say "This is a ghost," but then the next day you have a kid—and it's [just] a kid! The first thing the camera's going to see, if you're not skillful, is a kid *pretending* to be a ghost. That happens in a lot in horror movies where you go, "That's a kid pretending to be a ghost, or an actor disguised as a ghost."

So what do I do? I thought. *Do I photograph him in reverse? Do I suspend him from wires?*

I finally concluded that I should treat him like a curious boy. So he's trying to sneak a look—Carlos is looking at him, and he's trying to look at Carlos. I thought, the more we make him behave normally, the scarier it is.

So I told Junio, "Just move like that, like a

curious boy who wants to talk to someone." And that's the way Junio moves.

M: How are the interactions between a director and a child actor different than they'd be with an adult actor? I mean, there's the obvious factor of professional training, but on a human level, what is it like?

G: I know it's a cliché, but it's true: It takes a child a lot less to role-play than an adult. You tell a kid, "OK, you're the Indians and we're the cowboys," and instantly they're Indians and cowboys. I'm Superman and you're Iron Man. You fall into it really quick. So there is that shortcut that is real. And then the difficult thing is to try to direct [an experienced] child actor. Like, if you hire a kid who has been in fifty junk food commercials, you're fucked because then they're trying to be cute or their parents run lines with them the night before.

M: And they have all the inflections locked down.

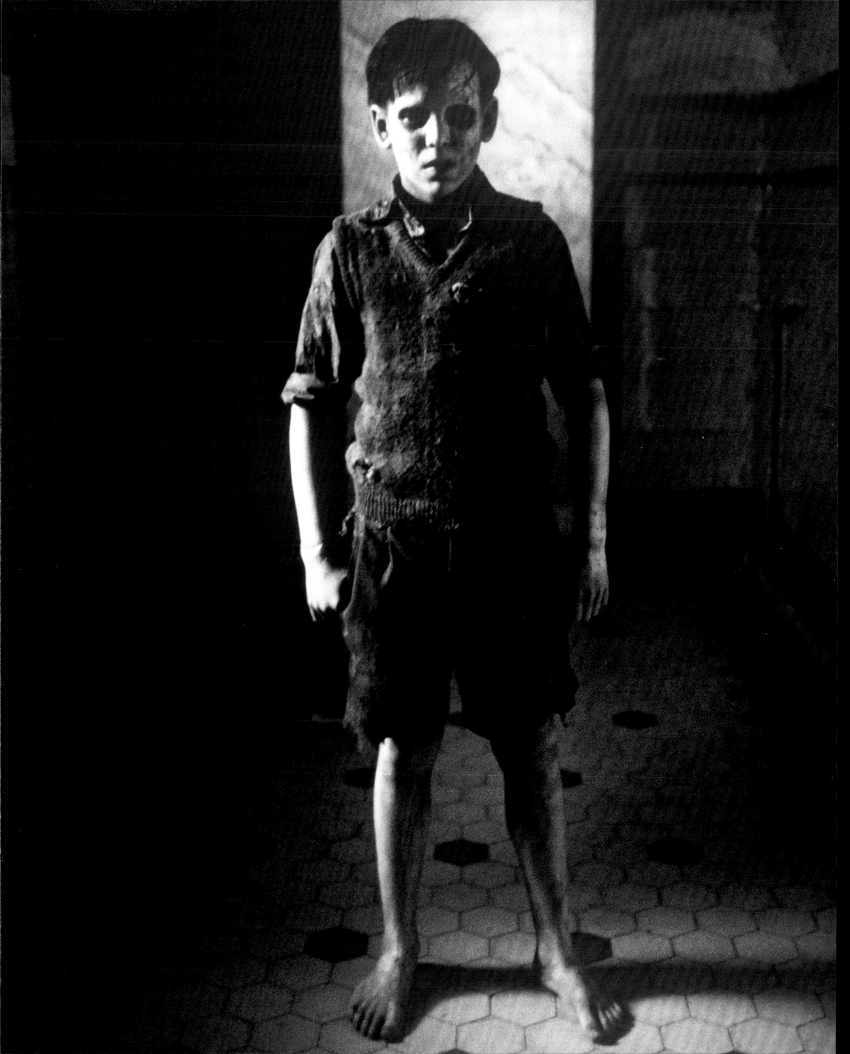

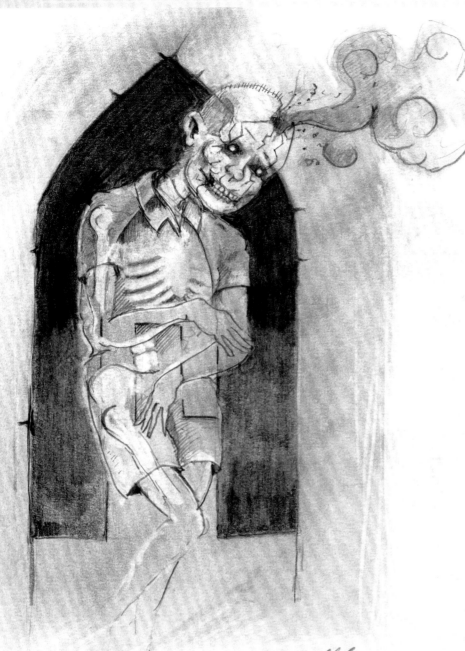

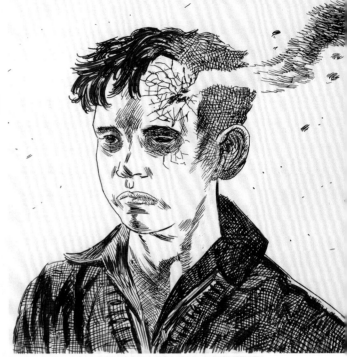

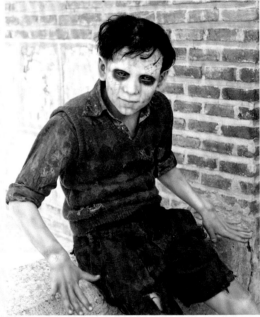

G: They're going to show up to work knowing where they're going to underline a word. Like, "If *we* do it."

No. Just say, "If we do it."

"If *we* do it!"

"No, no! Who gave you that?"

Of course it was the parents. Which is why the first thing you do when you're directing a kid is direct the parents.

M: How do you direct the parents?

G: You tell the parents, "Fuck you, if you give them a line reading! Don't give them a line reading! Don't talk to them about the scene! Don't help them with the part! Leave all that to me. *Then* you

have the conversation on safer ground. Don't talk about the movie, just read the lines flat. Make sure they memorize them, but make sure they're flat."

That's what you tell the parents.

There's a scene where Carlos and Jaime are talking about the drawing of a naked woman. I gave Íñigo a cigarette so he would be smoking, and there's a moment where I said to him, "Just scratch your belly like there's fleas on the mattress," and there's a couple times in the scene where he scratches his belly casually. You give him something to do, like any other actor. You don't ask him to play the scene, you know? He plays, he lives, he's there, and he's not that difficult to work with.

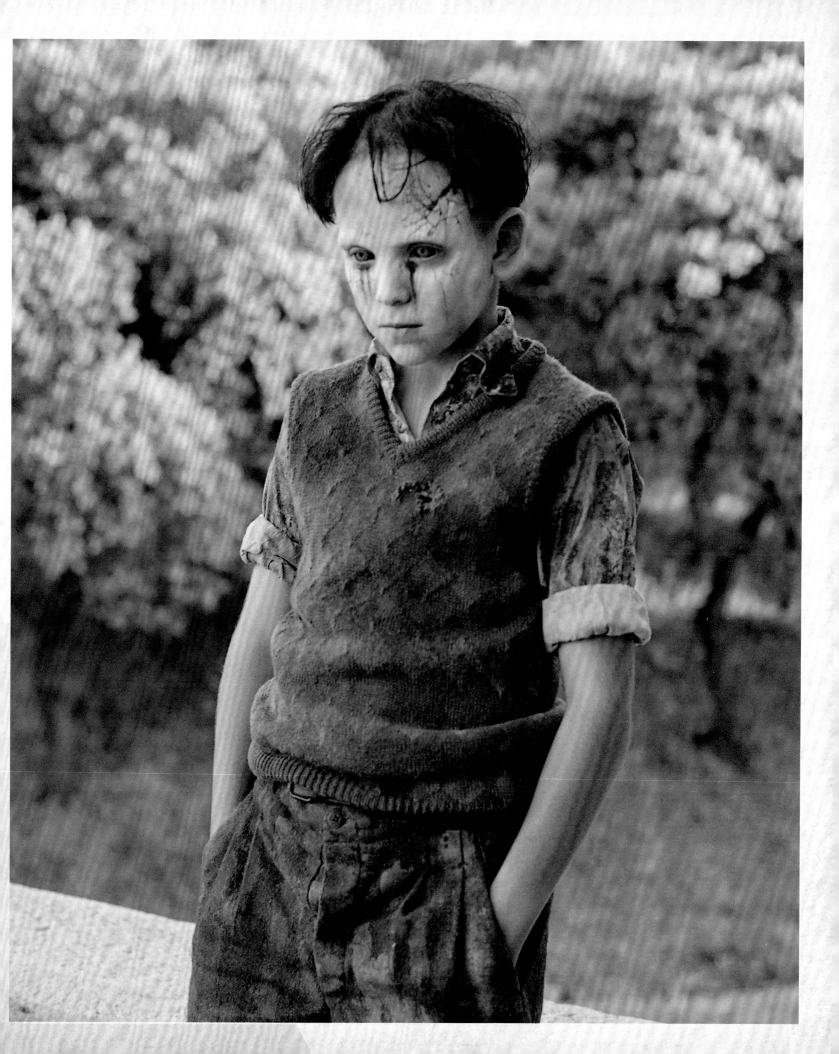

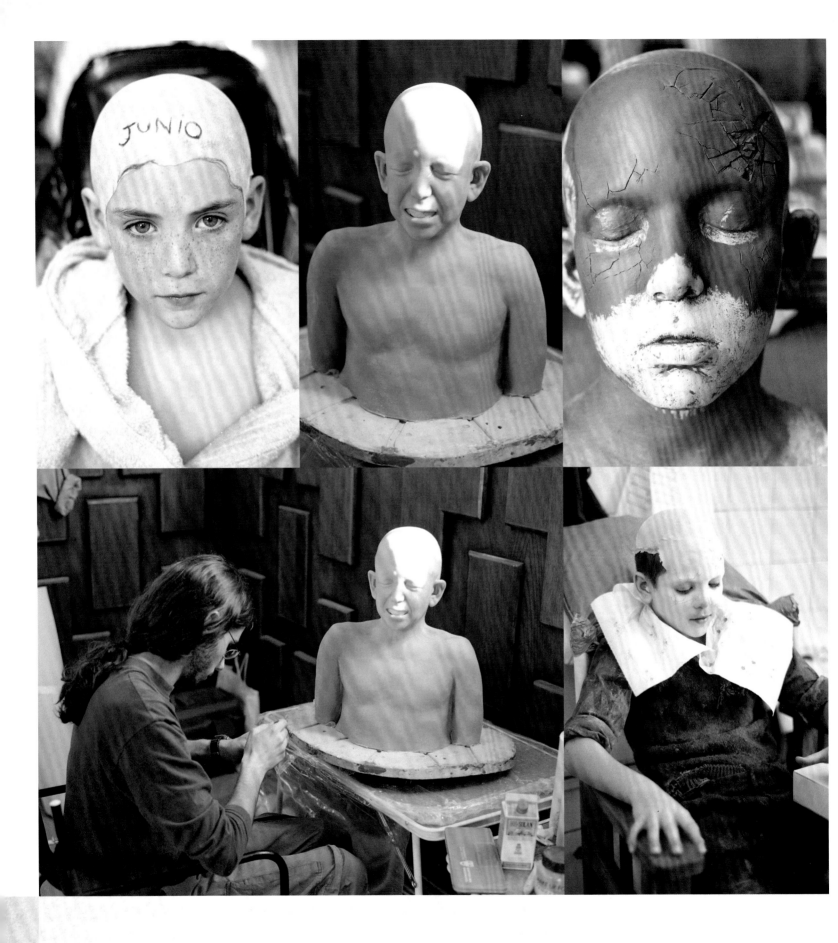

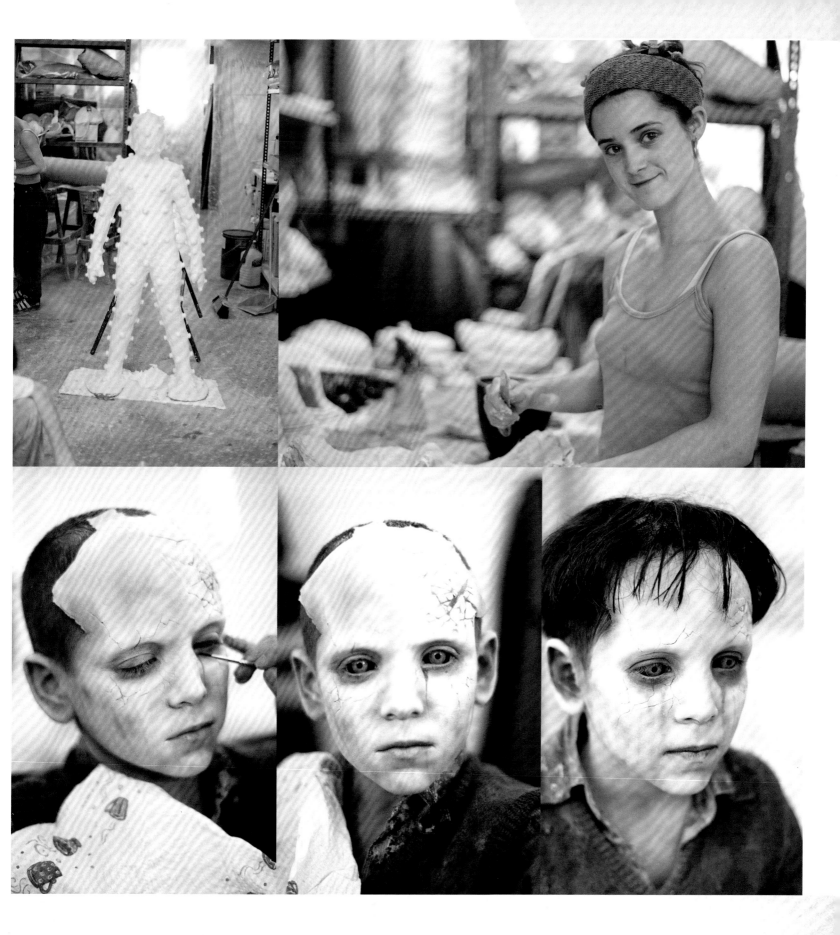

THESE PAGES Santi actor Junio Valverde undergoes the life-cast process so that effects house DDT can create a prosthetic head wound and other ghostly effects.

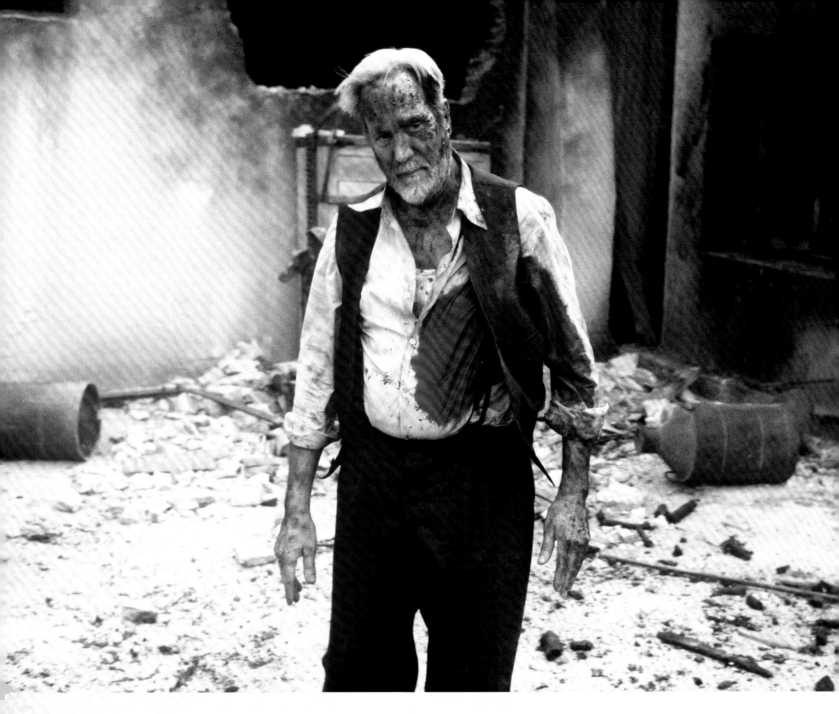

The Laurence Olivier of Argentina

M: Tell me about working with Federico Luppi.

G: Federico Luppi is like the Laurence Olivier of Argentina. He's the greatest Spanish-speaking actor alive. He is the most elegant, the most precise, the most genuine, and the most human presence on screen ever.

M: He reminded me of Burt Lancaster in *Atlantic City*.

G: He's a combination of Burt Lancaster and Christopher Lee! He has the precision of Lee, but with the acting presence of Lancaster. He's great to work with. I wrote *Cronos* for him, and I wrote *The*

Devil's Backbone for him, too. He always has, to me, an air of sadness.

There was a moment with Federico when we were preparing *Cronos* that I'll never forget. He said, "What do I do in this scene?" And I said, "Do whatever you want. I wrote it for you; I'm playing to your strengths." And he said, "No, if you want me to be free, you gotta give me limits. If you give me a corral, a big corral, I still can run freely within my paces. If you tell me 'The world's your oyster,' I don't know where to run."

I don't think that Argentinian cinema is well known outside Argentina the way it should be. Federico's in a seminal film called *The Romance*

ABOVE Casares (Federico Luppi) walks away unsteadily in the aftermath of the explosion.

OPPOSITE Del Toro and Luppi confer on set.

118

of *Aniceto and Francisca*, where he plays a great, tragic character. He is the best at playing nonverbal scenes. The way he carries himself, the way he uses his body and his hands—phenomenal.

There's a scene in *The Devil's Backbone* that I love, where he's thinking and rubbing his finger, just thinking, *What the fuck do I do?* I wrote it specifically because I wanted a completely nonverbal scene for him that was like a monologue without words. He's really just thinking, not moving.

M: Like Robert De Niro in *Heat*.

G: Yes. Like in the close-up of De Niro that says, *What do I do? Do I go to the airport and live, or do I turn around and kill this motherfucker?* And he chooses the latter. Jean-Pierre Melville does that a lot—has characters moving on screen, thinking all the time. He excels at that. Sometimes in a Melville movie, you can go five minutes without anything happening, really, and you're still mesmerized.

I love Federico because he's amazing at nonverbal acting. When we were doing *Cronos*, and he had to lick the floor with the drop of blood, I said to him, "Can you imagine licking champagne from the belly of your loved one? That's how you need to lick the floor." Of course we disinfected the floor, but I said, "You have to be in that space." Without ever having an explicit scene where he says to Carmen, "I'm in love with this woman but I cannot tell her," I wanted for you to feel that this guy would die for her.

M: How do you think he conveyed that in terms of his choices?

G: One of the things I discussed with him was, "Every time you're with Carmen, you should lean toward her, because that's what you'd do nonverbally." When you see him talking to her and they're talking about the kids seeing the ghost, he leans toward her and crosses his pinkie with hers. He shows his love for her through little details.

One moment I love is when he touches the wall when Carmen is on the other side of it. I said to Federico, "Touch the wall as if you're touching her face." The way he places his hand on the wall is so human and tender, it's like he's not touching the wall, he's touching a person.

Casares is in love with Carmen, but he doesn't act, although he's in love with her and she loves him. But he's not a *guy*. He's a friend, a teddy bear, you know?

My favorite scene in the movie is when he recites that poem to her as she is dying, the one she heard him recite every morning through the wall. That was their courtship. But him finally saying the poem to her face, not through the wall, as she goes away, that is my favorite scene.

M: I feel like their relationship is finally consummated in that scene.

G: It is, even in a symbolic way. The fact that they're sharing a life and the life is pouring out of her wound, you know? And they are together for

(Continued on page 125)

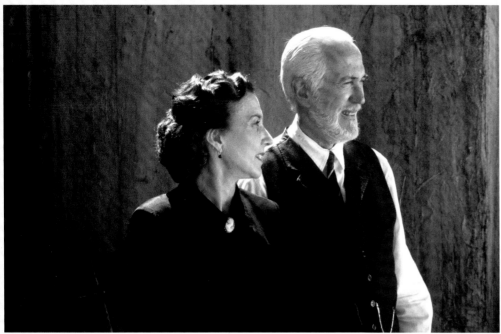

FEDERICO LUPPI

When Guillermo del Toro made *Cronos* in 1993, he knew that he wanted to work with Argentinian actor Federico Luppi. Luppi had starred in such films as *Chronicle of a Lady* (1971), *Time for Revenge* (1981), and *Sobredosis* (1986), as well as several TV programs. There was mutual admiration between del Toro and Luppi, and the actor's appreciation showed in his reaction to the script for *The Devil's Backbone*. Luppi was made for the role, as he and Dr. Casares were about the same age and even shared a similar outlook on life. Turning the part down never even crossed Luppi's mind.

FL: Guillermo and I developed a shorthand method of communicating on *Cronos*. His leadership was always guided by a deep sense of truth. His direction has always been completely organic. It was impossible not to understand when he gave directions, even during the most conventional fantasy scenes. He never got into lecturing master classes. Instead, his direction was in-depth but easy to grasp, both manageable and helpful. That's the kind of direction I like.

All I'm thinking about before each take is being both emotionally and physically available to discover what's going to happen in that moment. In this sense, Guillermo knows in an exact and deep way what helps and what doesn't at the moment the actor hears him say "Action."

During each take, everything, including makeup and costume, ended up feeling familiar to me—as did the character, after a few days. Everything else—whether it was lunch, my regular clothes, or traveling back to the hotel—felt like a movie because it was outside the reality of the film.

I had a clear vision of an old, elegant, and bourgeois man who could surely, at the peak of his life, have all the skills and abilities to walk the world without revealing too much of himself. In that regard, I found Casares's world to be deceptively complex. Guillermo had—and still has—the ability to explain, in a few words, a vast number of complexities.

Guillermo also possesses a kind of special gift when dealing with children, not only because of the good sense of humor that comes into play but because he establishes a rigor that is not tyrannical but understandable. I was interested to see many of those kids, as I thought they all had promising futures in cinema.

Marisa Paredes is also one of a kind. When you're around her, you can't help but establish a sympathetic and warm closeness. She has the ability to do a lot with very little and also has the face and demeanor of an old-movie heroine.

The poem that I read to Marisa's character when she is dying is one of the most beautiful in the English language. Just reading Tennyson's "In Memoriam" has the ability to place you on a very strong sentimental path. I still think that the poem's tremendous ending reminds us that the engine of our lives needs to be guided by the watchful eyes of our loved ones. My wife and I have the word "Stay" inscribed in our wedding rings, just like in the poem.

INTERVIEW BY SIMON ABRAMS

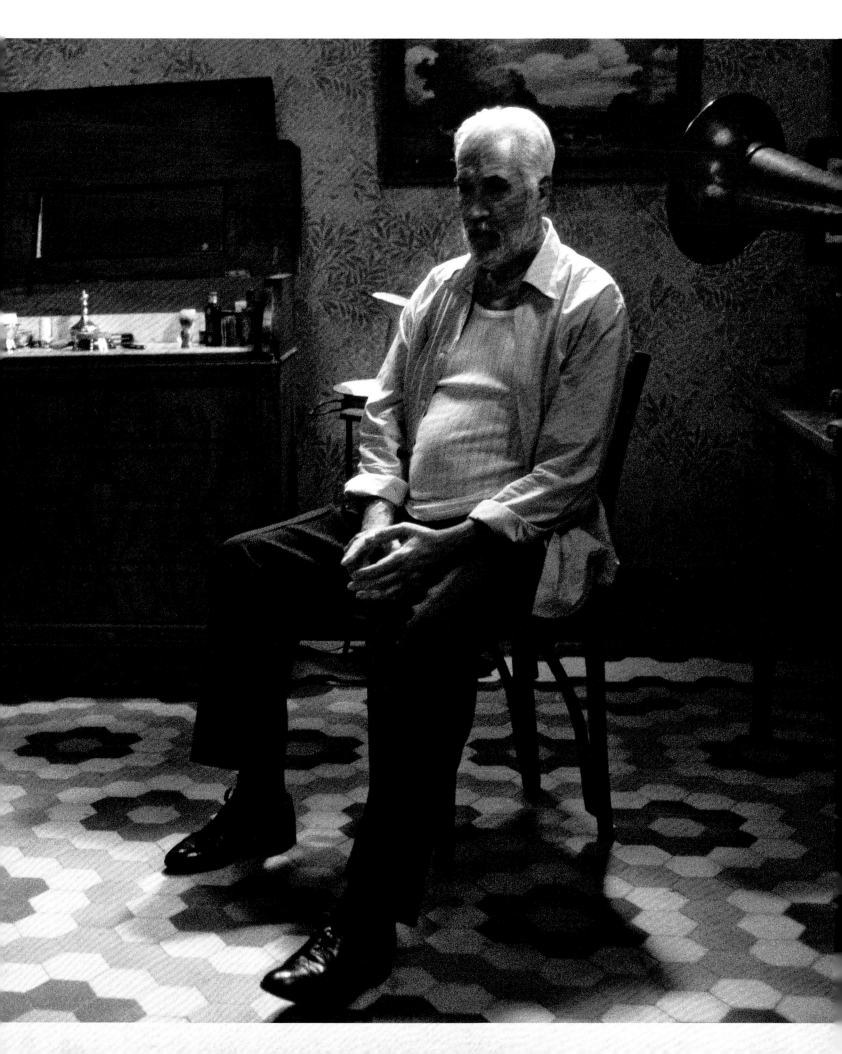

CASARES

ALFONSO CASARES MORENO
58 YEARS OLD
5' 9"

GREYING HAIR
SLENDER

What he likes: Good quality tango, Spanish wine, the sciences (especially biology and chemistry), clean clothes, having his belongings and objects in perfect order. He likes the music of Handel, Haydn, and Mozart, loves the movies (especially Chaplin, who always makes him cry), and problems in applied logic.

What he doesn't like: Poetry (yes, that's right: please read the following bio), superstition, violence, lies, the smell of perfume, tobacco, beer, sweat . . . losing control, strong flavors, fatty meat, citrus fruits, cheese, flashy clothing.

BIOGRAPHY by GUILLERMO "Corin Tellado" del Toro

Alfonso is born in the middle, is always in the middle, and right in the middle of three older and three younger brothers, at the heart of a low-income family. His father is extremely hardworking and honest. Alfonso is named after an uncle in Buenos Aires who has a good civil service job. The boy—forever serious, forever inquisitive—always makes his uncle laugh.

Alfonsito, as he is called, goes to study in the city. His father gives him two pieces of advice: Always be honest and always work to pay for what you own. "The only thing I can will to you," he says to his son, "is dignity."

Alfonso follows his father's advice to the letter. He studies all day, and at night he tutors fellow students who have difficulty with their lessons. With the money that he earns, he pays his uncle a token amount for his upkeep and buys himself new books with the rest.

He makes friends with a student from a rich family: Eugenio Malaparte. Eugenio's father is the Italian ambassador to Argentina. Alfonso is treated like a member of the family. Because Eugenio is an only child, Alfonso is invited to travel with the family, to attend functions at theaters and concert halls, and to go on vacation with them. Alfonso goes all the way to Mexico City and then to New York. Because Eugenio and Alfonso are more or less the same size, the latter is always fashionably dressed—a year late, however, after receiving the "old" clothes that his friend gives him.

Alfonso undergoes an unexpected change. All of a sudden it seems like money, power, and access to the bigger things in life are his right. He feels ashamed of his origins, and at get-togethers and parties he denies coming from a small town. He admires Eugenio's honesty and ease (years later he would identify these qualities in Carlos, a similar boy) and is excited by the prospect of becoming a formal part of the family when he meets Estela, Eugenio's cousin.

When Estela and Alfonso make their first fumbling attempts at romance, he fails because he's nervous and timid. From that moment onward, he develops an enormous insecurity about his sexual ability and potency. He develops a puritan attitude toward women and love, limiting himself to platonic friendships and camaraderie.

Eventually, Eugenio's father is posted to Spain and the family goes with him. Alfonso loses contact with Eugenio, except for the letters that they exchange throughout the years.

Alfonso's father has a fatal accident at work, and on his deathbed he embraces his son. He tells him that the dignity about which he used to talk, the dignity he wanted Alfonso to inherit, is not found in the clothes that one wears, but within oneself, and the poorer one is, the closer one is to that true dignity.

Alfonso assumes responsibility for his family. He begins to sympathize strongly with the left. He is passionate about science, math and, in general, the so-called pure sciences. He despises literature and fantasy. In his twenties, through Eugenio, he gets in touch with Ricardo Gimenez, a Spanish Republican. Ricardo offers to stay in contact and invites him to take part in the grand political experiment that is taking place.

A few years later, Ricardo pays Alfonso a visit, together with his wife, Carmen. Alfonso falls help-lessly in love with this woman. She loves literature and poetry, and Alfonso pretends he does, too. When he moves to Spain, he brings with him books of contemporary South American poetry and reads them aloud to Carmen, pretending that he enjoys them immensely. He never dares to act upon his feelings, but discovers that she has an affair with a young student at the center where they work.

Despite himself, Alfonso, an involuntary Iago, hints to Ricardo what is going on. The tragedy that his words unleash will weigh heavily on his conscience forever. He decides that it is misfortune, rather than love, that has linked him permanently to Carmen. He will never abandon Santa Lucia, or the woman he loves.

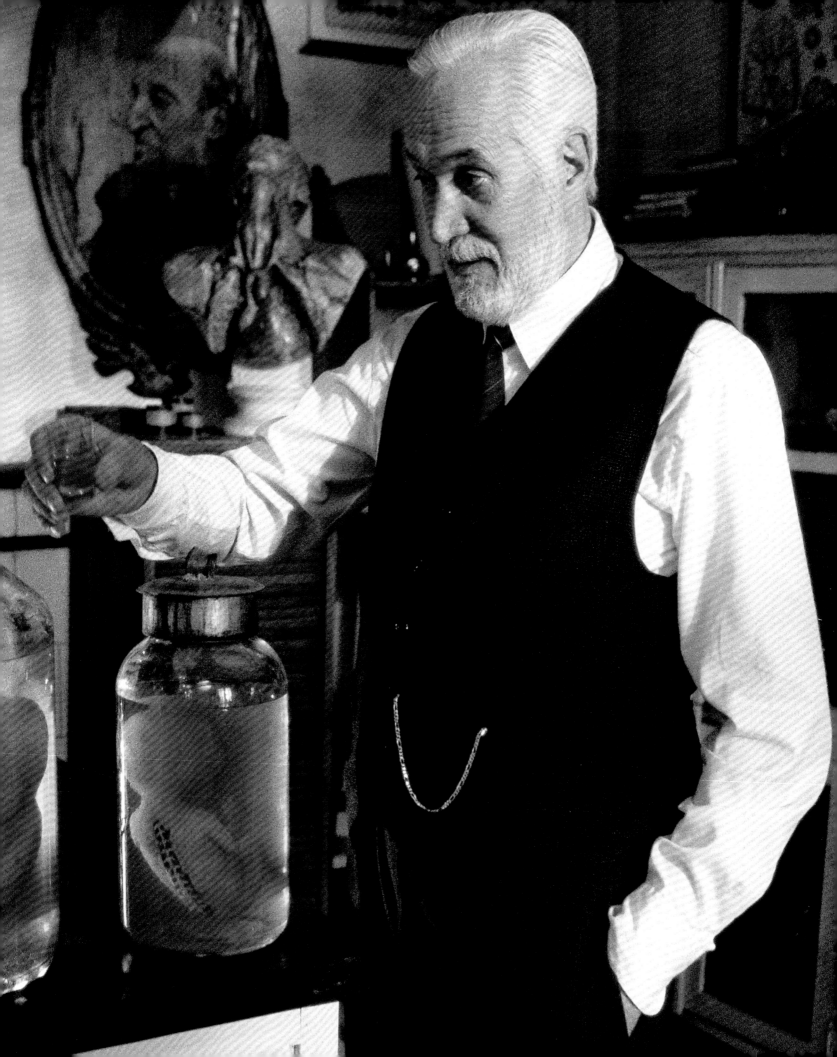

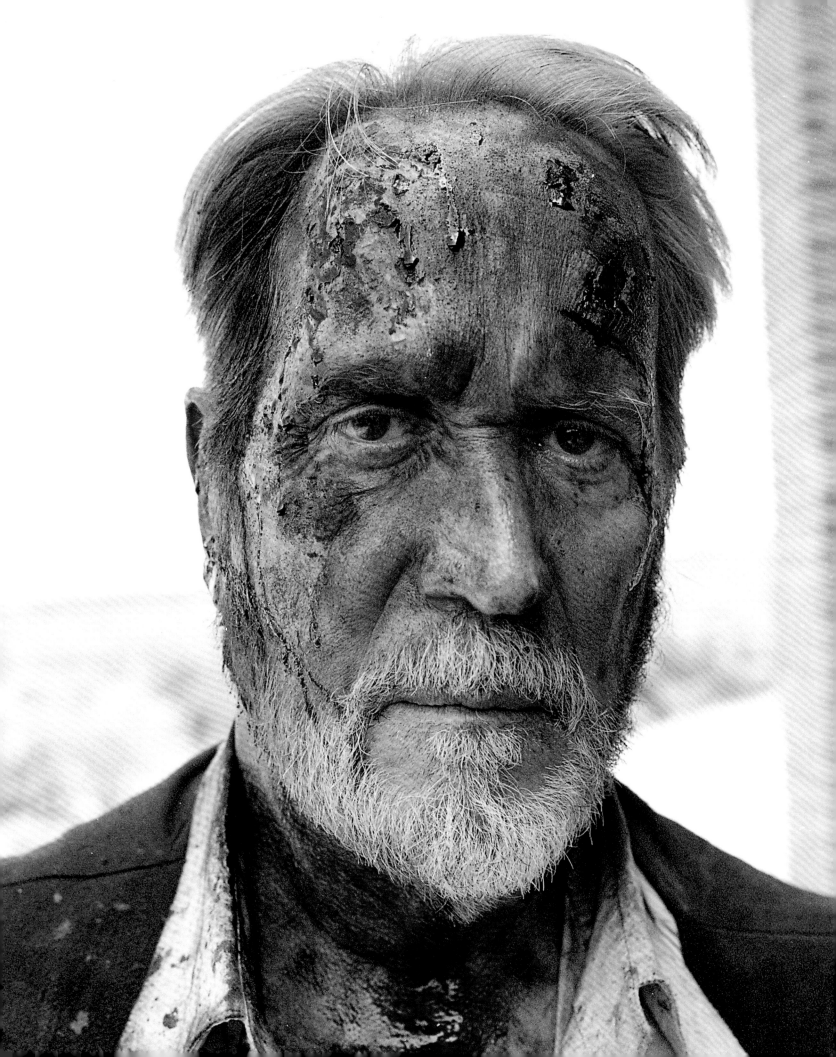

(Continued from page 119)

the first time and she says, "Say the poem to me." That scene is very curious because that was take three. The perfect take for that scene was take one, but one of the fucking kids in the background got up in the middle of the shot to listen to the poem! We're watching on the video monitor and we're all weeping, everybody, the cameraman is weeping, the script girl is weeping, I'm weeping, and we say, "That's it! Print!" and then the script girl says, "I think there's movement in the background." "What? Can we go back and rewind?" and this dead kid, like a George Romero zombie, gets up and looks at the camera!

I go up to this kid, who we are killing because he was a pain in the ass! He was in other scenes and he always ruined the scenes, so I said, "Let's kill him!" So he dies in the explosion and fucked up the last fucking scene he had! I go up to him and say, "Why the fuck did you do that?" and he said, "Because I feel my character wouldn't die! He would be injured!"

M: You're furious at him for blowing a take, and he wants to give you notes?

G: We never went back to the energy of take one. That kid!

There were lethal days on that movie. One of them was . . . the night Carlos is in the linen closet. That scene was supposed to take an hour to shoot, but it took the entire day.

M: Why?

G: We were really shooting in a linen closet! We removed one wall because it was a built linen closet on location. We created part of a corridor in that location, but it was a meter away from a real wall, so it was incredibly difficult to align and get in there. No space for the lens or the actors. Incredibly difficult.

The last difficult day was the day the bomb fell over on the patio. Everything that could go wrong went wrong . . . It kept going [*mimes the bomb starting to tip over to one side*] and it fell on the floor. I had three cameras on it running at high speed in case anything went wrong, and the bomb kept going and fell on the ground.

But in the movie I was able to cut right on the frame where it was like *that*. [*Holds arm at the angle of the bomb as seen in the film.*]

OPPOSITE Luppi in postexplosion makeup.

ABOVE Ever the hands-on director, del Toro helps apply blood splotches to the postexplosion set.

BELOW Del Toro plays with fire.

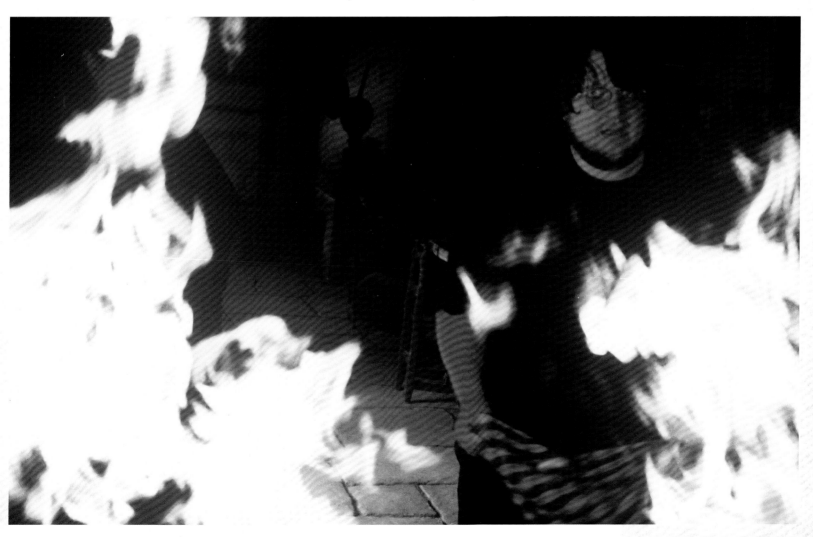

SARA BILBATUA

Before *The Devil's Backbone*, casting director Sara Bilbatua had no prior experience casting children in films. She'd previously worked with the brothers Almodóvar on *All About My Mother* (1999), which, like *The Devil's Backbone*, stars Marisa Paredes. But *The Devil's Backbone* proved to be a unique challenge. There were seven key roles for children in the film, so they playfully dubbed the roles the "Seven Dwarves." Finding the right actors—ones who would be simultaneously experienced and spontaneous enough—proved challenging, but Bilbatua and Guillermo del Toro worked tirelessly to find the right dwarves, as well as complementary adult foils.

SB: Experience is obviously good when it comes to child actors. But when it comes to young children, it's difficult to find ones who already have experience. We needed seven to eight kids between ten and eleven years old. It was OK if they didn't have experience, because there were more important factors. The character of Carlos, for instance, comes from a good background and family. He's quite relaxed and lively. He's very curious about everything that surrounds him. But generally speaking, we looked for confidence and high self-esteem.

The most important roles were Jaime and Carlos. Jaime had to be a character who kept a secret. He had to be a child who was not confident in anyone. He had to hold back before giving anyone his confidence. I thought of the kid who starred in *Secrets of the Heart*, Íñigo Garcés. It wasn't easy to find him since he was living in the north of Spain and wasn't represented by the usual casting agencies. I finally found him, and Guillermo liked him a lot.

Auditions were held in my office. I used to have an office with a stage. I set up an audition/casting space with a camera. When the children would come, they'd wait with their parents before coming in. Sometimes even their grandmas would be there to accompany them. There would be a counterpart: the actor and their counterpart, or the character they were trying out for, and the character they were acting opposite. They'd perform as their characters and then they would do the sequence again as their counterpart. The next day, Guillermo would say which children he liked the most.

But, ah, Santi. This role was obviously really important to Guillermo. We needed a very expressive kid in order to do all these different things as a ghost child. [Junio Valverde] almost ended up playing Carlos instead of Santi. He had these big, blue eyes, and Guillermo thought that that would add to the expressiveness of the character. He had little freckles on his face and was really cute.

Ensemble casts work best when the actor and the character are absolutely one and the same.

I continue to admire Guillermo's incredible psychological insight. I'm fascinated by how Guillermo presents benevolence and evil. He knows how to use feelings, emotions, and also desire. He has a special interest in and empathy with children of a certain age—how children interact among themselves, their sense of humor. He manages to communicate from the child's perspective in situations that are so dramatic. Everything is very personal in his movies.

INTERVIEW BY SIMON ABRAMS

The Muse

M: Marisa Paredes has done some wonderful stuff throughout her career.

G: She's always been one of my favorite actresses from the eighties. Franco put Spain in a time machine after the Civil War and basically wanted to reinforce medieval morality and oppressive Catholic dogma, and "good manners." He froze Spain in the forties up until the 1980s. The sixties happened in Spain during the 1980s, and that gave birth to this frantically bacchanal culture called La Movida. Everything was sexual, everything was illicit. Excess was a way of life: cocaine, binge-drinking, promiscuousness. It was an explosion of liberation, like the sixties in America.

Marisa was the muse for Almodóvar and many other filmmakers. She was the muse for La Movida,

and her work with Almodóvar is fantastic. But I think the movie that I like her in best is one called *Tras el Cristal*, which I think translates as *Behind the Glass*, by Agustí Villaronga.

M: I know that one. Actually, they translated it here as *In a Glass Cage*. That's the one with Günter Meisner as the ex-Nazi child molester who's paralyzed and needs an iron lung to live. [*Laughs.*] Definitely not a plot that you hear and go, "Oh, not that again!"

G: Yes! It's a very twisted thriller. She seemed to be game for the twisted stuff in *The Devil's Backbone*, too. I'm thinking particularly of her love scene with Jacinto. There's something disturbing about that.

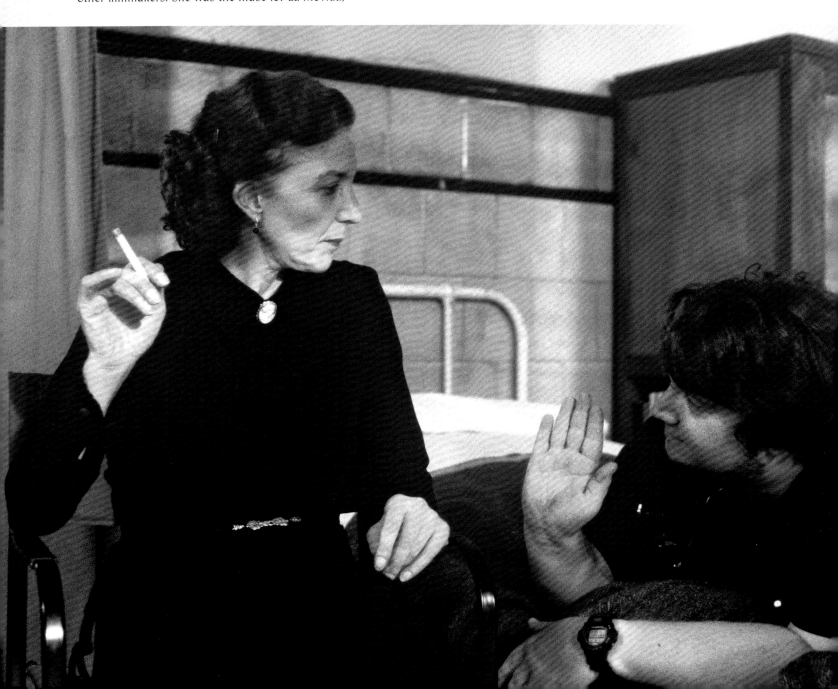

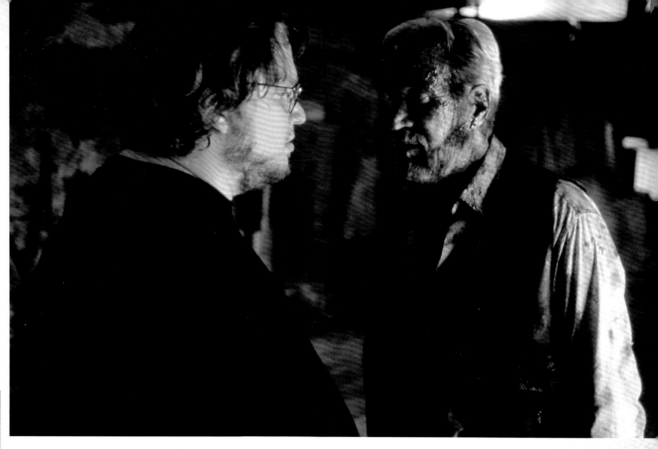

M: It reminded me a little bit of a scene from an Almodóvar film, actually.

G: Yes. It has those sorts of transgressive qualities. It has an incestuous aspect. You can see these two people are no good for each other, but they are not going to be able to leave each other alone, even though they would like to.

She became this grand dame of Spain. She had this elegant, almost aristocratic demeanor. We became friends. I thought, *I would love to write this character for her,* [because] she never plays that type of role. She always plays an exuberant woman.

And I thought, the interesting thing would be to have that exuberant woman be contained in Carmen. Like, if she had her two legs and she could escape that orphanage, she would. But Carmen's late husband was this idealist, much like Casares, who was not good in the real world, and she has a line to the effect of, "You're like my husband, always talking." Casting her, I knew there was going to be that tug-of-war between her incredible life force and the fact that [her character] was missing one leg.

M: How did you learn how to direct actors?

G: Well, I was in the theater as a teenager, and before that as a kid. I was an actor in a few comedies, and I was a leading man in one play when I was a teen! [*Laughs.*] When I was a teen and handsome, I was the lead in a play and it was a drama. I did not excel at drama as an actor. I was good in comedy. But you learn the basics and you

learn that actors are in dire need of feeling that they are being watched and protected. Each actor needs a different thing, and sometimes you need an actor who is so incredibly afraid of themselves. Like, there's no consolation you can provide, but you give as much guidance as you can.

But the real secret to directing actors is to be succinct, and do nothing when they don't need you.

You only find that out over the years. In the beginning, when you're a young director, you intercede after every take. But actors rarely need you after every take, and you learn that pretty quickly.

For example, I just shot *The Shape of Water* with Richard Jenkins. With Richard, I'd give him the first four or five takes alone. I wouldn't give him any direction. I'd just say, "Let's do another one." And then, if I had something very, very, very specific, I'd give him a note and say, "Can you try this without the hat?" Very prosaic instructions.

Hitchcock had two basic instructions: "Faster" and "Slower." I'm not advocating that, but when you go in with an actor you give him a verb. You do that in preproduction when you're doing a table read. But once you're on the set, you can say, "Look, grab this piece of paper and fold it in two. You're worried that your shirt is not well pressed. The pants are too tight."

I always quote the scene in *Diner*. Mickey Rourke is having a conversation and he unscrews the top of the sugar container and drinks the sugar out of it.

M: Like Brando with the glove in the park in *On the Waterfront*.

G: Or with the cat in *The Godfather*!

You use what you have. Like, my reality right now is my pants are too tight, you know? And we are talking, and I am just very conscious my pants are too tight.

M: So you're playing the pants?

G: Yeah, I'm playing the pants.

M: That's advice that an actor can actually use: "Play the scene as if your pants are too tight."

G: Yes. But when you're young, you go in and tell the actor, "This is the crux of the scene! This is where everything is!" and they go, "What use is that to me?"

see on Smith's face that he's embarrassed: *Fuck, I almost dropped the bottle!*

G: That's what I discussed with Tom Cruise about *Eyes Wide Shut*. Sometimes, Kubrick would do eighty takes because he was waiting for life to actually happen. People think, *Oh, he wanted them to move exactly a certain way.* Sometimes yes, but sometimes he wanted something to happen on the way.

When we're animating *Trollhunters*, I talk about that thing [Hayao] Miyazaki calls *ma*. He says, "*Ma* is the space between me clapping my hands." [*Claps hands.*] It is something that is *not* the action.

For example, in *My Neighbor Totoro*, the father puts on his shoe, misses the first time, and then he gets it [on the second try]. Now in real life, that's the actor trying to put on his shoe. In animation, a

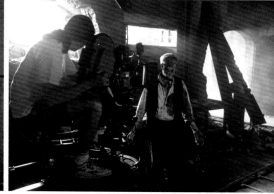

OPPOSITE The boys prepare to hightail it from the orphanage.

ABOVE, LEFT TO RIGHT Jacinto (Eduardo Noriega) lights up; Carlos (Fernando Tielve) checks to see if the coast is clear; and on the set with Luppi.

M: They really want to hear, "You're cold. You wish they'd turn the heat up, but you don't want to say anything."

G: "You want to get out of here. You're having a conversation, but you want to get out of here." You can give some more specific guidance by saying, "Try to avoid her eyes and don't look at them until the end of the scene." That has an effect. When you can tell the actor to be directed through the other actor—"Interrupt, don't listen," or just "Listen"—those are very simple instructions that are useful.

M: There's a scene in *American Graffiti* where a guy throws a bottle to Charles Martin Smith's character outside a liquor store. Smith caught the bottle perfectly take after take. George Lucas did some ridiculous number of takes. Then finally Smith fumbled the bottle and almost dropped it, and that's the take Lucas used, and Lucas goes, "Print it." Turns out that's what Lucas wanted all along: Smith awkwardly catching the bottle. And you can

bad animator would have him put the shoe on the first time, and it would look like animation. But if you animate the character in a flawed act, that's *ma*. You can add life. Suddenly, the space between getting the shoe on and getting the shoe right—the two tries—makes the animation come alive.

Sometimes, with an actor, you're waiting for *ma*, like the moment they mishandle a prop, or when the other actor is not on his or her mark.

M: I'm sure you know a good number of actors who feel that this idea that you keep going until life happens is insulting to the actor. They might say, "If you just ask me, I can just do it."

G: It depends on the actor. Michael Shannon is the most alive, precise acting machine I have ever met, because he both can keep it completely genuine at all times and at the same time, he repeats every gesture you need him to unless you tell him it's OK not to do it. He's as precise as an English actor, but he is completely *there*. So he is a rare combination.

CARMEN

CARMEN ROLDAN DE GIMENEZ **BRUNETTE**
48 YEARS OLD **SLENDER**
5' 6"

What she likes: Literature of exploration (Burton's discovery of the origins of the Nile; Shackleton's voyages on the *Endurance*; Stanley and Livingstone's adventures in Africa; and so on), symbolist writers, clear night skies. She is disciplined to the point of desperation (in more than one sense), loves coffee, photographs, reminiscing, rereading her youthful scribbles, justice, freedom, waltzes, poetry, songs, fruit, spending hours in the tub, and jasmine water.

What she doesn't like: Injustice, passivity, heat, solitude, feeling vulnerable or unproductive, delegating responsibility, modern music (foxtrot), cowardice, ignorance, opulence, jewelry.

BIOGRAPHY by GUILLERMO "Corin Tellado" del Toro

Carmen is the oldest daughter of Don Artemio Roldan, the patriarch of an eminent family of long social and cultural standing. From the time she was very little, Carmen has attended the literary salons hosted by her father to which the writers, journalists, and poets of the day are invited. Her mother, a writer and teacher, invites Carmen to participate actively in the sessions and encourages her to use her father's large library.

Carmen learns English and Italian and discovers the *Thousand and One Nights* through Burton's translation. The Victorian explorer becomes her first platonic love. She reads his diaries and obtains all of Burton's translations of Oriental literature. At 15 years old, she travels to London, visits Burton's tomb in Mortlake, and collapses in tears. She furtively buys and reads *The Perfumed Garden*.

Carmen has a brief fling with a young restorer who works at the British Museum, but their relationship ends abruptly when he confesses that he has always loved another woman and then goes to Florence. Carmen herself returns to Spain.

She dreams of a nomadic life filled with adventure and travel in faraway lands. The symbolist emphasis on an exotic network of associations fascinates her. Her favorite author is Schwob. She reads *The King in the Golden Mask* repeatedly. At the age of 20, she graduates from teachers' college and takes a job at a rural school for five years.

Then she meets her future husband, Don Ricardo Gimenez, at one of her father's salons. He is 50, and she is 27.

She is captivated by Don Ricardo's erudition, passionate argument, and self-confidence. She falls madly in love with him and follows him everywhere. When he leaves Madrid, she swamps him with letters, and in one of them she decides to declare her love, which until that moment she has kept secret. Two years later, they are united in a civil marriage.

Don Ricardo's lifework is the orphanage of Santa Lucia, a place in which he invests his entire fortune (he is the sole heir of a family that made its money in textiles) in order to create a center for pedagogical experimentation. He sets out to create an educational commune in which approximately 150 orphans of Republican parents live together under one roof, sharing chores and responsibilities.

Carmen stays by his side during the years of experimentation. An Argentinian teacher joins them: Alfonso Casares, a close friend of Don Ricardo's but one who is secretly in love with Carmen. Together the three of them embark on what will be the golden era of the institution. They achieve notable results and Ricardo establishes himself as an educational pioneer.

For Carmen, however, the romance has passed. She and Don Ricardo are rarely physically intimate; any illusion of romance or adventure has been crushed by the pressures of their shared responsibilities. On the cusp of his seventies, Don Ricardo frequently falls ill. He is a heavy smoker who suffers from respiratory ailments. Carmen feels trapped, tied to an aging and sickly husband who is twice her age. She sees her life wasting away—nursing him at

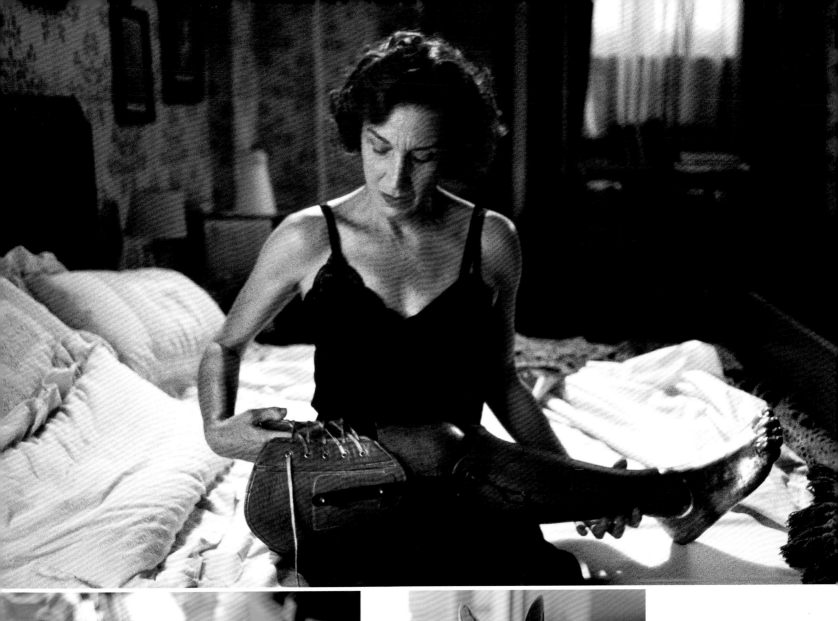

THIS PAGE Carmen's false leg as it's seen in the film, and under construction by DDT. Also pictured is the prosthetic leg stump created for the character.

night and during the day taking care of children who will turn their backs on the orphanage when they turn 18.

For a while, Carmen tries to get pregnant, but she is unsuccessful. In the beginning she thinks it is because of Don Ricardo's advancing age, but later she learns the truth: She herself is barren; conceiving a baby is impossible.

She and Casares share moments together that verge on intimacy, but they never let themselves succumb. They read poetry together and talk until the early hours of the morning. Carmen discloses her unfulfilled dreams to him, and he brings her books about adventure and voyages of discovery.

Together they avidly read about the feats of Admiral Byrd and his aerial conquest of both Poles. One evening when Don Ricardo is absent in Barcelona, where he is to receive an award, Carmen invites Casares to sleep over. She lies awake all night, the door to her room slightly ajar. Unknown to Carmen, Casares spends the night standing in the middle of the corridor, paralyzed by feelings of panic and guilt. Neither of them ever discusses what didn't happen.

Years later, an 8-year-old boy arrives: Jacinto. He is clever but emotionally repressed. Don Ricardo sees him as a boy who is full of potential. But Jacinto, who lacks self-discipline and the wherewithal to express his ideas, is always behind in his schoolwork. By the time he is 13 he has become indispensable around the orphanage. He takes charge of the children and is responsible for repairing and maintaining the old building.

Carmen tries to help Jacinto with his lessons, but he rejects her care and attention, interpreting it as motherly interference. Carmen admires his strength and his undeniable vigor, the immense vitality that in her eyes makes him "a prince without a kingdom."

As Jacinto matures he grows closer to Ricardo. He despises Casares, whom he considers disloyal and cowardly. It is clear to him that the teacher is in love with Carmen but isn't going to do anything about it.

Perversely, Jacinto works to seduce Carmen, allowing her to admire his physique and flirting with her constantly, alternating between trying to woo her and to overpower her. Finally, when they are on an excursion to Malaga, Carmen and Jacinto make love in a small beach hut. Their intercourse is rough but wild and passionate, and it shakes Carmen to her core. She has never felt love in such a palpable, carnal way. In spite of her guilty conscience, the encounters are frequently repeated, sometimes under very risky circumstances and always with the same voraciousness. Theirs is a thirst, an appetite, an addiction.

Jacinto is, for the first time ever, in total control of something and someone. Carmen, in contrast, is in turmoil but filled with an extraordinary vitality, a kind of hunger that she hasn't experienced since she was a young girl.

Casares discovers Carmen's affair and, unable to control himself, he hints at her infidelity to Don Ricardo, who then arranges for Jacinto to leave as soon as he turns 18. Carmen secretly plans to run away with Jacinto and help him build a new life in Madrid, perhaps living off the money that he has inherited from his parents. She doesn't care about anything anymore.

Finally, Don Ricardo's illness reaches its fatal climax. He speaks privately with Jacinto. Carmen will never find out what the old man has told him, but as soon as Don Ricardo dies, Jacinto hastens to depart. Carmen, insane with grief, attempts to follow him. Casares tries to stop her. Jacinto leaves, urged on by the old teacher. Carmen falls down the stairs and, in doing so, breaks her leg.

Heat, the terrible living conditions, and the lack of any antibiotics at the time result in a ferocious gangrene, and Carmen's leg has to be amputated above the knee. Casares will forever blame himself for this.

Carmen, now a desolate widow, assumes the position of director of the orphanage. But more than just taking on the role, she seems to disappear within it. Her emotional austerity and black clothing shield her from ever giving herself again, her dread of motherhood, and her desire to live.

A Beautiful Bruise

M: How about Eduardo Noriega, the actor who plays Jacinto in *The Devil's Backbone*?

G: Yeah, Eduardo, the actor, came to prominence in [Spanish director Alejandro Amenábar's] movies *Thesis* and *Open Your Eyes*, the latter of which was remade as *Vanilla Sky*. He is an actor trapped inside a matinee idol. His physique is "handsome leading man," but he is incredibly serious about his craft. I told him, "You should familiarize yourself with Sanford Meisner," who is not as well known in Spanish acting circles as [acting teachers] Constantin Stanislavski or Lee Strasberg. I thought it would be interesting if we used that to communicate.

M: How would you distinguish those three schools?

G: In my opinion, Strasberg and Stanislavski are incredibly good tools for an actor to ready and articulate his process.

Meisner gives you simple exercises that you can invoke. You can say, "Let's do this," to put the actor in the moment. It's not necessarily as tricky to invoke, or as intrinsic to a long and lonely process for the actor. I'm oversimplifying, but I think that with Meisner, you find cleaner tools of communication, and it's a good channel to give instructions to the actor.

M: So Noriega did Meisner, then?

G: He read the books, but the result was a mixture of all three [schools], because he was always in character on set.

M: I bet he was a joy to be around.

G: He was incredibly angry all the time, to the point where one day, I had to pull him to the side and say, "Listen, it's great that you're doing this, but it's not working when we have kid actors. So take it down a notch."

But he was phenomenal to direct. He was great because he was always hurting, which I think was key with Jacinto. There are people who sometimes you meet and are rich, good-looking, successful, and in the first three seconds of meeting them you know they are incredibly unhappy. That's the crux of the character. I think Jacinto is constantly in pain.

M: His performance reminded me of James Dean in *Rebel Without a Cause*. Dean in that movie is basically a beautiful bruise.

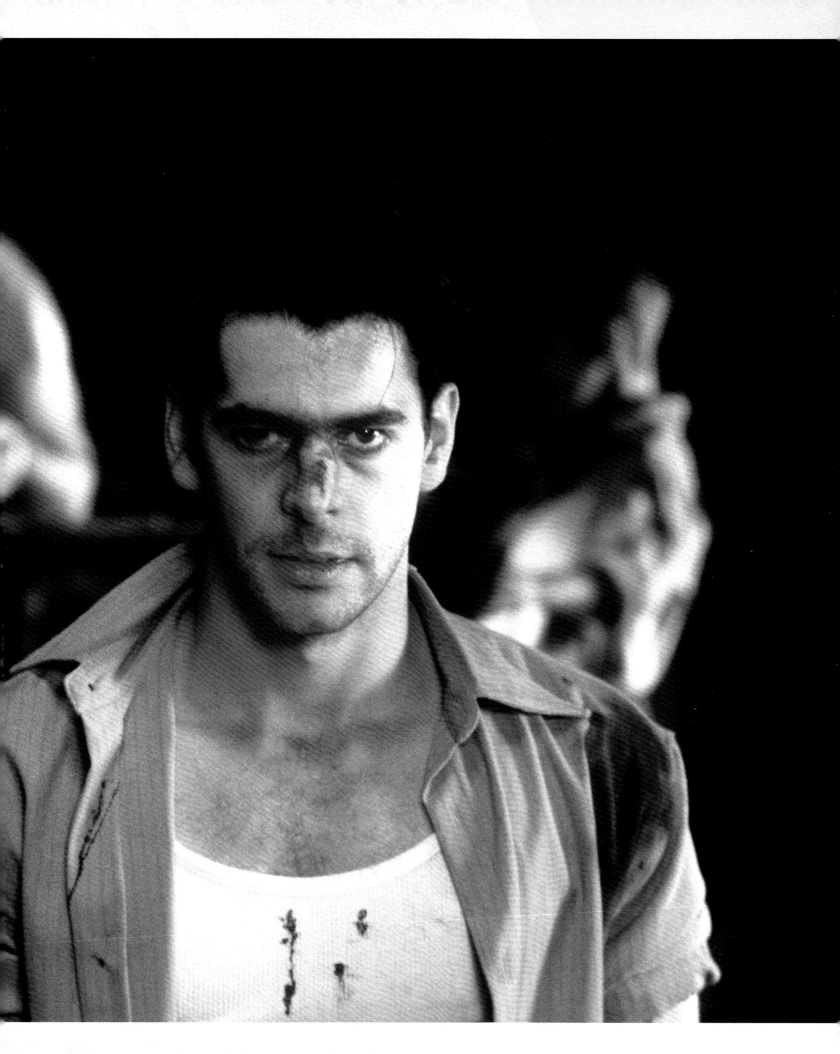

G: Yeah, I think he plays it like that, and physically he had to work a lot to beef up. He was doing weight lifting and training. He's a very slight, nimble actor, and normally he has a lean physique.

There was a great moment in a scene where he's making love to Carmen [and] he's fully in control. But the moment they literally separate—which is very pointedly [depicted] in the scene: You can actually feel when he gets out! [*Laughs.*] It was a very pointed moment for the actor. I said, "There's the slippage!" [*Laughs.*] And the moment he's not having sex, the character immediately goes to hurt and deceit.

M: It's a weird dynamic between Carmen and Jacinto. It's almost like she's motherly toward him in some ways. With Casares around, it's like he has a mother and a father right there if he wants them. But he can't accept love like that.

G: This may come from seeing [Italian filmmaker] Luchino Visconti's *The Damned* too many times. But when a disenfranchised character exists in a closed environment, it's a weirdly incestuous whole. I feel that's the creepiest thing to portray because it is profoundly Freudian and distressing. Whether it's the brother and sister in *Crimson Peak* or the prince and the princess in *Hellboy II*, these sorts of closed systems produce the inbreeding in the royal houses of Europe.

I find it incredibly dramatic and compelling that Jacinto belongs to a system in which everything is kind of rigged against him! The only mother figure he ever knew ended up having sex with him, and his father is this theoretically great guy, but he despises him.

M: This is another way the film becomes political without making too big a deal out of it. Jacinto is a representative of that macho, working-class laborer union guy who fell under the sway of Franco.

G: Fascists go to the disenfranchised or dispossessed, people who have it hard in their lives and they tell them, "Look! It's not your fault! It's the fault of *them!*" Whoever "them" is—the gays, Mexicans, Muslims, whatever you want to make it—if you exonerate them by saying, "It's not you, it's them!," they go, "Of course it's them, not me!" There's nothing more delightful than to say, "I didn't fuck up! My family didn't fuck up! Of course it's someone else's fault!"

You create the perfect breeding ground for fascism when you disenfranchise a person by saying, "You don't belong with those people, they are why you're fucked. You belong to me and my cause." Because you have people who can disentangle from empathy and objectify the other. Jacinto is like that.

BELOW Del Toro directs Noriega.

OPPOSITE Noriega fitted with a fake arm and "squibbed" with blood bags for the moment where he is stabbed by the orphans.

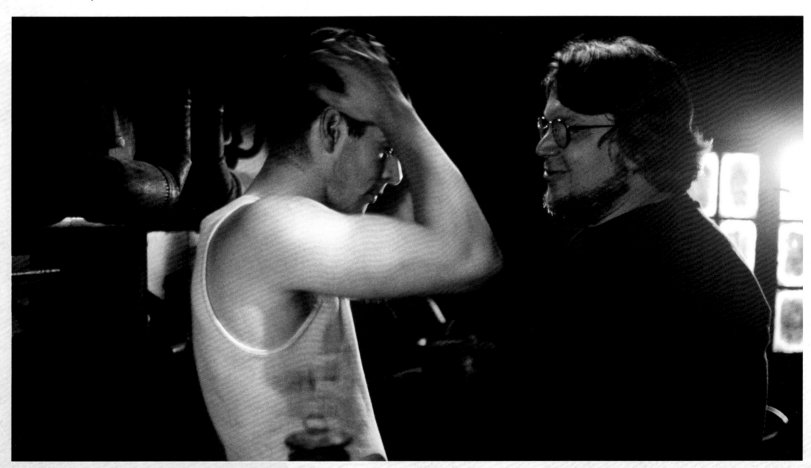

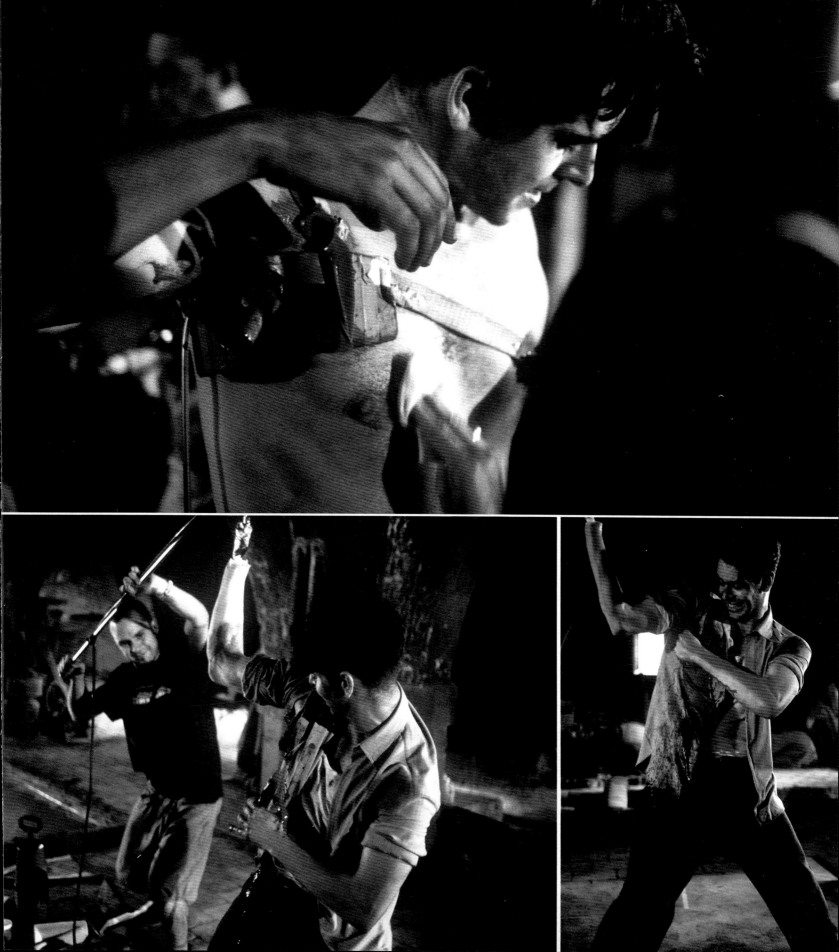

JACINTO

JACINTO RODRÍGUEZ COSTA
26 YEARS OLD
5' 9"

BLACK HAIR
SLIM

What he likes: "Fine" wine (which he's actually unable to distinguish), cigarettes (to which he is absolutely addicted), time to himself, being the subject of admiration, his sunglasses (which he acquired only three years ago), photographs, dreaming about the future, dreaming of himself being successful in the future, oranges, fucking, pork, cheese, bread, the smell of sweat (preferably his own), rain, night, the moon, and listening to the radio.

What he doesn't like: Vegetables, love songs, hugs, physical contact, rice, incompetence, "Rojos," fags, his past, children, sentimentality, poverty, sunshine, heat, sodas, pain, being ignored when part of a crowd.

BIOGRAPHY by GUILLERMO "Corin Tellado" del Toro

Jacinto's father, Antonio Rodriguez, originally from Calanda, is an accountant in a bank in Barcelona. There he meets one of the bank tellers, Francisca "Paquita" Costa.

Don Antonio, as he likes to be called, is a tall, distinguished man, well groomed, proud, an inveterate inebriate ("not a drunkard, mind you, because I carry myself with dignity," he explains), and a very occasional Catholic. Paquita Costa is a quiet, steadfast woman, with left-leaning sympathies, a good leader but even better follower.

When Antonio and Paquita meet, she is only 18 years old, and she has just arrived in the city. Everything dazzles her, including Don Antonio, who lords it over the tellers as if he were a prince among bankers.

Paquita allows herself to be courted, flattered by Don Antonio's romantic attentions (which cease abruptly after their third night together) and his sophistication. Dispensing with marriage, they opt to share a modest flat with his mother.

Passion dies off quickly, to be replaced by a docile domesticity in which there are infrequent—and remarkably swift—sexual encounters.

Jacinto is born two years later.

Moved upon seeing his son, Don Antonio proposes to Paquita, but she refuses him. The last years have made it clear to her that Antonio is an asshole. But as soon as she refuses him, "Prince" Rodriguez's lost passion is rekindled.

Every time Paquita spurns him, he grows increasingly obsessive. Flowers, courteous attentions, tenderness, and poetry all return to a relationship that had become mired in routine. But it is all in vain. Paquita still submits to the occasional physical encounter, not only because of its blessed brevity but also because she considers it a minor concession in order to maintain the peace for the real man of her life: Jacinto. But little by little, Don Antonio turns into a jealous monster.

Paquita moves to a rooming house, taking with her her son, Jacinto, who grows up quickly. She gives him her full attention, joins a union, and begins proselytizing.

Although Jacinto admires his father, Antonio is continuously criticizing him: They don't understand one another. In spite of being showered with material gifts, the boy spends his entire childhood without receiving much affection.

Don Antonio points out each and every one of the boy's mistakes, always comparing Jacinto to himself, teaching his son that in order to become a "man" it is necessary to be strict, honorable, and persistent. The boy tries to please his father in every possible way, by improving his attitude, his physical appearance, and so on, but all he receives in return from Don Antonio are reprimands and questions . . .

He always asks the same things: How is Paquita? Is she seeing a man? Has Jacinto seen her hugging anyone?

The boy is disconcerted and despondent. His relationship with his mother suffers severely because of his father's constant insinuations and insistence the boy spy on her. He comes to despise his mother and blames her for his estrangement from his father.

During a union meeting, Paquita meets a worker who is younger than she is: Rodrigo. She falls head over heels in love with him. Don Antonio, aware of this, asks his son to tell him everything that is going on. The boy keeps him informed about every single one of his mother's dates with Rodrigo.

One summer afternoon, led there by his own son, Don Antonio surprises the couple in a hotel room and stabs them. During the subsequent trial he doesn't utter a single word. He is sent to jail, where he dies two years later.

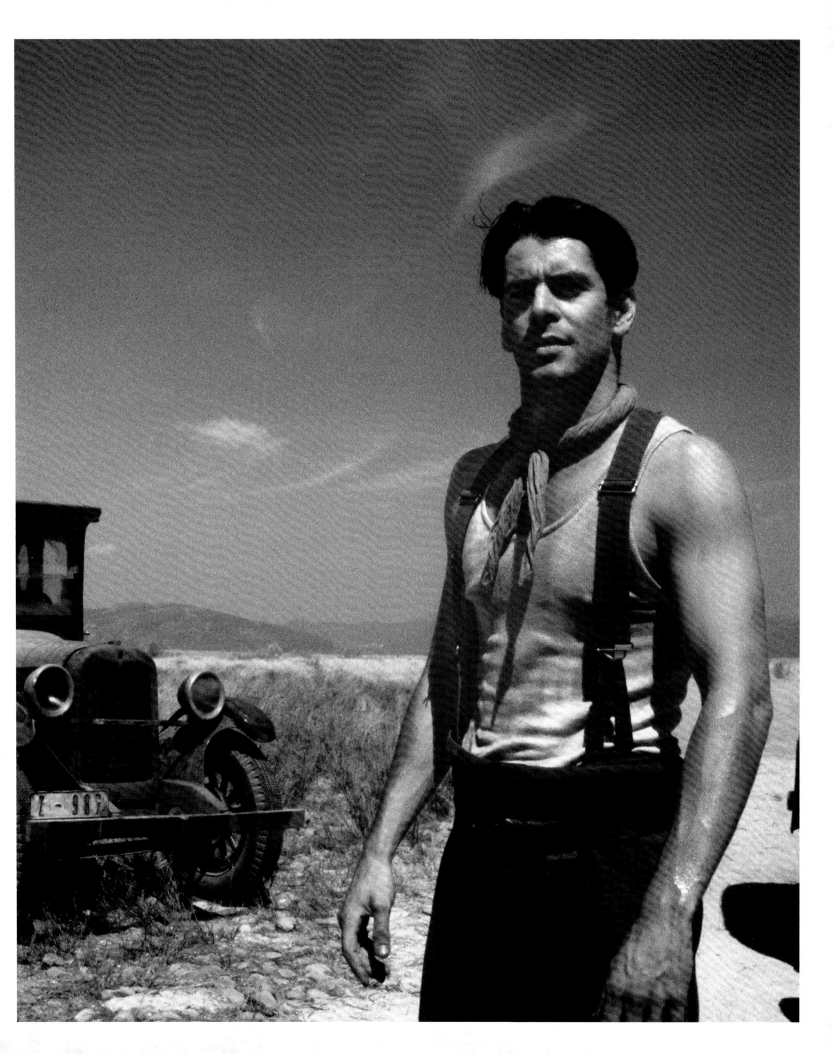

Jacinto is taken into care by the union's orphanage, but because of his bad behavior he is transferred to Santa Lucia when he is 8 years old. During the next few years, Jacinto intimidates, dominates, and punches almost every child in the orphanage.

Jacinto grows up terribly lonely. But when he turns 12, Carmen enters his life together with the orphanage's principal, Ricardo Gimenez. Carmen is fond of him and tries to help him. But Jacinto avoids her and refuses to accept her motherly attentions. His relationship with Don Ricardo, her husband, is, on the other hand, very good.

At 15, Jacinto is already a young man, and his presence begins to unsettle Carmen. They commence a subtle game of seduction that climaxes with Jacinto, under Carmen's guidance, having his first sexual experience at 16 during a trip to the beach.

A series of infrequent and guilty encounters follows over the course of the next couple of years. They always end explosively with Jacinto swearing to overcome his addiction, but succumbing once again.

For Jacinto, sex becomes an act of dominance, of subjugation. He alone reigns supreme in Santa Lucia. No one and nothing escapes his control, except a man called "Canas Negras," a mature Argentinian who seems detached from everything except pure philosophy.

When Jacinto turns 18, Don Ricardo asks him to leave the orphanage. The young man goes out into the world where he finds himself in the school of hard knocks. Because of his belligerent attitude and his questionable background, any decent jobs are out of his reach: The only employment he can find is doing manual labor or making shady deals.

He survives in a dirty rooming house, eats wherever he can, and, because he needs the money, he's even driven to mugging people violently. In spite of the distance and his attitude to her, he cannot stop thinking about Carmen. He returns to the orphanage at age 23, defeated and full of hatred, his past weighing heavily upon him. The orphanage is, at one and the same time, stigma, root, home, and prison.

Jacinto lies to himself, saying that he will stay for only a few months. That doesn't happen. Once war begins, Carmen offers to keep him in hiding.

One year later, Carmen's husband, Ricardo, dies with Jacinto at his side. The man confesses to knowing everything about the boy's affair with Carmen and asks him to take care of her: He wants to believe that Jacinto loves her. Jacinto doesn't answer. Moments later, he closes the man's eyes: Don Ricardo has died. Jacinto will never share this final conversation with anyone.

When he is 25 years old, Jacinto meets Conchita, who starts working in the kitchen at Santa Lucia. Destiny decrees their courtship emulate that between his parents. Jacinto does not love her.

He discovers the gold that Carmen keeps in her safety deposit box and decides to take it to pay the "bond" for his freedom.

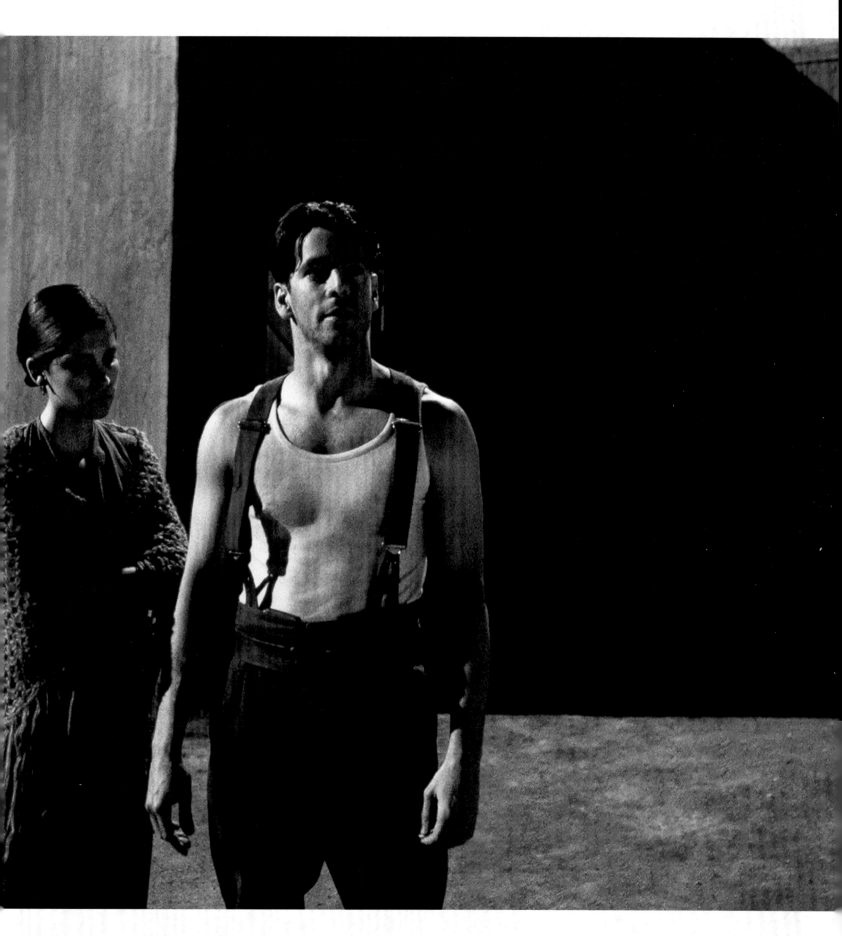

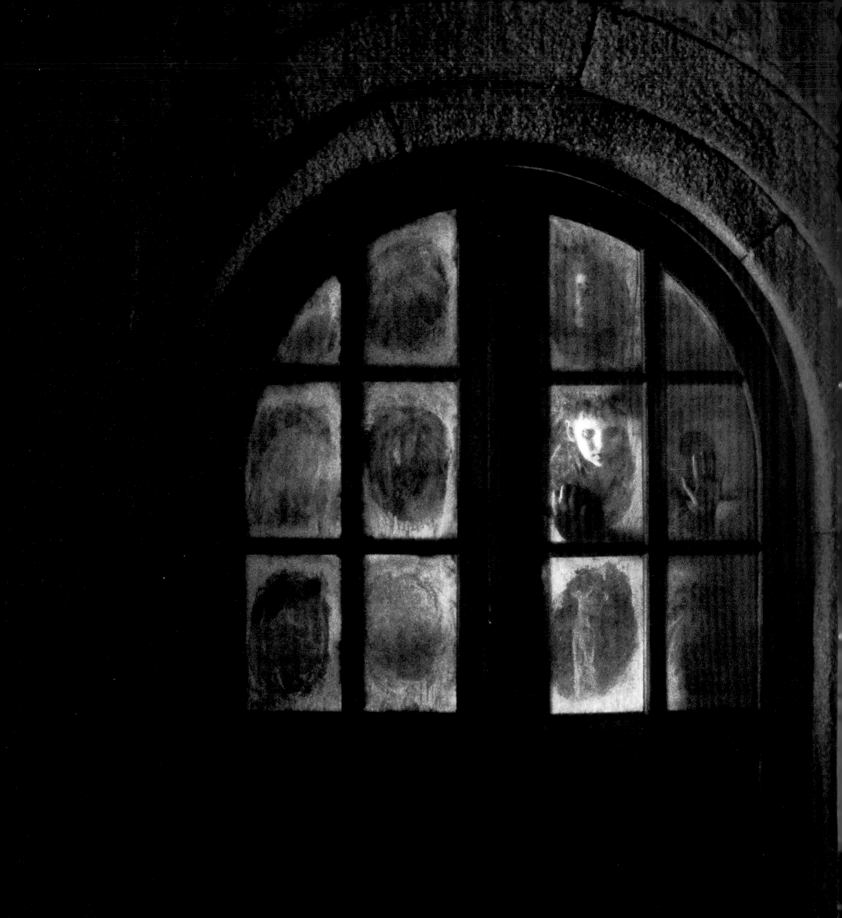

PART THREE

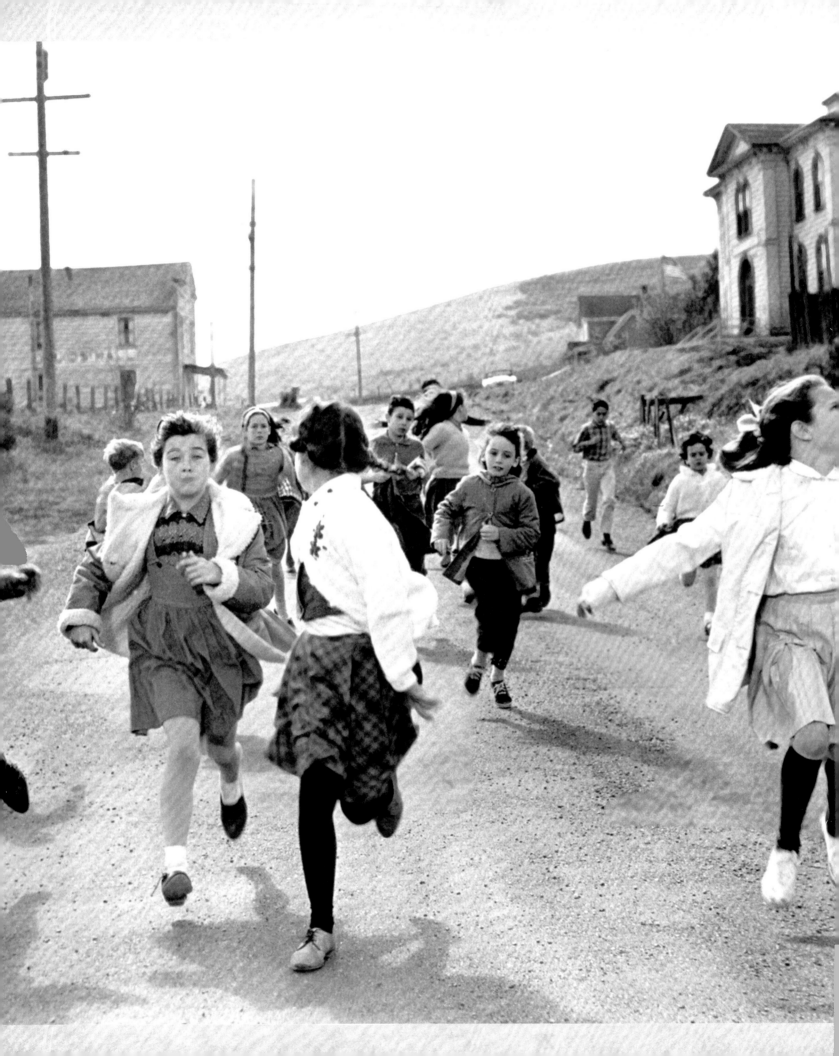

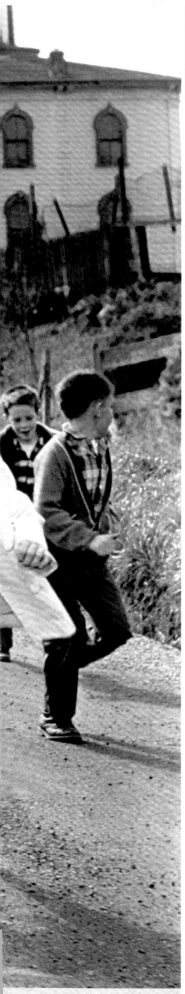

The Script

M: You wrote a screenplay years before you shot what eventually became *The Devil's Backbone*, and you combined it with another screenplay written by David Muñoz and Antonio Trashorras. Your first screenplay, prior to working with Muñoz and Trashorras, wasn't really anything like the movie that we saw, was it?

G: It still had some of the characters, but it was set against the end of the Mexican Revolution. Two friends of mine [Trashorras and Muñoz] who were Spanish critics had written, I think, five screenplays, and they gave them to me and I thought, *Oh my God, what am I going to say?* Most of the time, when somebody gives you a screenplay, the friendship ends because you go, *Well, uh . . .* End of story, you know?

I read four of them and I didn't like them *at all.* And I thought, *Oh my God. This fifth one is going to be a disaster.* The last one was called *The Bomb,* and it was the story of a bullish caretaker and a bomb in the middle of an orphanage patio.

The setting of Antonio and David's version was very, very different, by the way. It was set in the middle of nowhere. The setting was desolate, cold.

M: Was it set in any particular country?

G: Yes, it was set in what I call the European Co-Production Country.

M: [*Laughs.*]

G: That's a country in Eastern Europe that exists solely in order to make a movie more salable internationally, which in my opinion is the worst possible sort of place to set a movie. Alfred Hitchcock is supposed to have said that a movie

that could happen anywhere happens nowhere. You know? You have to be geographically specific in order for your movies to matter.

M: I hadn't thought of Hitchcock as a geographically specific filmmaker, but I can see it. In his own way, he's as rooted in specific terrain as somebody like Robert Altman.

G: Yes. Think of how *Vertigo* portrays San Francisco, or the area that the train passes through in *Strangers on a Train.* Or the towns in *Shadow of a Doubt* or *The Birds.* The setting is very strongly informing the mood of every Hitchcock film, the way the characters behave, everything.

So, of course, my first instinct was to go in the opposite direction and set *Devil's Backbone* in a sun-drenched landscape. But originally, Antonio's story was basically set in the "Zone" territory from Andrei Tarkovsky's film *Stalker.* There were structures with medieval walls and so forth.

M: So they provided the raw materials, and you grafted your own ideas onto their script and took it home.

G: Yes. But we couldn't write it at the same time as each other because this movie was written during the kidnapping of my father in Mexico. We co-wrote this script in phases, giving each other what we had written and passing notes to each other back and forth without being in the same geographical location.

M: Let's talk about the kidnapping.

Location, location, location: **OPPOSITE** Alfred Hitchcock's *The Birds* (1963) soaked up the atmosphere of Bodega Bay, California; **TOP LEFT** Hilly San Francisco looms in every exterior of Hitchcock's *Vertigo* (1958); **BELOW** A signature shot from Andrei Tarkovsky's *Stalker* (1979), shot in Tallinn, Estonia.

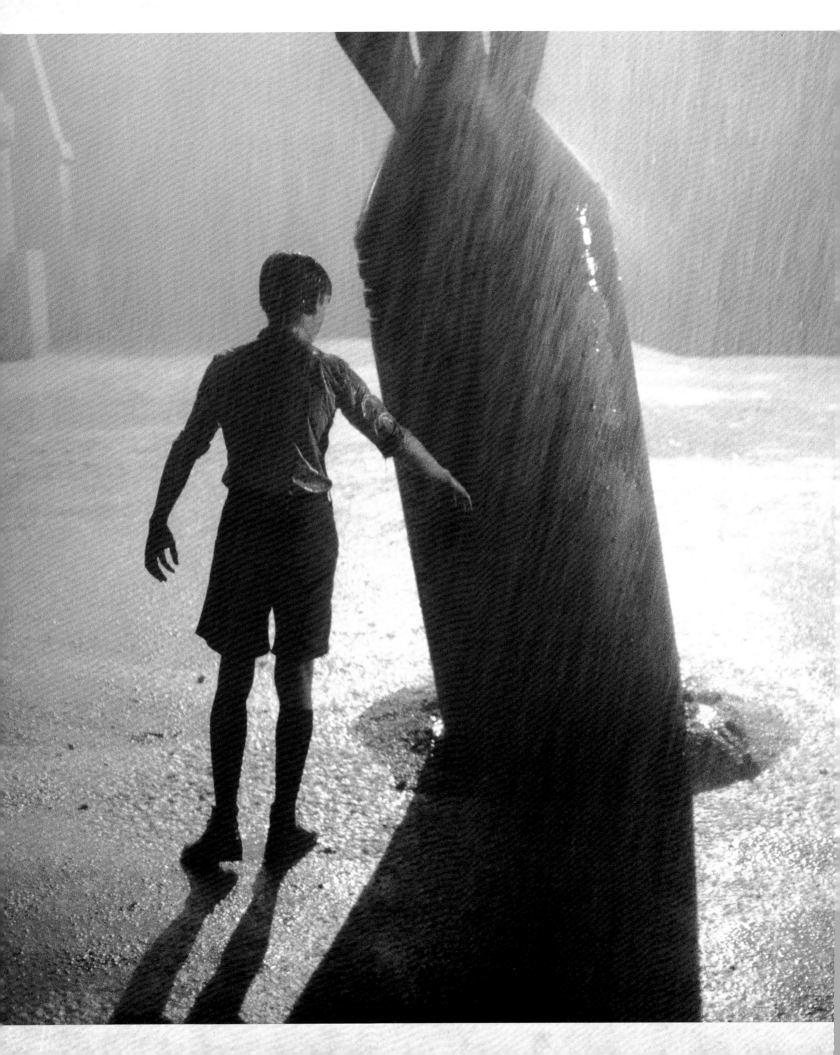

ANTONIO TRASHORRAS

Spanish screenwriter Antonio Trashorras originally showed his screenplay for a film called *The Bomb* to Guillermo del Toro in October 1997 at Spain's Sitges Film Festival. Trashorras, who was a film critic at the time, had co-written the script with David Muñoz. He quickly bonded with del Toro over comics, literature, cinema, and more. Del Toro promised to read *The Bomb*. Two month later, he agreed to buy the screenplay rights and suggested that they change the film's title to *The Devil's Backbone*, a title for an unproduced script that del Toro had written in Mexico years before. Trashorras, Muñoz, and del Toro then worked together on the shooting script for *The Devil's Backbone* over the course of two years.

AT: *The Bomb* was situated in an unknown country during a war. David and I did not specify the time or nature of the conflict. It was set during an imaginary time. We took elements of almost every war that occurred in Europe during the twentieth century. We were interested in telling a story within the closed and symbolic universe of an isolated orphanage in an area near the battlefield, a place where the so-called invading army had not yet arrived. I remember that the story began with a scene where, in the middle of the night, a child woke up in the bedroom where he slept with all his companions and quietly descended to the patio where we [the viewers] discover that there is a huge unexploded bomb stuck in the ground.

The boy approaches the bomb, touches it, and stands next to it as if he's receiving some kind of message from it. Then another boy appears, who we later discover is the ghost of a murdered pupil. Both kids play around the bomb until dawn.

Many of the elements that are present in *The Devil's Backbone* were present in the story that David and I did, albeit in a somewhat different way: school, war, bomb, ghost, murder . . . That having been said, I remember that the adults were less important in our story.

The Bomb had more scenes focused exclusively on children. The elements of love, sex, and secrets between Casares, Carmen, Jacinto, and Conchita are all Guillermo since David and I practically did nothing to develop any of these relationships between adults. Instead, we focused on the life of the children at school, how they related to one another, the mystery behind the existence of the ghost boy—how he died and why—and the situation of chaos that occurred at school when the students seize control. The subplot of the gold [that Jacinto covets] doesn't exist in *The Bomb*, nor does any of the political context related to the two ideological sides of the Civil War.

The plot of the original *The Bomb* script was basically: Carlos arrives at an orphanage where only women work. He hears the other children speak of a ghost that began to appear the same day that an immense bomb that didn't explode fell onto the courtyard. This ghost may be the specter of a boy who disappeared that night. During the course of the story, Carlos discovers that this boy—Santi—has accidentally died because of one of his companions, Jaime.

When Guillermo bought the script, he not only rightly placed the story in the Spanish Civil War but also asked us to add elements such as the character of Professor Casares as well as all the relationships governing the adults at school.

Guillermo also asked us to create a masculine character who would be the antagonist. We thought of a mature janitor, who was mean and violent with the children, representing exactly the opposite values represented by Luppi. Guillermo made a fundamental change in this character by lowering his age and turning him, in his words, into a sort of young fallen angel, beautiful and consumed by hatred and resentment. He turned a character conceived as a beast in one piece into a villain full of psychological nuances and pain, capable of even generating some understanding and empathy from the viewer.

David and I worked remotely with Guillermo, through phone calls and emails. Guillermo settled in Madrid a few months before the shoot, so that gave us the chance to speak to him in person about some small things, although by then, the script was almost completely finished.

When a writer is also a director, like Guillermo, there comes a moment when there is not much time left before the movie shoot; when the decisions made not only influence the script but also the shooting plan, aesthetic intentions, planning, et cetera. As a result, what he has in mind is no longer the result of the written page but also what he can put on screen.

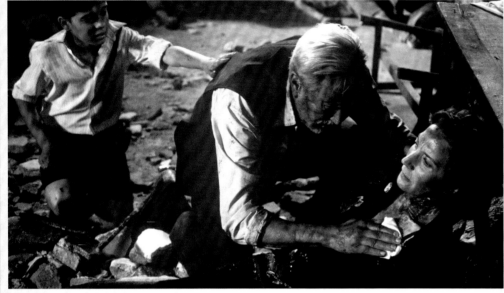

So during the script's final phase, Guillermo made some changes that had to do with production factors that went beyond the scope of our previous work on the script. We also slightly tweaked the dialogue, as Guillermo wanted to make sure that all the phrases of the actors sounded completely "Spanish." He wanted the Spanish viewers to never know that one of the screenplay writers was Mexican.

As a screenwriter, I believe in the construction of characters of a certain complexity, that bear a certain sense of "reality." I also believe in the use of human archetypes that effectively fulfill simple narrative functions. Archetypes are useful when you want to elaborate the plot without overloading the story with a kind of cheap psychologism that sometimes betrays the scriptwriter's "deep" aspirations.

In the case of The Devil's Backbone, it's clear that the mold we used to tell the story is the English Gothic romance, a model based on archetypes. Despite its origins dating back centuries, the Gothic romance's tropes are particularly liberating when used today given the dictatorship of psychological realism inherent in most commercial Hollywood screenplays.

I was fortunate that Guillermo allowed me to be by his side during the whole shoot. I learned a lot about how to make movies and, above all, how to overcome the unforeseen difficulties and obstacles that always arise during filming.

I also perfectly remember that Guillermo spent several days sick with respiratory problems and a somewhat worrisome cough because of the great amount of airborne dust in the underground pool where Santi's and Jacinto's deaths were filmed.

It was quite difficult to shoot down there, but especially for Guillermo, who had to take medicine so that his breathing problems wouldn't increase.

I remember the good—and hard—times spent with Guillermo during the shooting in Madrid. And each time I watch the movie, I like it more.

INTERVIEW BY SIMON ABRAMS

TOP LEFT Jaime and Carlos.
TOP RIGHT Sooty orphans.
ABOVE Carlos looks on as Casares tends to the dying Carmen.
OPPOSITE Carlos meets Santi.

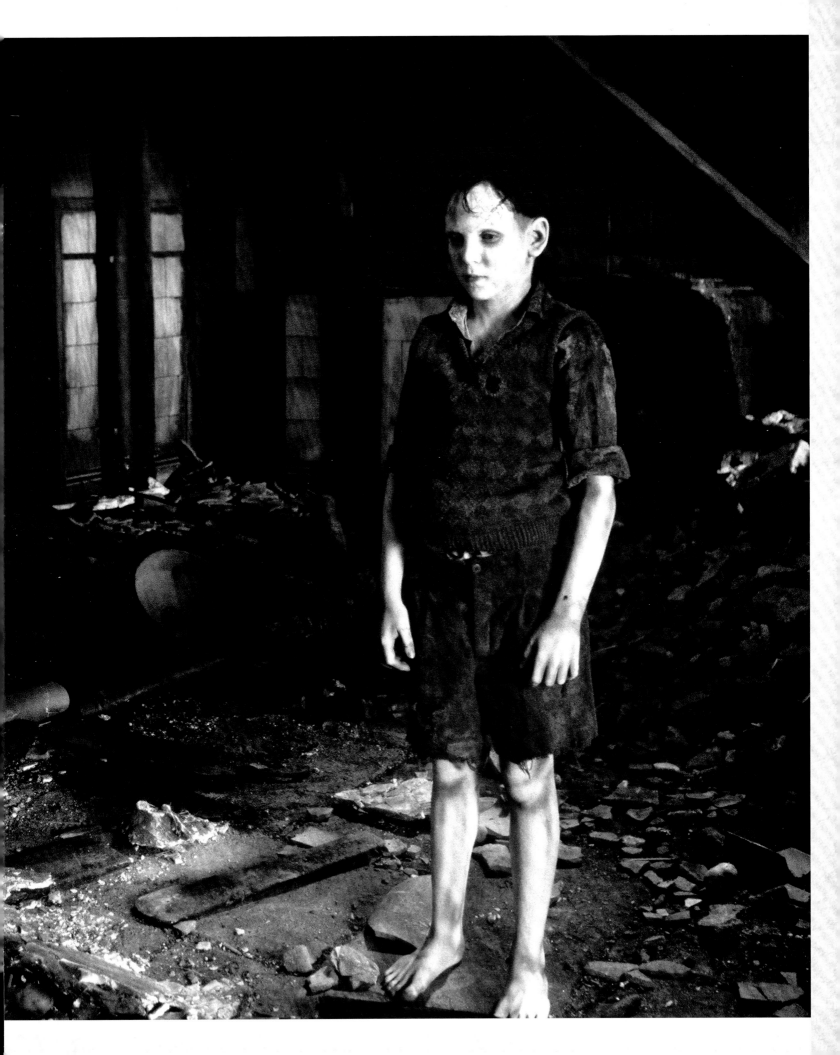

The Kidnapping

G: My father was held for seventy-two days.

M: When was he kidnapped? What was that like for him?

G: It's better if I don't give you details like that. I need to respect my father's privacy.

M: All right, then. What was it like for you and your brothers?

G: On the first day, the police kidnapping negotiator arrived and said, "What do you do for a living?"
I said, "I write."
And he said, "Well, this is what I want you to do: Go on writing. I don't want you to make yourself a target by disrupting your routine and being kidnapped along with your dad. You need to circumvent being on a kidnapping detail 24-7."
So I wrote *The Devil's Backbone* during the kidnapping. I did a pass and sent it to my co-writers, and they did a pass. I didn't see my co-writers until after the screenplay was done.
There are references to *The Count of Monte Cristo* in *The Devil's Backbone* because at the time of my father's kidnapping, I was also being paid to write a screenplay of *Monte Cristo*.

M: The references are quite prominent. It's obvious that Alexandre Dumas's novel meant a great deal to you at that point in your life.

G: *Monte Cristo* is intrinsically tied to *Devil's Backbone*—the idea of the escape, the liberation, and the fact that revenge, at the end of the day, is a hollow act. It's not going to give you a solution.
The beauty of *The Count of Monte Cristo* is in the partnership between Edmond Dantès and Abbé Faria in prison. A prison escape is at the center of that novel. It is about coming together in the middle of a prison situation and finding the hope that you could conquer it.
I remember when we wrote the screenplay— Kit Carson and I—and I had the Count digging the tunnel with a spoon. I thought, *How do we show the passage of time?* So what I did is, every day they'd bring them a plate with rancid bread and a leg of chicken, and I had him put the bones on the side of the wall every day, so when you go through the tunnel and it's littered with chicken bones, that tells you he's been there fifteen years.
In the mornings, I worked on *Monte Cristo*. I worked on *Devil's Backbone* in the afternoons.

And then at night or in the early, early morning, I'd transcribe the conversations between the negotiators and my father's kidnappers. That was the other duty that I had every day. My older brother did this during the first half of the negotiation, then during the second half it was my younger brother and me.

M: Why did you have to transcribe it?

G: Because I spoke English and Spanish, and the negotiator was English from London. Most negotiations of kidnappings in Latin America are done by a firm in London. It went on like that for a while, then the UK negotiators changed after thirty days [and we got some new guys]. The final fifteen days of the kidnapping were done without negotiators, but with the assistance of a special police negotiator in Mexico.
When you see *Proof of Life*, with Russell Crowe and Meg Ryan, that's exactly how it is two-thirds of the movie. The first two-thirds of *Proof of Life* is exactly how it happens. And then they fall in love, and everything goes south!

M: There's no Meg Ryan in your story!

G: No! [*Laughs.*] I was part of a bumbling group of rescuers.

M: It sounds excruciating but also tedious.

G: Reality is prosaic, you know? Nothing is exciting. Everything happens at a snail's pace.
My brother and I, for example, were told, "You need to photocopy every single [dollar] bill of the ransom, to have the serial numbers, because the IRS will tax you for that money if you don't prove that it was delivered as ransom."
So my brother and I go to pick up the second payment, which is another half a million, and we go to the bank, and the guy goes, "I'm going to give it to you all in fives and ones!"

M: Why? Was he just being a jerk?

G: No, he said, "That's what we have." And we go, "OK."
So my brother and I come out of a subterranean vault in Guadalajara with a suitcase full of money, and I said, "Where are we going to photocopy this?"

M: You walk into Kinko's with crates full of cash?

G: No, we went to Office Depot and bought a photocopier and took it home with us.

We went home and we took turns photocopying the money. Both of us had a 9mm gun. One of us would be by the door with a 9mm, and the other would be in a room with the other 9mm photocopying the money. We took turns photocopying ten thousand dollars each while the other guy stood by the door.

I tell you, it took two days, nonstop, to photocopy half a million in one and five dollar bills. Seventy-two days this went on.

M: The photocopying of the money is almost like a scene out of slapstick comedy.

G: It was. I mean, there were moments of sheer tragedy that were also funny as fuck.

We tried to pay the ransom two times. The first time, the guy who was supposed to drive it there chickened out.

The second time, the kidnapper told me, "We want you on an airplane. Don't tell the police, and when you're on the airplane, give us the flight coordinates because this is what you're going to do with the money: You're going to put it in three plastic bags and then you're going to tie them until the money is really, really, really tight because any air from the money when it drops from the airplane is going to fill the vacuum with air and make the trajectory difficult. So pack them almost airproof. Then you wrap it with gaffer tape and you put a couple bricks tied to that. And that's what you're going to toss from the plane."

So I call the police and I say, "The only thing I really need your help with is the plane."

M: But didn't the kidnappers warn you not to go to the police?

G: Yes. But we had already talked to the police utilizing back channels. We had to, because paradoxically, if you don't talk to the police during a negotiation, they can accuse you of collusion later.

So then the police say, "OK, we'll get you a plane."

"And the pilot needs to be able to fly coordinates," I say.

"OK, we'll get you a plane with a guy who can fly coordinates."

I'm driving to the airport with half a million in cash. I get to the airport and they got me a plane with a huge sign on the bottom that says "Federal Police," with the shield of the Mexican government!

M: Not good.

G: So I get the phone call and—these are not nice phone calls. They start by insulting you, because that's how they disarm you: "Listen to me, you fucking motherfucking cocksucker. We're gonna do this, you'd better fucking do it right or when you get home you're gonna find your father's hands in the fucking doorway waiting for you." So the kidnapper on the phone says, "What are you waiting for?"

I say, "I'm at the airport, I'm not yet on the fucking plane."

* "Flores" en animación C/computadora
* Gag en escalera eléctrica C/sangre para "Spanky" (aparecen gotas, manchas, ríos de sangre en una escalera eléctrica que desciende).
* LOTTIE LE DA el cuchillo a Martya al Final.
* Gag con espadas y una puerta
* "Guante" mecánico para el conde de Montecristo VERSION ORO puro. Ⓐ
* Importante: "Guante" tiene abertura & cristal

And he goes, "You better get on the fucking plane."

I say to the cops, "What are we gonna do?"

They say, "That's it. We don't have any other plane."

"Can I rent one right now?"

"They're all gone."

And I think, *Well, fuck it. They're gonna look at the plane, and probably it's still daylight, the contrast is very clear and it'll make the plane black. I hope they don't see the sign.*

So I climb on the plane. You have to ride it with the door open because if you open the door in the middle of the flight, there's a change of balance in the air. From the moment you take off, the door needs to be open.

So I'm riding, grabbing a metal bar, and with the other hand I'm grabbing half a million in cash, riding in an open fucking cockpit. And we are high, high, high.

M: Who else is in the plane with you?

G: It's just me and the pilot.

The phone rings, I pick up, and the kidnapper says, "OK, I'm going to give the coordinates to the pilot."

"OK."

I give the phone to the pilot. He says, "Yeah?"

Kidnapper says, "Forty degrees west, eighteen east, five north." Hangs up.

The pilot says, "I don't fly coordinates."

I go, *"Then why the fuck didn't you tell him?"*

"I don't have to tell him, it's your problem!"

"What are you doing?"

"I don't know!"

M: [*Laughs.*] Sorry, I know I shouldn't be laughing—but it's just so ridiculous!

G: I'm shitting my pants! So I'm now flying on a marked police airplane with a guy who doesn't fly coordinates!

So I waited for the kidnappers to call back and then told them, "The guy doesn't fly coordinates."

"Fuck you! I told you he needed to fly coordinates!"

"The guy doesn't fly coordinates."

He says, "Give me ten minutes."

Now the sun is going down. The guy calls me back, says, "Give the phone to the pilot." I go, "OK," and hand the phone to the pilot.

The pilot says, "Yeah? I know the mountains. Yeah. Next to the lake. Yeah. OK."

The pilot hangs up, and says to me, "I'm not going there."

I go, *"What? Why didn't you tell him?!"*

He says, "The sun is falling, the fog is racing in from the lake, we cannot fly that close to that mountain."

I go, *"Why didn't you tell him that? Why do I have to fucking tell him?"*

"It's not my problem."

So the guy calls me again, and I say, "The guy doesn't want to go because there's fog."

M: [*Laughs.*] Oh God!

G: The kidnapper says, "OK, go down, get in a car. You're bringing me the money, you motherfucker. You're bringing me the money."

I go, "Listen to me: I'm not bringing you the money, because all you're going to do is free my father and then kidnap me; then you're going to try to get more money for me. And that's not fucking happening."

The guy says, "Listen, I don't give a shit who brings me the money. But the next time the phone rings, the voice I hear is the voice I want to hear for the rest of the night or the deal is off, and we kill him tonight. Period. Do you understand?"

"I understand."

"Next time the phone rings, you bring me the money or we kill him tonight."

So we land in the airport, I jump into my car, and from the plane I'm calling the guy who was supposed to deliver the money the first time but chickened out.

I go, "You remember you said you wish you delivered the money? Well, you got your wish, you're delivering it."

Then I jumped into an armored car. Normally it takes me forty minutes from my house to the airport. This time, I do it in ten. I'm going at, like, 150 miles per hour in a bulletproof car, super-fast speed.

And as I arrive at my house, the guy who is going to deliver the money comes out. The phone starts ringing and I hand him the phone on the street. He picks up, he gets the location, and he delivers the money.

M: And your dad was released.

G: Yes.

M: There's this feeling in *The Devil's Backbone* of claustrophobia, imprisonment, and incipient violence. All these different aspects make a lot more biographical sense knowing the circumstances under which the film was written. Of course *The Count of Monte Cristo* is in there.

All movies are therapy to some degree, but perhaps this one maybe more so than others?

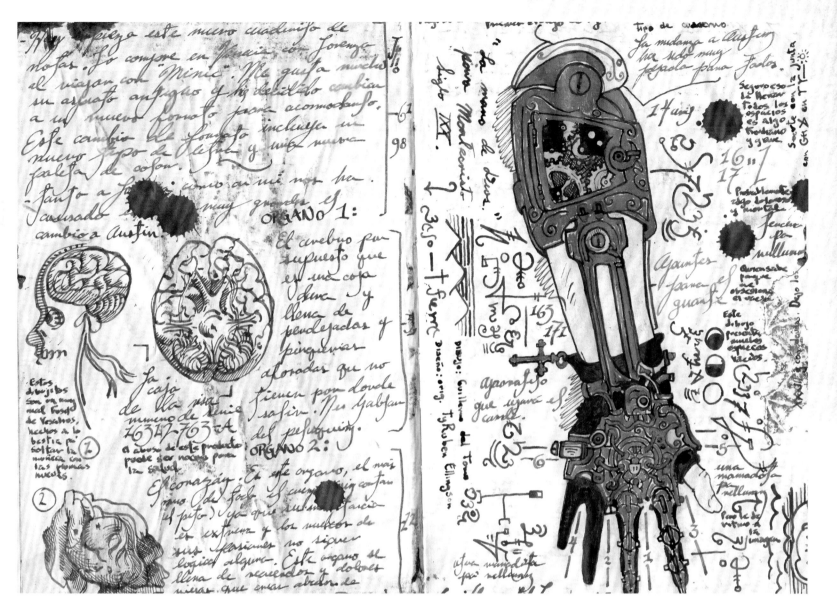

G: The three movies of mine that are completely therapy for me are *Pan's Labyrinth*, *Devil's Backbone*, and *Crimson Peak*. And now a fourth, *The Shape of Water*. Completely, fully, one hundred percent therapy for me. How they played for other people, or whether they played and are seen as beautiful fantasy or this or that, I have no control over. But to me the four movies are parts of my brain interacting within my head.

M: The last sentence of *The Count of Monte Cristo* is "All human wisdom is contained in these two words: wait and hope." That resonates with the story of *The Devil's Backbone*, I think.

G: It does. That's why I feel such ardent love for *The Devil's Backbone*. I literally came back to life while writing it. *The Devil's Backbone* is my *Monte Cristo*—I escaped the prison, and Pedro Almodóvar was in the cell next door and helped me dig my way out!

I was trapped inside of something horrible, with the hope that one day it would be better,

because when you're in the middle of a kidnapping there are two outcomes. One is you're responsible for the death of your father. That's one outcome.

M: Well, you *feel* responsible.

G: Yes—but it would take a lot more years of therapy to realize that you were not, you know?

M: Yes.

G: And the other possible outcome, which is really life-transforming, is you save your father's life. I try to advise everybody to go through it once in your life, because it's incredibly cleansing.

M: [*Laughs.*]

G: But while you're going through it, you live every day thinking, *If I fuck up, my dad is dead.*

Fortunately, the good outcome was the one we got.

155

The Loneliest Person in the World

M: The relationship between fathers and sons, and grandfathers and sons, is something that recurs in most of your films. You see this even in the movies that people describe as light, which—well, I don't really see a division between your so-called light and heavy films, but—

G: There is no division.

M: Even in *Blade II*, the relationship between Kris Kristofferson and Wesley Snipes in that movie feels real, whereas in the first *Blade* it felt more like a conceit. In the second one I felt, *Wow, this guy is his dad*. I really felt that.

G: And even more important is the relationship with the bad guy and his father. That's the reason I made that movie. I said to Wesley when I met with him, "I have no interest in *Blade*, but I'm very interested in the bad guy. Can you take care of Blade being cool, and I'll take care of the bad guy being emotionally strong?" Because the bad guy in that movie is a tragic prince.

M: He is—and, not to get too grandiose, but the structure of it reminded me of how, in a Shakespearean tragedy, there'll often be a second story that duplicates the main story, or that mirrors it in some way. So in *Blade II*, you have a healthy father-son relationship with some tension, and then on the other side of the movie, you have a deeply fucked-up one.

G: It's deeply fucked-up. To me, all the characters in stories are different permutations of the same problem. That's why in *Devil's*, I coded the initials,

BELOW Jacinto (Eduardo Noriega) peruses long-lost papers before burning them.

OPPOSITE The hunters prepare to slay a mammoth.

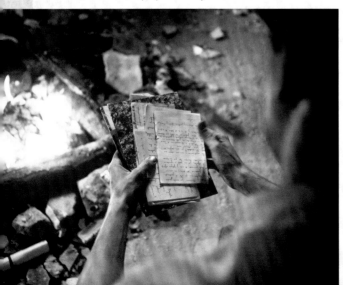

which we talked about—Carlos, Carmen, Casares, and Conchita—they all share the same initial. And Jaime/Jacinto—if the story had gone another way, Jaime would have become Jacinto.

M: Of course, yes.

G: As it is, he's on his way to becoming Jacinto.

M: But then he meets Carlos.

G: But then he meets Carlos, yes.

M: And my favorite moment, I think, in the entire movie, is when Carlos compliments him on his artwork.

G: Yes!

M: It was so unexpected.

G: That's me in school.

M: It reminds me of the famous image from the sixties of the young hippie putting a flower in the barrel of a National Guardsman's gun.

G: It is like that!

And I tell you, I'm not by any means a perfect person, but at fifty-two, I do know one thing: The only thing that stops hatred is love. I have a scar from a stabbing on my leg. I've been in fierce fucking fistfights. I'm not a wilting fucking flower. I can duke it out. But the only thing that can stop hatred is not hatred, it's love. It deactivates everything.

Just two weeks ago, I had an incredibly, intensely antagonistic exchange of emails with a creator I respect and love, and the next-to-last email was the end of the friendship, right? That was it. And I'm having supper with my youngest daughter and I said to her, "I fucked up." Then I listed all the ways that I fucked up. And she says, "What are you gonna do?" and I said, "I'm going to write him an email and say, 'I unreservedly and completely own my mistake and I apologize completely, and I think you are right to be angry.'" And that stopped it. We are still friends on great speaking terms.

But the reality is, hatred just isolates you completely. There is no one lonelier than the person who hates. That's the loneliest fucking person in the world. The loneliest person in that orphanage is Jacinto. He's actually, in many ways, the only person who is completely alone.

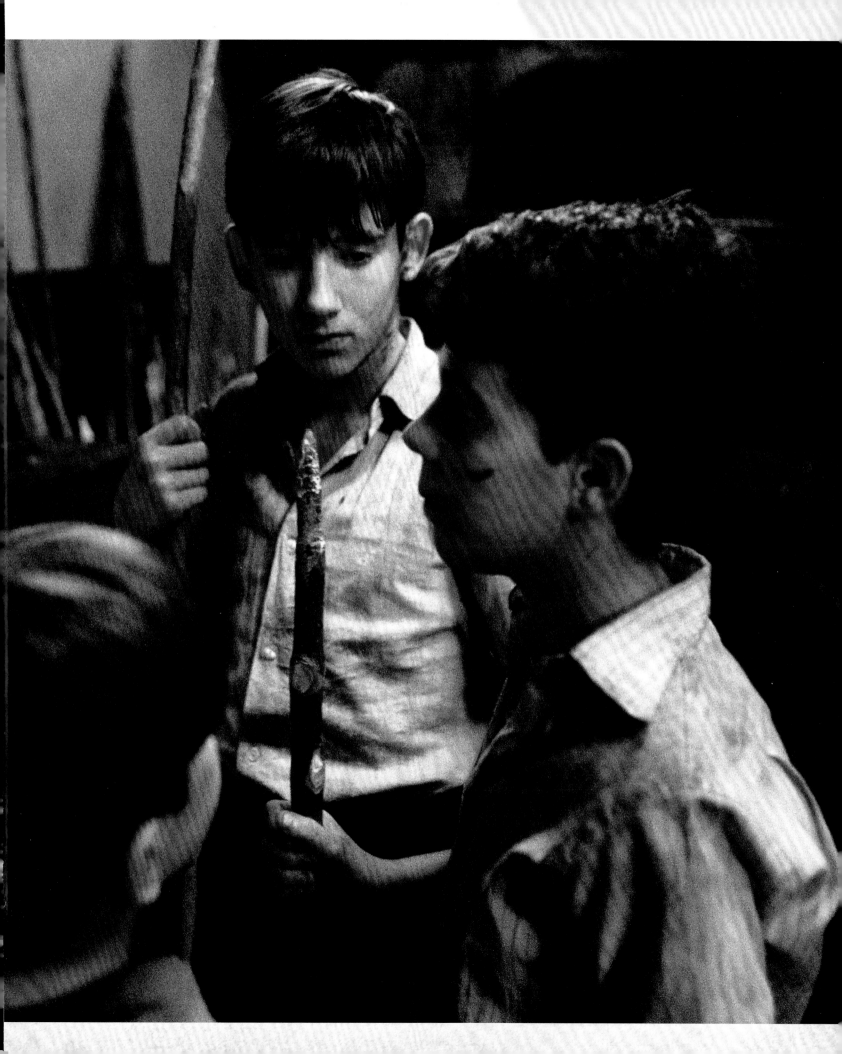

The Kubrick Principle

M: *The Devil's Backbone* was my favorite movie the year it came out, and it spoke to me on a lot of levels. One of the things I liked most about it is how it's an example of that principle Kubrick talked about. I'm not saying every movie has to be like this, but: He said that for his movies, he had an idea, and every character, scene, line, image, and metaphor somehow embellished that idea. This movie is that kind of a movie.

G: It all serves a purpose.

M: Yes, it's very exact. And it's very clean.

G: I tried to—not that I succeeded—but I tried to make every movie since *Cronos* be about one thing.

That said, you make every movie about something, and it may be about something else you don't know. I think you may be functioning, organizing all the symbols to your thesis and enacting all the characters for your thesis, but it turns out the movie signifies something else that you were never aware of. That is completely possible. That happens to me when I study other people's films, you know?

But yes. *The Devil's Backbone* is the cleanest and the leanest of all my movies. It's elegant in the way it presents a thesis, and it's organic, and it never needs any more resources than it has, and it has a lot of style without being STYLE in all caps. It's a very invisible style, which I think is always a little better.

Will I ever return to the simplicity of *Devil's Backbone*? I don't know.

You only complete a movie when it belongs to the audience. You never know. When *The Devil's Backbone* came out, it was released in, like, three or four theaters. It did no business. It was not reviewed in Toronto because 9/11 happened the next day. It made a couple of top ten lists.

M: Including mine.

G: Including yours, and I was grateful for that. But it was not a movie people were clamoring to see at that precise moment, a movie about war and children.

Then ten years pass, and I find it's the movie that is reevaluated the most by people who like what I do.

M: It resonates throughout the rest of your filmography.

G: It does. *Pan's Labyrinth* is a return to that form, but differently because it's also a pageant. *Crimson Peak* is sort of some of the same ideas, taken in a more psychosexual rather than a social direction. I think *The Shape of Water* is a return to the simpler resources and form of *The Devil's Backbone*. Shooting it, I felt the same freedom.

M: *The Devil's Backbone* is my favorite of your films.

G: Mine, too.

LEFT Casares (Federico Luppi) waits for Jacinto to return.
BELOW A lost tribe.

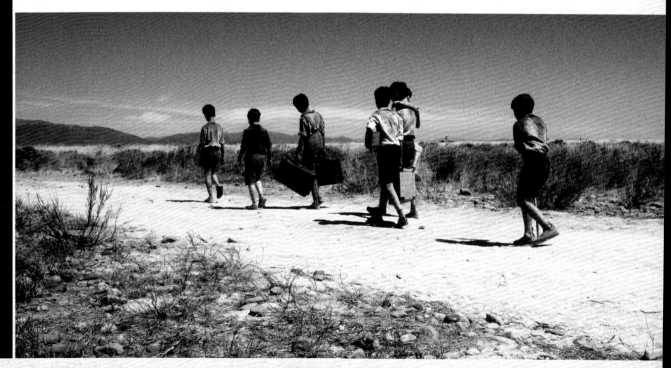

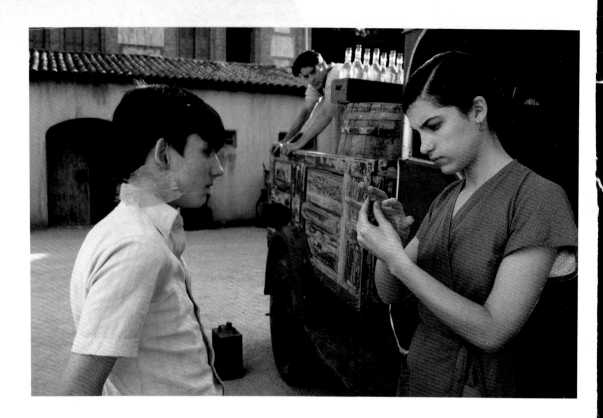

INSIGHT
EDITIONS
PO Box 3088
San Rafael, CA 94912
www.insighteditions.com

Find us on Facebook: www.facebook.com/InsightEditions

Follow us on Twitter: @insighteditions

Library of Congress Cataloging-in-Publication Data available.

ISBN: 978-1-68383-108-2

PUBLISHER: Raoul Goff
ASSOCIATE PUBLISHER: Vanessa Lopez
ART DIRECTOR: Chrissy Kwasnik
DESIGNER: Jon Glick
DESIGN ASSISTANT: Kai Glick
SENIOR EDITOR: Chris Prince
MANAGING EDITOR: Alan Kaplan
EDITORIAL ASSISTANT: Hilary VandenBroek
PRODUCTION EDITOR: Rachel Anderson
PRODUCTION MANAGER: Alix Nicholaeff

ROOTS of PEACE REPLANTED PAPER

Insight Editions, in association with Roots of Peace, will plant two
trees for each tree used in the manufacturing of this book. Roots of
Peace is an internationally renowned humanitarian organization
dedicated to eradicating land mines worldwide and converting
war-torn lands into productive farms and wildlife habitats. Roots of
Peace will plant two million fruit and nut trees in Afghanistan and
provide farmers there with the skills and support necessary for
sustainable land use.

Manufactured in China by Insight Editions

10 9 8 7 6 5 4 3 2 1

DEDICATIONS
To my wife, Nancy, and my children, Hannah and James; to two of my earliest writing teachers,
Octavio Solis and C.W. Smith; to the good folks at RogerEbert.com and *New York Magazine* for
tolerating my side projects; and finally to my maternal grandfather, Emil, who read me the Brothers
Grimm at bedtime and relished the gory parts.

—Matt Zoller Seitz

For your inspiration and love: Beth Abrams, Bruce Abrams, Catherine Abrams, Daphne Abrams,
Eleanor Abrams, Robert Abrams, Bill Best, Steve Carlson, Alex de Campi, and Odie Henderson.

—Simon Abrams

ACKNOWLEDGMENTS
For their insight, advice, and invaluable help in putting this book together, the authors would like to
thank: Guillermo del Toro, Gary Ungar, Carlos Giménez, Bertha Navarro, Guillermo Navarro, Javier
Navarrete, Esther Garcia, Pilar Revuelta, Fernando Tielve, Federico Luppi, Sara Bilbatua, Luis de
la Madrid, Antonio Trashorras, David Marti, Luis Martinez, Óscar Valiente, Desirée de Fez, Dean
Mullaney, and Danel Olsen.